"It's the sort of place where you have to wear a shirt."

NICK NOLTE in *North Dallas Forty*

CHIC
SIMPLE®
Guides

WORK CLOTHES

ALFRED A. KNOPF NEW YORK 1996

Grateful acknowledgment is made to the following for permission to reprint previously published material:

FORTUNE MAGAZINE: Excerpt by Masuru Ibuka from "How Sony Keeps the Magic Going" by Brenton R. Schlender (as quoted in *Fortune Magazine*, February 24, 1992). Reprinted courtesy of *Fortune Magazine*. ICE NINE PUBLISHING COMPANY, INC.: Excerpt from "Scarlet Begonias," words by Robert Hunter, music by Jerry Garcia, copyright © 1974 by Ice Nine Publishing Company, Inc. Reprinted courtesy of Ice Nine Publishing Company, Inc. SCRIBNER: Excerpt by F. Scott Fitzgerald from *A Moveable Feast* by Ernest Hemingway, copyright © 1964 by Mary Hemingway, copyright renewed 1992 by John H. Hemingway, Patrick Hemingway, and Gregory Hemingway. Reprinted by permission of Scribner, a division of Simon & Schuster.

KIM JOHNSON GROSS JEFF STONE

WRITTEN BY J. SCOTT OMELIANUK
ART DIRECTION BY WAYNE WOLF
PHOTOGRAPHS BY ROBERT TARDIO

STYLING BY MARTHA BAKER
CHAPTER ILLUSTRATIONS BY DAVID PLUNKERT
ICON ILLUSTRATIONS BY AMY JESSICA NEEDLE
TROUSER BLUEPRINT BY CHENG•OLSON DESIGN
TIE ILLUSTRATIONS BY ANN FIELD
HANGER ICON ILLUSTRATION BY ERIC HANSON

Library of Congress Cataloging-in-Publication Data
Gross, Kim Johnson.
Chic Simple. Work Clothes/[Kim Johnson Gross, Jeff Stone: written by J. Scott Omelianuk: photographs by Robert Tardio]. — 1st ed.
p. cm.
ISBN 0-679-44716-4
1. Clothing and dress. 2. Fashion. I. Stone, Jeff, 1953–. II. Omelianuk, J. Scott. III. Title.
TT507.G75 1996
646'.32 — dc20
96-22654
CIP

Printed and bound in Great Britain by Butler & Tanner Ltd, Frome and London
First Edition

For Joanne, Wayne, and the Chic Simple staff, with gratitude for their hard
work and good humor. And to Knopf for their enthusiasm and support.

Grateful acknowledgment is made to Levi Strauss & Co. for its support and generosity in sharing
its resources of four years of surveys, focus groups, and interviews on the new corporate
dress code—and, even more importantly, for creating the staple of Jeff's wardrobe: the 501 jeans
that he has buttoned and unbuttoned his entire life or at least since he was seven years old.
It is truly one of the great American icons.
J.S. and K.J.G.

For David, Glenna, and Carolyn, for your love, encouragement, and flexibility,
and Jeff for a great adventure.
K.J.G.

For Sonny, whose sartorial flair made me leave the corporate world.
J.S.

For Pamela.
S.O.

"The more you know, the less you need."

AUSTRALIAN ABORIGINAL SAYING

CHIC
SIMPLE ®

Chic Simple is a primer for living well but sensibly. It's for those who believe that quality of life comes not in accumulating things but in paring down to the essentials. Chic Simple enables readers to bring value and style into their lives with economy and simplicity.

HOW TO USE THIS BOOK: Office dress has gone through a drastic transition in the last few years. Many of the newer CEOs know that employees are more creative and productive when their clothes are relaxed. And with continuing refinements in casual clothes, even the most button-down corporations are able to find a happy medium between the presentable and the comfortable. All those changes can be a bit confusing, but this book, and the icons below, are here to help clarify and light your way.

BASIC. Survival gear, must-haves, or just the BASIC wardrobe building blocks, these are the essential items that will allow you a lifetime of pleasure and service when carefully selected. They're the kinds of things that you borrow from friends, and that friends borrow from you.

BODY. This icon indicates an item that is flattering to one BODY type but perhaps not to another. As in all broad generalizations, there will be exceptions to the rule—so read with one eye cocked at the mirror.

COLOR. This icon calls attention to a COLOR issue—both when it's used to a flexible, wardrobe-expanding advantage and when it's used to add sizzle.

DRESS CODES. Remember when you got sent home for wearing cutoffs or punk jewelry to school (or work)? With the dress-down Friday becoming a weeklong phenomenon, DRESS CODES are now more about appropriateness.

FAQ. Who, What, Why, When, are common questions in this new world. Here are the answers to the most FREQUENTLY ASKED QUESTIONS (acronym courtesy of the Net).

FIRST AID. Something (to use the euphemism) always happens, so follow the page number to the back of the book for preventive medicine and remedies for clothing misfortunes.

ON THE ROAD. Travel is central to business culture, and simplifying it can ease the long, strange trip it can be.

PATTERNS. Chintz is tough to pull off, but a judicious use of classic PATTERNS is another way of adding vitality to the basics.

PROFILE. Throughout the long journey of style there have been certain individuals, companies, and even products that stand out as important design milestones.

SIMPLE TRUTHS. Wisdom and pieces of advice to help make life simpler. It's a fact: earrings shouldn't weigh more than (and ties shouldn't be wider than) your head, plus other clarifications.

TEXTURE. Material or surface treatment can add to your clothes' visual and tactile impact. Different TEXTURES, especially when expertly countering each other, bring added dimension, not to mention extra versatility, to your look.

VALUE. Invest in VALUE. Which doesn't always mean buying what costs the least. Even if you feel a bit of a sting at first, take comfort in knowing that buying a high-quality item is always smarter than buying something cheap that you'll soon need to replace.

VERSATILITY. How easily can an item mix and match with a variety of wardrobe fundamentals? This icon doesn't mean you can use it to dry the dog and polish the silverware, but it can go from home office to head office.

E N T S

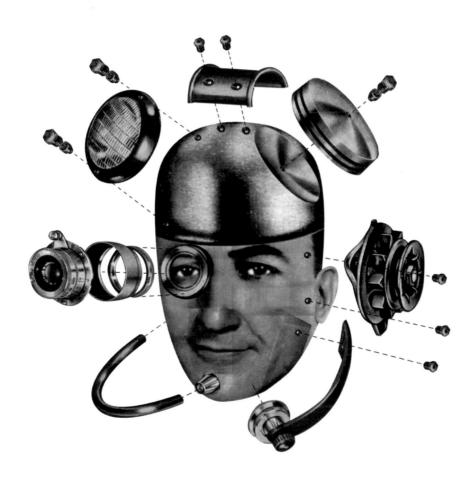

EVOLUTION: ADAPT TO SURVIVE

" . . . implies that the individuals which are best fitted for the complex and changing conditions to which, in the course of ages, they are exposed, generally survive and procreate their kind."

CHARLES DARWIN, *The Variation of Animals and Plants under Domestication*

"... for now is the time to raise legitimate children, and make money, and dress properly, and be kind to one's wife, and admire one's boss, and learn not to worry, and think of oneself as what? That makes no difference, he thought—I'm just a man in a gray flannel suit. I must keep my suit neatly pressed like anyone else, for I am a very respectable young man."

SLOAN WILSON, *The Man in the Gray Flannel Suit*

1955

W O R K P L A C E

Adapt or die. It's Darwin's law of the jungle. And, as we move from the industrial to the volatile information age, it's more and more the law of the office. A company must be versatile to survive. So must you. Once, the gray flannel suit embodied the ideals of a rigid business era. Now what's called for is a more creative, entrepreneurial attire—one that combines the authority of the power suit with the comfort of a casual look. It's the new PC—that's Personal Code. This book helps you crack it. Helps you adapt. Because in today's mobile marketplace it can be deadly to look as if you're taking cues from a twenty-year-old dress-for-success manual. People will wonder if your way of doing business is similarly outdated.

7

"Many critics may charge that my approach to successful dress is snobbish, conservative, bland, and conformist. They may further charge that I am encouraging the executive-herd instinct. To these charges, I must plead guilty, for my research documents that, in matters of clothing, conservative, class-conscious conformity is absolutely essential to the individual success of the American business and professional man. Executives in particular do constitute a herd, and those who understand how to cope rather than fight are much more likely to emerge as leaders than casualties."

JOHN T. MOLLOY, *Dress for Success* (1975)

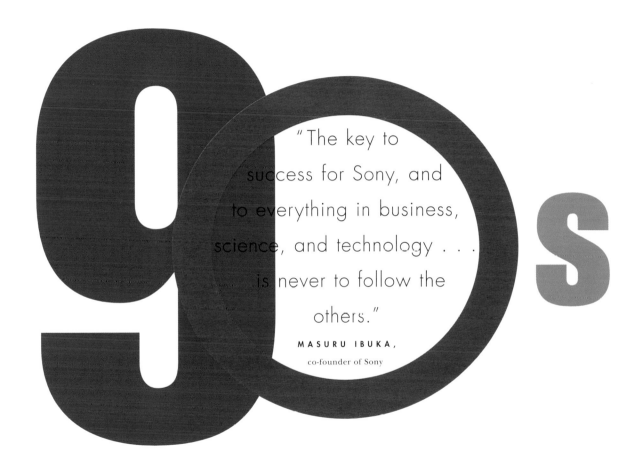

"The key to success for Sony, and to everything in business, science, and technology . . . is never to follow the others."

MASURU IBUKA,
co-founder of Sony

SHIFTS IN BUSINESS ATTIRE ALWAYS ACCOMPANY SHIFTS IN BUSINESS PRACTICE. THE BLACK FROCK COATS OF TURN-OF-THE-CENTURY LONDON businessmen sent an important message: the upright sobriety of the counting house. The gray flannel suit of the 50s signaled *and* imposed the conformity desirable in a stable corporation in a stable economy. Today things aren't so stable. Enterprises open, close, merge, split, downsize, and re-engineer on a daily basis. When a kid in blue jeans can launch a corporate conglomerate with only a string of computer codes, three identical pinstriped pieces don't mean much. And they mean even less when geographic and temporal boundaries can be breached with the screech and beep of a modem. Meetings are taken and deals inked in satellite offices, home offices, virtual offices, and anywhere people gather. We don't need a suit to say "I am at work now." Thus, dressed-down suits thrive. As do sport coats, sweaters, vests. The non-uniform must take you wherever you have to go.

IN **1848**, the California gold rush lures west thousands of young entrepreneurs looking to strike it rich. These new prospectors find farmers', clerks', and shopkeepers' clothes unsuited to the rugged work of mining and adopt Levi's denim overalls—arguably America's first civilian work uniform. Claims are staked, the West is tamed, unheralded prosperity ensues . . .

...AND IN THE **1900s**, a burgeoning class of "firm" managers—by-products of the Industrial Revolution—adopt the lounge suit, characterized by three matching pieces, a white shirt with stiff collar, and a necktie. The Great Depression follows.

During World War II, the work force goes through a major shift as men leave for war and large numbers of women enter the working ranks to replace them. The word "uniform" becomes part of the new vocabulary of dress in the **40s**.

"The truth is America began as a We won the Revolutionary War clothes and firing homemade garbed in tailored

JOHN

The GI bill brings a wave of former soldiers into universities and then the work force in the early **50s.** The veterans' new uniform, the gray flannel suit, becomes a metaphor for the conformity of the times.

As the good poet wrote, the times they are a-changin'. The gray flannel uniforms of the **60s** are buffeted by widespread social change as women seek the independence of careers, khaki casual evolves into a denim counterculture, and hair gets its own paragraph in dress codes.

dress-down country. by wearing everyday bullets at people scarlet coats."

POWERS

THE **70s**

brought a reaction to the unfortunate peacock revolution in menswear. Dress-for-success books pop up, penned by "consultants" contending there is only one way to dress—in navy blue pinstripes, a white shirt, and a small-print red tie. Women, seeking to emulate men, wear the same, replacing trousers with knee-length skirts. Select disco mavens react by strapping on gold medallions and refusing to button their shirts at all. A recession follows.

THE **80s**

see an embrace of high-style businesswear: broad-shouldered double-breasted suits worn by men Tom Wolfe calls "Masters of the Universe" in his novel *The Bonfire of the Vanities.* "Power" is the operative word, whether it applies to suits, ties, or boats. An even worse recession follows.

"Some of us change, some of us mutate."

JOYCE DAVENPORT

in *Hill Street Blues*

THEN IN THE **1990s,**

a new gold rush draws thousands to California, this time to Silicon Valley for the fortunes to be made with the dawning of the information age. These young freethinkers adopt a more relaxed dress code, which includes the same blue jeans worn by those originally drawn to Sutter's Mill.

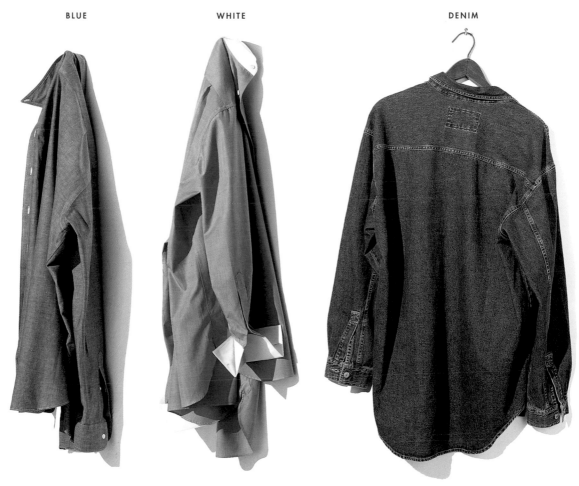

BLUE WHITE DENIM

WORK-SHIRT DARWINISM

BLUE COLLAR. Chambray shirts, usually with dungarees, were de rigueur six decades ago on Works Progress Administration endeavors. Today, men still wear them, though more often with a tie. And their works are more likely to boost profits, not rebuild a nation. **WHITE COLLAR.** French cuffs and a contrast collar were Lee Iacocca's trademark and a symbol of the proper high-powered businessman—or stylish businesswoman. Until one removes the collar itself, at which point the shirt steps down from the formality of the board of director's dais. **DENIM COLLAR.** An American icon. The material in which the West was tamed. To many, the flag of freedom and independence. Which is exactly why—despite its blue-collar roots—it's so often the perfect choice for wearing to the new office now.

CASUAL CLOTHES?

UNLIKE TRADITIONAL CLOTHES, WHEREBY ANY MAN OR WOMAN COULD WEAR TWO MATCHING PIECES AND LOOK PROFESSIONALLY APPROPRIATE (PROVIDED SAID PIECES

are clean, in good repair, and fit well), the new dress code takes a bit of savvy. You've got to land squarely on that sharp little point where comfort, neatness, and professionalism harmoniously intersect, no matter what you do, no matter where you work, no matter what you choose to wear. What's right for a Microserf (who spends his days shooting wastebasket hoops while puttering with hot new "apps") isn't right for a mutual-fund manager (who spends his days shooting craps with lots of money). And vice versa. Perhaps a sport coat and tie are as casual as your environment will ever get. Maybe you can wear a polo shirt and jeans. Whatever the case, you've still got to be suitable when you're without a suit. Not even the folks at Nike sit around the boardroom in sweatpants.

 BIG BLUE Forty years ago, IBM's foot soldiers were known as "wing-tipped warriors" and they dressed like the boss: white shirt, blue suit, subtle tie, and the aforementioned shoes. It was rigid, it bespoke the way they did business, and it nearly rendered them obsolete when their own PC revolution took a more creative turn. These days, Big Blue is dressing down. While you still might see plenty of suits at HQ, its research facilities are dubbed "sweater central." The lesson is clear: you can't dress in vacuum-tube style when you're competing in a microchip world.

NATURAL SELECTION

"I have called this principle, by which each slight variation, if useful, is preserved, by the term natural selection.... But the expression ... of the survival of the fittest, is more accurate."

CHARLES DARWIN, *Origin of Species*

"The first thing I noticed was that he wasn't wearing a tie. Instead he wore a big yellow scarf with horses racing around the edges, and a big yellow handkerchief to match, which dangled rakishly over the pocket of a sports coat you could have played checkers on. He reeked of toilet water. He was certainly a long way from the thin, pale, eager little kid who used to say, 'Thank you, Mr. Manheim.' At least superficially."

BUDD SCHULBERG, *What Makes Sammy Run?* 1941

RE-ENGINEERING

Corporations do it. Farmers do it. Even those who build the Ford Taurus did it—all in the name of a superior product. It's taking a cold, hard look at the assets at hand and figuring out how to improve them, increase their value. The result should be goods that suit the market. When it comes to clothes, the goods need to suit your environment, your clients, and your colleagues. In *Re-engineering the Corporation*, analysts Michael Hammer and James Campy need a whole book to outline the steps for a top-to-bottom corporate overhaul. Your wardrobe takes only three.

Step 1: **Audit.** Step 2: **Dejunk.** Step 3: **Reinvest.**

WHERE TO START?

1. AUDIT

2. DEJUNK AND RECYCLE

3. REINVEST IN ASSETS

Like a successful presentation or product launch, the answer isn't in how much money you throw at the challenge, but the thought and preparation behind the campaign. Which means spending the time and effort to get it right from the start. It's not going out to buy a whole new wardrobe, but reevaluating what you have, what's appropriate, what's superfluous, and what's now necessary to dress for your life. A simple three-step process will help facilitate an orderly transition to a versatile wardrobe that is perfect for whatever your job may be. Once you've figured it out, updating and replacing elements of your wardrobe is effortless. And with it comes a little extra insurance of survival in today's quick-moving world.

PERSONAL ADAPTATION.

ARE YOU TOURING THE SOOTY FACTORY FLOOR IN THE MORNING? MEETING A BANKER FOR LUNCH? FLYING

business-class to the Far East in the afternoon? Or maybe you're dropping by a cocktail party to schmooze out-of-town clients before, finally, that romantic dinner—but only after you pick up your daughter at soccer practice. Each morning you've got to check out your calendar before you check out your closet and play it accordingly, flexibly. You need to know where you're going, what's expected of you, and how to practice good business etiquette (which is nothing more than observing customs that make people comfortable). Think about fitting into your client's culture if you're making a visit, and making your own culture clear to visitors. Once you know what you're doing business-wise, you'll know how to answer that age-old question: What am I going to wear today?

BUSINESS ETIQUETTE GUIDELINES
How do you practice good etiquette and follow the customs of your business associates? By learning how they dress and how they expect those they meet to dress. How? You call ahead and ask, surreptitiously if necessary, so you can plan accordingly. It seems so simple, even simplistic, but it's the kind of advance-man research that pays off. Closer to home, keeping a spare sport coat and an extra dress shirt and tie, or heels and a blazer, tucked behind the office door can pay off, too. Imagine the anxiety when you come to work wearing T-shirt and khakis when B.P. (the rather large, cigar-smoking, three-piece-suited president of your company) shows up with Nedrick (his toady three-piece-suited assistant) to ask you to join them for lunch at the formal away-from-the-office executive dining room at the Four Seasons. The instant meeting outfit behind the door erases any distress.

"It's not what you are that counts. It's what they think you are."
ANDY WARHOL

AUDIT

TAKING AN HONEST WARDROBE AUDIT IS THE FIRST STEP TO GETTING BETTER

performance from your closet. You've got to know what works and what doesn't before you can make intelligent decisions about what to get rid of and what you still need to acquire. What to buy? Think basics that are versatile enough to play a variety of wardrobe roles, that can keep you covered no matter what situation life throws at you. Once you know what you need wardrobe-wise, those things go at the top of the shopping list—before another Cowboys jersey.

ASSETS Belt • Blazer • Chambray shirt • Cotton polo shirt • Dark blue denim jeans • Dress trousers • Khakis • Knit tie • Loafers • Oxford button-down shirt • Shoulder bag • Socks • Sweater

[🖼 ON THE ROAD—*page 154*]

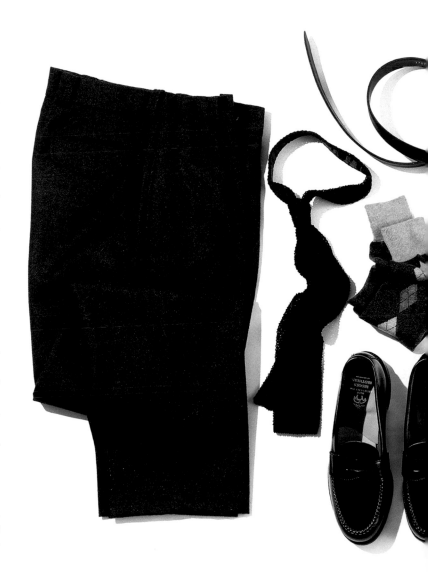

You might not appreciate them, but
someone will. Think consignment shops,
Goodwill, shelters. You'll have done the
right thing and you'll feel liberated.

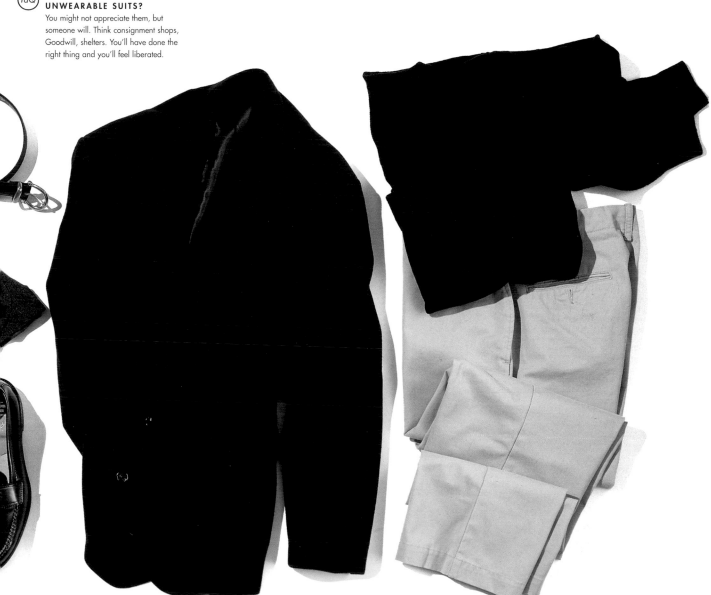

ASSETS

THEY NEVER MAKE THE COVERS OF FASHION MAGAZINES. UNLIKE THE SKINTIGHT, SEQUINED, OR RUBBERIZED NUMBERS THAT ONLY A FIVE-TEN, SIZE EIGHT CAN

pull off, basics look good on just about anyone. They are the items that go with absolutely anything else in your wardrobe—and look good on their own as well. Neutral colors and quality in fabrics and tailoring are the characteristics to watch out for. An impeccable white shirt that looks as right with jeans as it does under a smart suit jacket. A cardigan over a tee that complements the pants of the suit whose jacket you wore the day before. When it comes down to it, basics are classics and classics are always equal opportunity. Unlike the covers of fashion magazines.

WARDROBE PRINCIPLES Some mornings you might feel creative and show your élan by a witty mixing of clothes with the sort of subtext messages that might have left Michel Foucault green with envy. But then there are other mornings, like the ones that include important presentations at 7:30 a.m. —only four hours after your delayed flight finally touches down at the airport, and only three hours before you actually get to sleep. It's times like those when everyone needs the reassurance that for any occasion there is the appropriate outfit on the cedar hanger in one's closet. You'll always have such goods if you build and maintain your assets. There can be room for fun, pieces with sentimental value, even items you bought in a fit of trendiness; but remember, relying on the basics is an essential step in simplifying life and getting dressed under duress.

[🧳 ON THE ROAD—*page 154*]

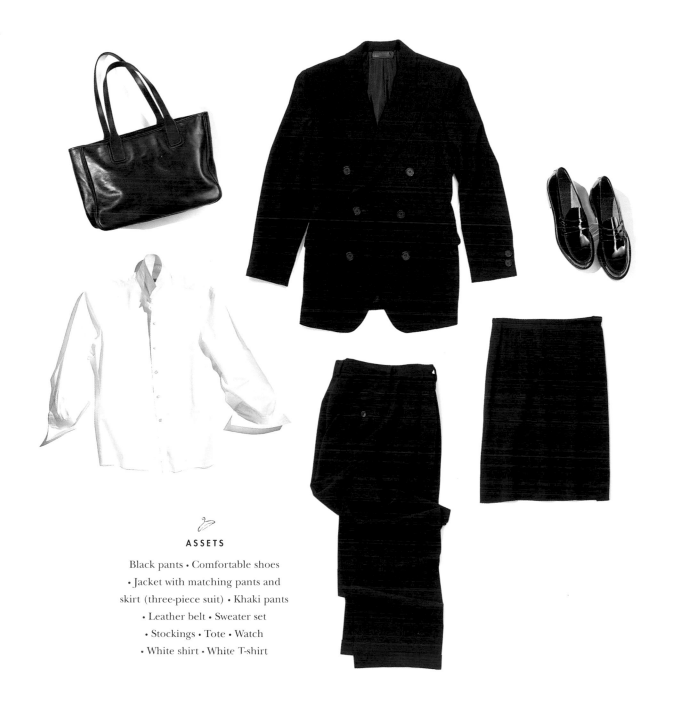

ASSETS

Black pants • Comfortable shoes
• Jacket with matching pants and
skirt (three-piece suit) • Khaki pants
• Leather belt • Sweater set
• Stockings • Tote • Watch
• White shirt • White T-shirt

WE STARTED OUT RIGHT. AS CHILDREN, BOYS RELIED ON THE BASIC NAVY BLAZER AND GIRLS ON A SIMPLE party dress to get them through occasions that required more pomp than jeans could deliver. But somewhere things went all awful. We fell for trendy things,

of commodities in today's new business age: information. How much do you travel? How casual is your CEO? What do your clients wear? Then audit your resources: What's worth keeping in your closet? Now, think of yourself as a ruthless efficiency expert and play the hatchet man. The art of

DEJUNKING

things that didn't flatter, things that weren't of the quality we really required. Re-engineering your wardrobe allows you to reverse those mistakes and return to simpler days. Are you familiar with the corporate mantra of Keep It Simple, Stupid? That's smart, if blunt, advice. You start with that most important

dejunking requires a real bottom-line mentality. Is it an asset? Does it fit into your daily work environment? Does it still fit you? Have you worn it in the last six months? If you can't say yes, recycle—give it to the local thrift shop. It will make the process of suiting up (even if you're not putting on a suit) a bit easier.

"If you're gonna sell
out, make sure
they're buying."

MARTHA DAVIS
of the Motels

REINVEST

PEOPLE USED TO GO OUT AND LEVERAGE THEM-SELVES TO BUY BRAND-NEW BUSINESS WARDROBES EVERY SEASON. WELL, THE EIGHTIES ARE OVER, AND CREDIT, NO MATTER HOW

well you're doing, is a lot tighter than it used to be. That means making use of those assets already in your closet. Making sure they continue to perform. How? First, engage in a capital-improvement plan. Second, reinvest—not in what you want but in what you need. Buy quality. You'll forget the price tag fast enough, but that blazer will be with you for years. Reinvesting in your wardrobe may require a few purchases. If you do need to buy, think big.

You're not just acquiring clothes for Monday through Friday, nine to five. You need pieces that work all of the time. Don't waste a paycheck on a sweater suited only to raking leaves. Make it a fine-gauge turtleneck that looks super under a suit jacket. Or get quality khakis that can go from the car pool to the Concorde. The idea is to do more with less. The goal is a utilitarian wardrobe that fits into one garment bag and will take you everywhere.

CAPITAL IMPROVEMENTS Once you start paying for quality clothes, you'll find yourself reluctant to rid yourself of them when they wear out. Fortunately, you don't have to. One of the qualities of good threads is their inherent resurrectability. Resole those cordovan shoes. Replace the lining that hangs below the hem of the classic camel overcoat. Sew suede patches on that well-worn tweed jacket and wear it to the office on Fridays. All of this, of course, requires finding specialists—a tailor, a shoemaker—you can trust. They'll cost, too. But the new life they give your clothes will make them well worth it.

[**FIRST AID**—*page 160*]

CORPORATE CASUAL

SOUNDS LIKE AN OXYMORON, DOESN'T IT? IT IS.

AS COMFORTABLY DRESSED AS YOU MAY BE, YOUR APPEARANCE

SHOULD NEVER BE CASUAL WHEN YOU SHOW UP AT THE CORPORATION—

or wherever else it is you punch the clock. Cleanliness, press lines, and the more amorphous appropriateness all count. Attention must be paid, to quote an old salesman's wife, because even at the newest, most freewheeling technology companies, one's choice of threads still sends subtle visual messages. As the graph on this page shows, the increase in dressed-down days is as much a part of today's business landscape as the increase in downsizing. And, like downsizing, it's a policy that's here to stay. But that doesn't mean the occasional genie can't be put back in its bottle. Just ask the folks who work for the city of Newark, New Jersey: Their boss rolled back its relaxed dress policy when too many people thought casual meant ragged shorts and revealing halter tops.

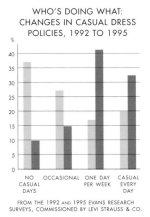

WHO'S DOING WHAT: CHANGES IN CASUAL DRESS POLICIES, 1992 TO 1995

FROM THE 1992 AND 1995 EVANS RESEARCH SURVEYS, COMMISSIONED BY LEVI STRAUSS & CO.

> "Every organization has to prepare for the abandonment of everything it does."
> **PETER DRUCKER,** *Harvard Business Review*

A CASUAL LIST *Alcoa*, American Airlines, *American Express*, Cellular One, *Central Intelligence Agency*, Chase Manhattan, *Chic Simple*, Citibank, *Firemans Fund*, Ford Motor Co., *General Electric*, General Motors—Saturn Division, *IBM*, Alfred A. Knopf, *Kroger Co.*, Levi Strauss & Co., *Microsoft*, NYNEX/SNET, *PepsiCo*, Quaker Oats, *Sun Microsystems*, Westwood-Squibb Pharmaceuticals

"He changed out of the business suit he wore to church into work clothes. He had once suggested to the vestry that early communicants be encouraged to attend church in the sports and work clothing most of them wore on Sunday, but Father Ransome had countered by asking if he would be expected to serve the sacraments in tennis shorts."

JOHN CHEEVER, *Bullet Park* (1969)

CASUALIZATION OF AMERICA. People dress for the theater like they do to watch TV. They shop in sweats, take restaurant meals in T-shirts, and go to church in clothes that ought to be a sin. How did it happen? Part of the blame can be placed on Kennedy's hatless inauguration, baby boomers, liberalism, rock 'n' roll, and fluoride in the water supply. The fact remains, we've gone lax. But not lazy. In *Waiting for the Weekend*, Witold Rybczynski writes that we're working more than ever, and have lost our ability to enjoy leisure. The boundaries of life and work are blurring. According to Juliet Schor, author of *The Overworked American*, free time has fallen nearly 40 percent since 1973. Today people roll out of bed to the marching beat of percolating coffee, answer the e-mail, create two new Web pages, check their voice mail and their home fax machine, start a new company, and a subsidiary, and *then* get dressed. So the new casualization in the land of fast food, fast times is also a partial by-product of a work ethic in overdrive.

A ROSE BY ANY OTHER NAME. Corporate Casual, Fridaywear, Friday Casual, Work Casuals, Casual Businesswear, Dress Down, Workday Casual, Office Casual, Easy Friday, Work at Ease, Dress Casual, Casual Style

SURVIVAL SKILLS

"It is an error to imagine that evolution signifies a constant tendency to increased perfection. That process undoubtedly involves a constant remodeling of the organism in adaptation to new conditions; but it depends on the nature of those conditions whether the direction of the modifications effected shall be upward or downward."

T. H. HUXLEY, *The Struggle for Existence in Human Society* (1888)

"Harry was startled, and then pain set in. Dwayne had never said anything about his clothes in all the years he'd known him. The clothes were conservative and neat, in Harry's opinion. His shirts were white. His ties were black or navy blue. His suits were gray or dark blue. His shoes and socks were black. 'Listen, Harry,' said Dwayne, and his expression was mean, 'Hawaiian Week is coming up, and I'm absolutely serious: burn your clothes and get new ones, or apply for work at Watson Brothers. Have yourself embalmed while you're at it.'"

1973

KURT VONNEGUT, *Breakfast of Champions*

FUNDAMENTALS

Yes, these are complicated times, but complicated times are best confronted with one simple philosophy: Learn the basics. We're thinking of the basics of human interaction, of the various business cultures you'll find yourself working in, of the basics of etiquette, to be precise, of the matter at hand: how to dress. Once you know the code (to borrow a popular phrase), you can decipher whatever messages the day brings.

WHERE AM I?

THE ANSWER TO THIS QUESTION IS MOST DEFI-NITELY NOT THE FIFTH CUBICLE TO THE RIGHT OF THE REAR ELEVATOR BANK. WE'RE TALKING ABOUT AN ALL-ENCOMPASSING,

more philosophical "where." Where does your industry fit into the new business paradigm? Legal, sales, advertising, finance? Specifically, what role do you play within your industry? Are you on the business side or the creative side? The publisher and the editor at the same magazine aren't going to dress similarly, just as a midlevel tax attorney will dress differently from the firm's ace trial lawyer. Does your office have a five-day corporate-casual policy, or is it just a Friday treat? And, of course, it's a geographical where, too. Those on the West Coast (the presumed cradle of corporate-casual dressing, not to mention the place where many don't wear socks) are almost always going to be a bit less formal than their East Coast counterparts in the same business. Just as Dell's engineers can't design a computer without having a general idea of how it's going to be used, you can't sensibly build a wardrobe unless you know where you're going to wear it.

"You got to know the rules before you can break 'em. Otherwise, it's no fun."

SONNY CROCKETT in *Miami Vice*

faQ

**WHAT IF I DON'T WANT TO
WEAR CASUAL CLOTHES?**
Don't ever dress in a way you don't want
to. You'll look more uptight that way than in
a three-piece suit. Instead, wear something
in between—say, a sport coat and tie.

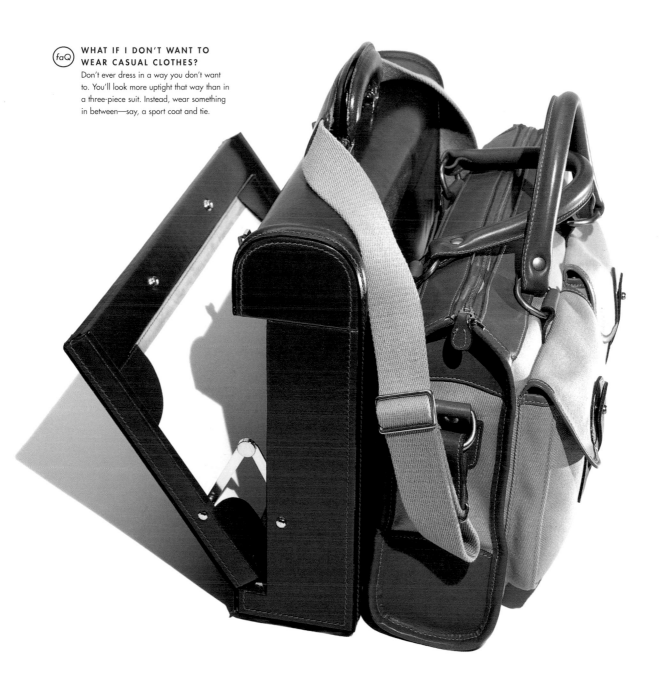

BACK POCKET
Casual pants often have one besom pocket, usually with a button-flap closure.

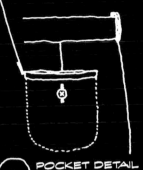

① **POCKET DETAIL**

CUFFS
Cuffs are usually 1 1/2" wide—no less.

BREAK
Cuffed pants should break slightly on shoe.

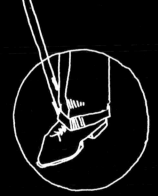

② **CUFF BREAK**

THE RISE AND FALL OF PANTS

RISE	Measures from the crotch to the top of the waistband. Measurements normally reflect a person's height (short, regular, long).
INSEAM	Measures from the bottom of the crotch to the bottom of the cuff.
OUTSEAM	Measures from the top of the waistband to the bottom of the cuff.
DROP	The difference between chest and waist measurements.

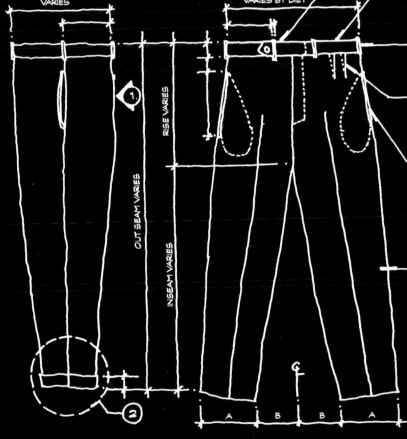

VARIES

VARIES BY DIET

RISE VARIES

OUT SEAM VARIES

INSEAM VARIES

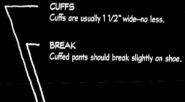

Ⓐ **SIDE ELEVATION**

Ⓑ **FRONT ELEVATION**

WAISTBAND
On casual trousers they are softer, less constructed, and can either be non-roll with expandable sidetabs or have hook closures.

GRIP
A piece of fabric in the inside part of the waistband. Holds the shirt in place.

BELT LOOPS
Normally, trousers with expandable waists do not have belt loops.

PLEATS
Pleats can be "reverse" (folded inside) or "forward" (folded outside). Reverse pleats can create a slender appearance—unless the pants are too tight, in which case the bulging pleats can actually make you look heavier.

SIDE POCKETS
Continental, or western, pockets are cut nearly parallel to the waistband. More common (and less casual) on-seam pockets run along the outer seams with a vertical or diagonal cut.

WIDTH
Jeans or fashion-forward pants may be more narrow at the ankles than suit pants.

FLAT FRONT
Though generally informal, flat-fronted trousers also happen to be favored for suits by traditional men's shop tailors.

FEEDBACK

According to communications consultant Roger Ailes, people form an impression of someone within seven seconds of the first meeting. Consequently, "each person is his own message," Mr. Ailes notes in the aptly titled *You Are the Message.* If he's right—and let's face it, he probably is—you've got to be comfortable with the statement your wardrobe delivers. Does your suit, or lack thereof, suit the role? Do you want to be known as the office wise man? A professorial tweed would fit the bill. Are you the forward-thinking iconoclast or the deal-making master of compromise? The latter would probably prefer a collegiate cardigan; the former might never give up those red suspenders. Are you the office standard-bearer? Do you confuse professionalism with wearing a tie? Or are you the hip, creative type—in which case you're probably already clad in black. To understand how best to send your message, you need to understand the vocabulary you're using. Take the time to know how everything works together. The ultimate message is worth the effort.

"Never speak to a man wearing leather trousers."

TOMMY NUTTER

quality **control**

SPLIT-SHOULDER YOKE
Derived from custom-made techniques, it makes for a better fit in the shoulder.

COLLAR
Most collars have a slight roll (traditional spread collars being one exception). Also, make sure the points are of identical length. Button-down and banded collars are considered the most casual styles.

PLACKET
The fabric strip on which the buttons are sewn gives the shirt a clean center line.

BUTTONS
Cross-stitched mother-of-pearl buttons are the highest quality—but they break more easily than plastic.

SINGLE-NEEDLE STITCHING
A single needle is used to sew one side of a double-tracked seam at a time. It produces more durable seams and makes the shirt fit better against the body.

GAUNTLET BUTTONS
Keep the sleeve opening closed so that the forearm doesn't show.

TAILS
They should be long enough to cover your seat.

FIT AND TAILORING. "He's a details man." Always a compliment. And when it comes to suits, it's details like high-quality material, lasting design, and masterful tailoring that say good things about you. You're looking for stong integral workmanship and clean alterations. Seams should lie flat and be securely sewn. The collar must lie flat around the neck, the lapels curve smoothly along the chest, and the collar fit close around the neck. The fabric should be smooth, without rolls or pulls. Sleeves must hang straight and end at the wrist, and trousers should

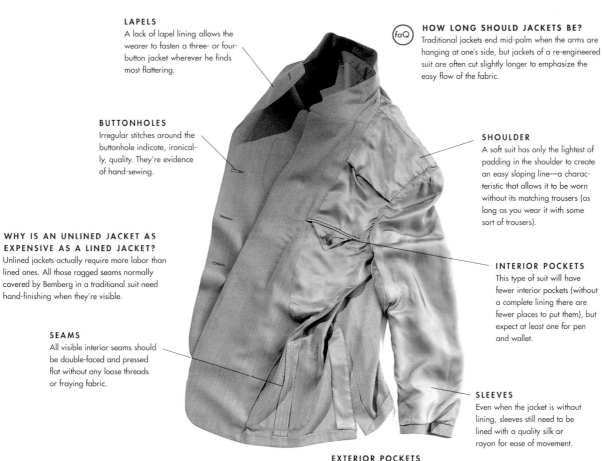

LAPELS
A lack of lapel lining allows the wearer to fasten a three- or four-button jacket wherever he finds most flattering.

BUTTONHOLES
Irregular stitches around the buttonhole indicate, ironically, quality. They're evidence of hand-sewing.

(faQ) **WHY IS AN UNLINED JACKET AS EXPENSIVE AS A LINED JACKET?**
Unlined jackets actually require more labor than lined ones. All those ragged seams normally covered by Bemberg in a traditional suit need hand-finishing when they're visible.

SEAMS
All visible interior seams should be double-faced and pressed flat without any loose threads or fraying fabric.

(faQ) **HOW LONG SHOULD JACKETS BE?**
Traditional jackets end mid-palm when the arms are hanging at one's side, but jackets of a re-engineered suit are often cut slightly longer to emphasize the easy flow of the fabric.

SHOULDER
A soft suit has only the lightest of padding in the shoulder to create an easy sloping line—a characteristic that allows it to be worn without its matching trousers (as long as you wear it with some sort of trousers).

INTERIOR POCKETS
This type of suit will have fewer interior pockets (without a complete lining there are fewer places to put them), but expect at least one for pen and wallet.

SLEEVES
Even when the jacket is without lining, sleeves still need to be lined with a quality silk or rayon for ease of movement.

EXTERIOR POCKETS
Exterior pockets on soft suits are often of the patch variety—a sportier pocket once found only on sport coats.

be cuffed to about an inch and a half and break on the shoe. And the jacket itself should gently but closely follow the body. That might mean going beyond customary hemming and having the jacket taken in. Such close attention shouldn't end with your suit. Shirts and trousers should all be similarly scrutinized—and adjusted, if necessary.

"God is in the details."
MIES VAN DER ROHE

FABRIC

IT ALL USED TO BE SO EASY. NO WORRIES ABOUT DOWNSIZING. NO FEARS OF HARASSMENT SUITS. NO CONFUSION ABOUT WHAT SORT OF FABRICS TO WEAR WHEN. IT

was wool in the winter and wool again in the summer—hot, maybe, but a no-brainer. With the recent advent of new textile-mill technology and corporate casual dressing, choosing the right fabric may seem more complicated than choosing the right HMO. For the winter there's still wool, but now it's blended with everything from rayon to cashmere. For summertime, it's cotton, linen, silk, and even rugged burlaplike weaves. For the indeci-

LOW-MAINTENANCE FABRICS

Wool knits and crepes; crinkle cotton, wrinkle-free cotton, and cotton knits; machine-washable silks; synthetic blends; microfibers; denim; corduroy; fleece; jersey

HIGH-MAINTENANCE FABRICS

Finely woven cottons; linen; peau de soie; suede; raw silk; metallic, hand-painted, embroidered, or beaded fabrics

sive, there's seasonless, breathable wool that's light enough to wear year-round. In either case, the new fabrics confer plenty of benefits. Whether they're animal, plant, or petroleum based, you'll find them softer and more comfortable, often seasonless, and easy to care for (one of the great advantages of corporate casual clothes is that many require only the washing machine). The only wrinkles you need to worry about now are on your boss's brow.

 KHAKIS Back during WWII, original-issue khakis, the pants to end all pants for most men, came in one cut, without pleats. The uniform entered the civilian world first as the trousers-of-choice for garage tinkerers and lawn mower-ers. Then, with the help of the GI bill, they started to evolve and mutate. Men started wearing them to college. The evolutionary jump from higher learning to hipster leaning was capped by the khaki-clad Kerouac's opus *On the Road*, and a new casual uniform was born.

[FABRIC *first aid—page 160*]

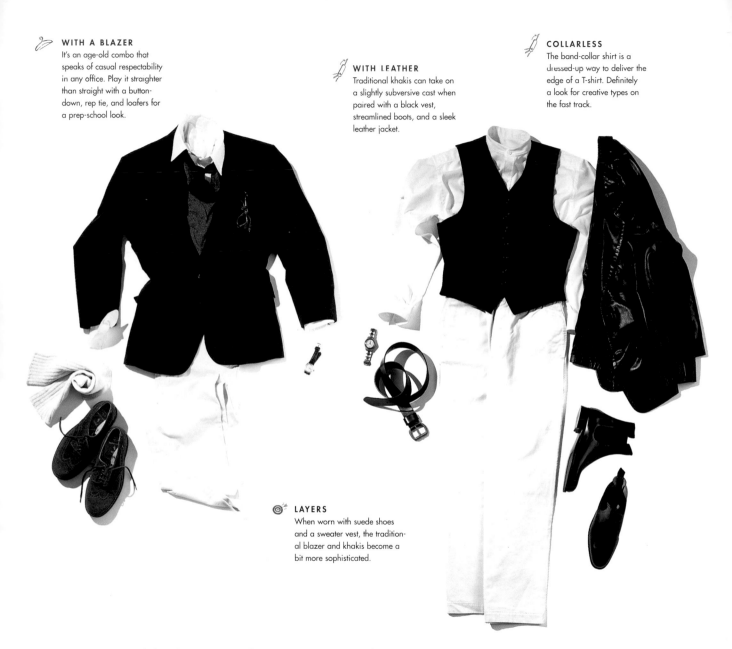

WITH A BLAZER
It's an age-old combo that speaks of casual respectability in any office. Play it straighter than straight with a button-down, rep tie, and loafers for a prep-school look.

WITH LEATHER
Traditional khakis can take on a slightly subversive cast when paired with a black vest, streamlined boots, and a sleek leather jacket.

COLLARLESS
The band-collar shirt is a dressed-up way to deliver the edge of a T-shirt. Definitely a look for creative types on the fast track.

LAYERS
When worn with suede shoes and a sweater vest, the traditional blazer and khakis become a bit more sophisticated.

SIMPLE LESSON: khaki = uniform versatility

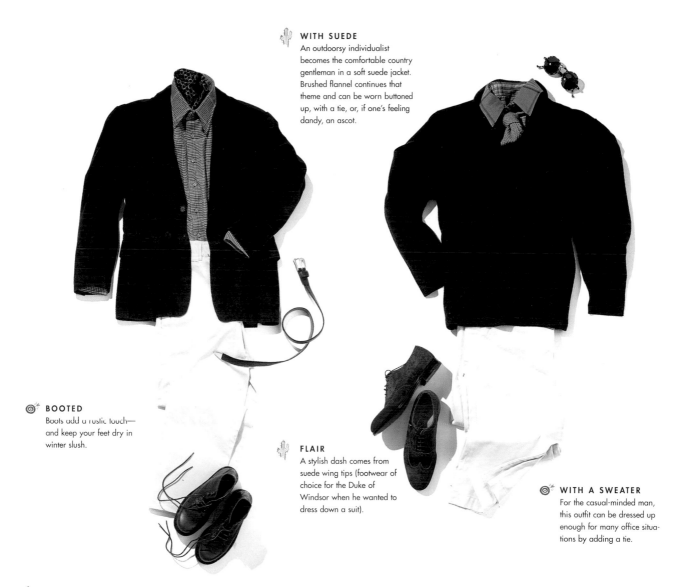

WITH SUEDE
An outdoorsy individualist becomes the comfortable country gentleman in a soft suede jacket. Brushed flannel continues that theme and can be worn buttoned up, with a tie, or, if one's feeling dandy, an ascot.

BOOTED
Boots add a rustic touch—and keep your feet dry in winter slush.

FLAIR
A stylish dash comes from suede wing tips (footwear of choice for the Duke of Windsor when he wanted to dress down a suit).

WITH A SWEATER
For the casual-minded man, this outfit can be dressed up enough for many office situations by adding a tie.

KHAKI REDUX Today's casual work uniform isn't so uniform. You want pleats? You got pleats, which heighten formality. You prefer a full cut for your fuller butt? You got that, too. Cuffs? Yeah, cuffs are available and look especially good on pleated models. Then there's the choice between zipper or button fly. In a classic example of smart niche marketing, there are dozens of khaki variations available to the consumer, and that doesn't even include color choice. Clearly, the saw about not fixing something if it ain't broke—like so many old-time business aphorisms—doesn't apply here.

CLASSICS CUBED

Khakis, those simplest of pants, look fresh when worn with like-minded classics, a white shirt and a blazer.

UN-BUSHED ACCESSORY

The way this outfit is accessorized removes any in-the-bush connotations: dressy black trousers, a crisp white shirt, and unexpectedly colorful shoes add a sophisticated elegance.

GLOSSY

Glossy black accessories can add an edgy urban touch to an otherwise unassuming outfit.

UNIFORM STYLE

In a safari jacket, khaki looks less like a uniform. Though it's not urban, it's definitely urbane—an informal substitute for a blazer.

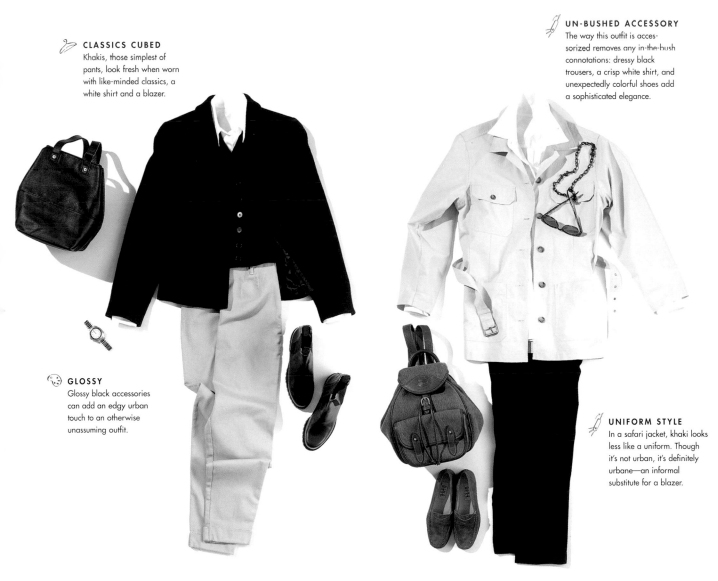

PRACTICAL ELEGANCE

Far from being boring, khaki can offer the wearer an understated panache. Everyday trousers paired with an opulent jacket, for example, create an unexpected mix that suggests practicality and style at the same time.

INSTANT ACCENT

Simple clothes get a dose of panache when they're jazzed up with colorful accessories like a scarf.

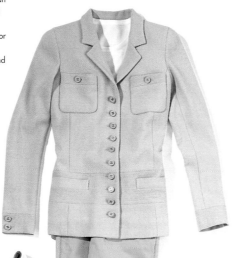

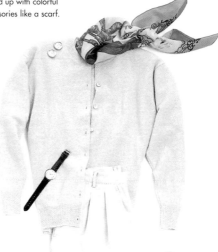

FOUNDATION

Simple underpinnings are the key to carrying the theme. An unadorned, simple white T shirt and feminine ballet slippers complete the look.

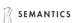

SEMANTICS

A sweater set is a feminine alternative to a tailored jacket.

"Just because I wear a uniform, that doesn't make me a Girl Scout."

SHIRLEY MACLAINE

in *The Apartment*

Mixing textures contributes to wardrobe versatility and personal style.

T E X T U R E

IT'S THE CRUNCHY CHIPS OF CHOCOLATE AND THE CHEWY CHERRIES IN CREAMY BEN & JERRY'S ICE CREAM. OR THE FRAYED WAISTBAND OF AN OLD PAIR OF LEVI'S

jeans against a smooth, bronzed belly. It's texture, and it's what makes life interesting. Smart use of texture is fundamental to savvy dressing. It lets you personalize your style. It allows you to escape the lockstep of traditional business attire. Plain flannel and worsted and gabardine, for all their worth, don't have quite the same dimension, literally, as melton or corduroy. Sometimes a mix of textures can conspire to feel quite country-estate, especially if you choose pieces with an outdoor pedigree: houndstooth, or corduroy pants and a herringbone jacket. But texture can be elegant in an indoor, urban setting, too, as in the case of a woman who wears patent-leather shoes under plush velvet trousers with a sleek silk blouse to the office holiday party.

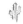

RENEGADES IN A STARCHED-COLLAR WORLD

Knit ties
Suede vests
Cable-stitched cardigans
Ribbed turtlenecks
Burlap woven blazers
Linen shirts
Cotton ties
Denim shirts
Suede shoes
Tweed sport coats
Merino-wool polo shirts
Corduroy pants
Leather vests
Velvet trousers
Mohair sweaters
Moleskin pants
Houndstooth shirts
Nylon backpacks

PULLING THEIR WEIGHT

(from top to bottom) 1. Heathered merino-wool pullover 2. Cashmere V-neck 3. Cashmere crewneck 4. Merino-wool ribbed turtleneck
5. Ribbed cotton turtleneck 6. Cable-stitched cashmere pullover

WEIGHT

YES, WE'VE ALL GOT TO PULL IT ON THE JOB TODAY, BUT THERE'S NO bonus involved in making yourself look as if your own girth is greater than the scale indicates. Yet that's a lesson that's often lost on people who don't understand the subtler aspects of the art of layering, especially sweaters. As you build a wardrobe, the question to ask is, "Where and how will I wear this?" Chances are, the answers are, "For work" and "Inside." That means forgoing bulky ribbed and cable-knit pieces

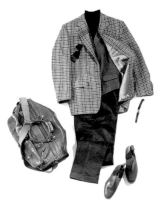

IF TWO-PLY CASHMERE IS GOOD, IS FOUR-PLY TWICE AS GOOD?
Three- and four-ply cashmere sweaters—you don't want them. They're invariably too hot in a heated office and almost unwearable under a sport coat or suit—unless, that is, you've been dispatched to the Nome, Alaska, field office.

for more versatile lightweight ones. As good as an Aran-knit fisherman's sweater looks, its work space is the Irish Sea, not the data-processing office. Keeping knits thin keeps them versatile. If it's warm, one piece will do. When it turns cold, you can turn to layering. Alone, a single- or two-ply cashmere sweater is as good as a Shetland wool number. And if you need more, a sport coat will sit nicely atop it, without making you look like the middle-management version of the Michelin Man— which for some can be a concern even without any clothes on.

 LAYERING Like stocks that split, the art of layering has several levels of rewards. For the traveler, it allows a light suitcase that still provides heavyweight results and a range of looks: the suit with its vest and again without. The vest (with shirt, of course) on its own. A sweater to wear over a button-down, or later tied comfortably over the shoulders. Second, multiple layers lend a texture and contrast that make other outfits look oddly two-dimensional. Most important of all, like a well-tied tie, a vintage watch, or even the perfect pair of eyeglasses, a smartly layered look indicates the wearer knows how to put the polish on presentation.

[🧳 ON THE ROAD—*page 154*]

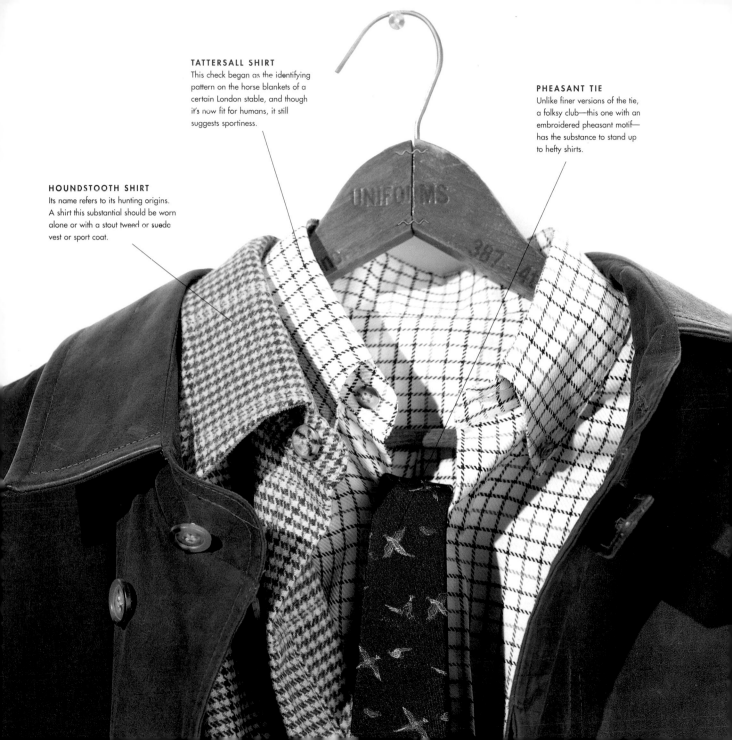

TATTERSALL SHIRT
This check began as the identifying pattern on the horse blankets of a certain London stable, and though it's now fit for humans, it still suggests sportiness.

PHEASANT TIE
Unlike finer versions of the tie, a folksy club—this one with an embroidered pheasant motif—has the substance to stand up to hefty shirts.

HOUNDSTOOTH SHIRT
Its name refers to its hunting origins. A shirt this substantial should be worn alone or with a stout tweed or suede vest or sport coat.

PATTERN LANGUAGE

FROM MISSIONS AS EXCITING AS CODE BREAKING TO TASKS AS QUOTIDIAN AS TRACKING SALES TRENDS, WE'RE ALWAYS LOOKING FOR PATTERNS. EXCEPT IN CLOTHES. NOT

nearly enough of us pay attention to our clothes' patterns. And it's too bad, because that—besides the accent—is exactly what makes that English M&A expert with the office on Canary Wharf so damn natty. Smart, restrained pattern-mixing is what elevates dress to the next level of style. Not just the traditional blue striped suit, but the blue striped suit with a gingham checked shirt and a plaid tie. Of course, such creative dressing can be executed more casually, especially with outdoorsy plaids and checks and tweeds. When done right, such combinations suggest someone who's a bit creative, who doesn't like the mundane, and who, above all, pays attention to the details. When done wrong, it suggests Emmett Kelly. See below for the way to do it right and not play the clown.

HARMONY. Different scales, complementary colors. It's the cardinal rule for anyone looking to mix patterns, whether in a serious suit, shirt, and tie combination or something a little more relaxed. Take, for example, the casual outfit opposite. All of the pieces are in leaf-turning shades, creating a color harmony. Just as important, the checks are dissimilar. That guarantees the wearer rescue from looking as if he or she is dressed head to toe in graph paper.

[ON THE ROAD—*page 154*]

COLOR

THE TECHNICOLOR BRILLIANCE OF SOME NECK-
WEAR ASIDE, MEN HAVE NEVER HAD MUCH TO WORK
WITH. FOR DECADES, GRAY WAS THE NONCOLOR OF INDUSTRY—

the heavy machinery it manufactured; the cast of the skies around its factories; the uniforms of its foot soldiers, be they janitorial smocks or junior-executive suits. It's a serviceable tint, but as outdated as the Bessemer furnaces at rusting steel plants. With the new work wardrobe, however, comes options in color. Just a few years ago, cosmetics magnate Charles Revson summed up the consensus on brown: "Looks like shit." Now brown is commonplace on suit racks, as are soft olives, greens,

golds, black, and a whole range of blue besides navy. Sport coats come in heathers, plaids, and tweeds flecked with maroon, red, green, or blue. And, of course, accessories provide another outlet for color experimentation. Still, unless you have the color sense of Matisse, discretion is always wise. Choose one neutral as your canvas and add one or two complementary colors in accessories. It's better to be known around the office for your ideas rather than your similarity to a color wheel.

MONOCHROMATIC
Wearing just one color
from collar to pant cuff
connotes elegance even if
the pieces aren't formal. A
black cashmere cardigan,
trousers, and French-cuffed
shirt is as handsome as a
tux—and a line of unbroken color gives an illusion
of slimness and height.

"Never wear
anything that
panics the
cat."

P. J. O'ROURKE

TIE-DYE

What a long, strange trip it's
been for ties (first worn as
battle garb by Croatian mer-
cenaries 400 years ago)—and
it got a whole lot stranger
when Jerry Garcia Neckwear
was introduced to the market
by the nine-fingered musician
who would never have worn
one himself. The ties, featur-
ing the late Grateful Dead
singer's art, have been flying
off the racks at stores like
Bloomingdale's and Lord &
Taylor. They provide an inter-
esting dose of color and sug-
gest the wearer has an offbeat
sensibility—someone a bit
younger, say, than Bob from
Purchasing, who only dons
those yellow ties adorned with
miniature tack-room
paraphernalia.

COMFORT

IT'S A WARM WORD THAT DOESN'T MEAN MUCH IN TODAY'S COLDLY CHAOTIC WORLD. ALL THE MORE REASON YOU'VE GOT TO FIND IT WHERE YOU CAN—LIKE IN YOUR WARDROBE.

Mental. Noel Coward wrote his plays in his pajamas. Howard Hughes ran a global empire from his bed. It may have taken many years, but workplace policy setters have finally realized that feeling at ease boosts the morale of an overburdened staff. It frees us to think more clearly, and when we're not perched atop torturously high heels, we're infinitely more amenable to laboring into the wee hours. Beyond comfort, the eased-up mode of dress is also less hierarchical. A cashmere sweater not only feels good but it also seems a bit friendlier than flannel pinstripes.

Physical. The new comfort in today's clothes comes from not just a paradigm shift in the workplace but from design and technology shifts in the clothes themselves. Clothes fit and move more with the body, and the cut has evolved to allow for a less structured and more relaxed silhouette. Technology has revolutionized fabric with lighter yet stronger threads, from fine-spun miracle wools that are comfortable year-round to synthetic blends that have the natural drape of the finest silk or cashmere. And even the centuries-old staple of cotton has metamorphosed into a pesticide-free, organic softie that is markedly different from its starched, stiff-necked business cousin of only a few years ago.

[🧳 ON THE ROAD—*page 154*]

KING FRIDAY

"Hi, neighbor!" Not exactly what you want to hear when you saunter into the office in a comfortable old cardigan. How to avoid the Fred Rogers comparison? Wear it only in serious colors like black, gray, or navy. Never pair it with canvas sneakers. And for Pete's sake, when the coffee cart comes rolling by, don't ever say, "Hello, Trolley."

"Everyone has the right to be comfortable on their own terms."

FRANK ZAPPA

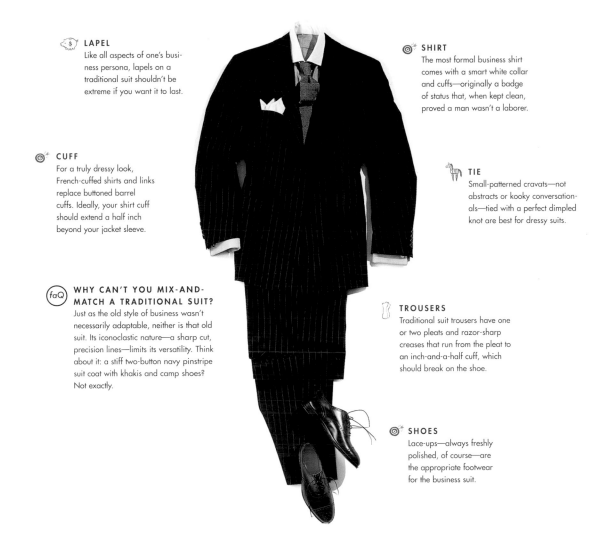

LAPEL

Like all aspects of one's business persona, lapels on a traditional suit shouldn't be extreme if you want it to last.

SHIRT

The most formal business shirt comes with a smart white collar and cuffs—originally a badge of status that, when kept clean, proved a man wasn't a laborer.

CUFF

For a truly dressy look, French-cuffed shirts and links replace buttoned barrel cuffs. Ideally, your shirt cuff should extend a half inch beyond your jacket sleeve.

TIE

Small-patterned cravats—not abstracts or kooky conversationals—tied with a perfect dimpled knot are best for dressy suits.

WHY CAN'T YOU MIX-AND-MATCH A TRADITIONAL SUIT?

Just as the old style of business wasn't necessarily adaptable, neither is that old suit. Its iconoclastic nature—a sharp cut, precision lines—limits its versatility. Think about it: a stiff two-button navy pinstripe suit coat with khakis and camp shoes? Not exactly.

TROUSERS

Traditional suit trousers have one or two pleats and razor-sharp creases that run from the pleat to an inch-and-a-half cuff, which should break on the shoe.

SHOES

Lace-ups—always freshly polished, of course—are the appropriate footwear for the business suit.

Traditional Armor. Legend has it the pinstripes on suits were designed to symbolize the lines in the ledger books of London stockbrokers. True or not, the stripe has become synonymous with business. Properly tailored, a business suit's broad structured shoulders, lined chest, and fitted waist create a V-shape that some clothing historians say mimics the physique of Greek gods. Perhaps that's why it remains a staple of the more mortal creators of commerce.

SEPARATE BUT EQUAL

You've gotten comfortable in that uncomfortable uniform you're always complaining about, haven't you? A little nervous about giving it up, aren't you? It's understandable. Truth is, the suit provides a lot of armor—both actual (it'll conceal that paunch) and psychological (it'll give authoritative punch)—and a guy's gotta wonder if the new dressed-down duds do that. They should, of course, because you can't afford for them not to. That means carefully cultivating a wardrobe that, though less formal, will still make you look just as smart, important, creative, ambitious, or whatever else it was that you always thought that old two-piece pinstripe did.

"This morning he was a serious individual, representing Park Avenue and Wall Street. He wore a blue-gray nailhead worsted suit, custom-tailored in England for $1,800, two button, single-breasted, with ordinary lapels. On Wall Street double-breasted suits and peaked lapels were considered a bit sharp, a bit too Garment District."

1987

TOM WOLFE, *The Bonfire of the Vanities*

ENVIRONMENTAL ADAPTATION: MALE

"Isopraxism [is] a non-learned neurobehavior in which members of a species act in a like manner: Dressing like your colleagues and neighbors dress reflects a deep reptilian behavior. . . . "

DAVID GIVENS, research anthropologist

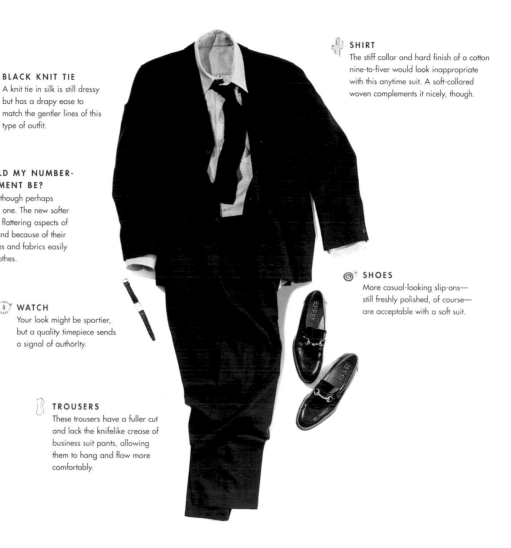

BLACK KNIT TIE
A knit tie in silk is still dressy but has a drapy ease to match the gentler lines of this type of outfit.

SHIRT
The stiff collar and hard finish of a cotton nine-to-fiver would look inappropriate with this anytime suit. A soft-collared woven complements it nicely, though.

faQ WHAT SHOULD MY NUMBER-ONE INVESTMENT BE?
A suit, of course, though perhaps not the traditional one. The new softer suits retain all the flattering aspects of traditional suits, and because of their less structured lines and fabrics easily pair with other clothes.

WATCH
Your look might be sportier, but a quality timepiece sends a signal of authority.

SHOES
More casual-looking slip-ons—still freshly polished, of course—are acceptable with a soft suit.

TROUSERS
These trousers have a fuller cut and lack the knifelike crease of business suit pants, allowing them to hang and flow more comfortably.

New "Soft" Suit. The best of this new breed comes in a relaxed year-round fabric like wool crepe, with padding in the shoulders or chest like a traditional suit and the same attention to tailoring, but no stiff canvas. It's comfortable, yet it still projects a certain formality. And because it's less structured than its historic counterpart, the trousers and jacket can be worn separately, demonstrating great versatility—and suggesting the same of the wearer.

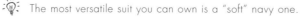 The most versatile suit you can own is a "soft" navy one.

Synergy. A fancy word for a simple idea: two things working together for enhanced effect. It's Time Warner putting its magazines online. It's Disney previewing a musical in its new 42nd Street theater before turning it into an animated feature. Your wardrobe can—should, if you're smart—have that kind of synergy. It all starts with a good product: the re-engineered "soft" suit. In a seasonless fabric such as a high-performance wool, it can work for you year-round and remain wrinkle-free—a very poolable resource. Navy and gray are the best colors. They cooperate with virtually every other item in your wardrobe. Wear the suit's two pieces with a shirt and tie. Or with a band-collar shirt. Or wear the jacket alone with khakis. If only associates could work together so well.

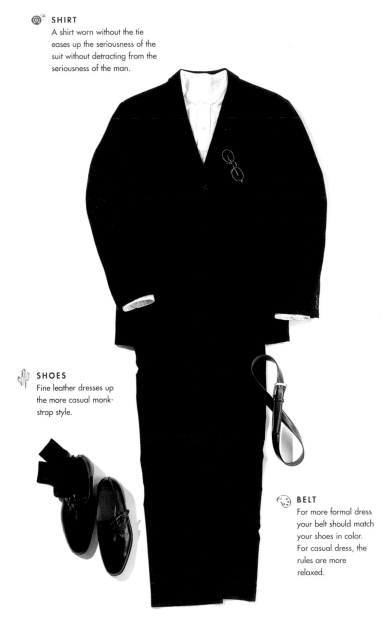

SHIRT
A shirt worn without the tie eases up the seriousness of the suit without detracting from the seriousness of the man.

SHOES
Fine leather dresses up the more casual monk-strap style.

BELT
For more formal dress your belt should match your shoes in color. For casual dress, the rules are more relaxed.

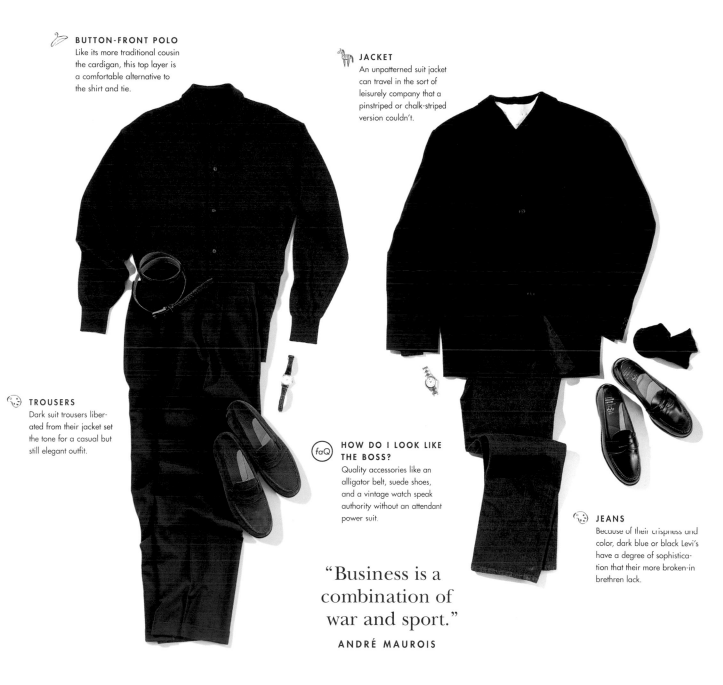

BUTTON-FRONT POLO
Like its more traditional cousin the cardigan, this top layer is a comfortable alternative to the shirt and tie.

JACKET
An unpatterned suit jacket can travel in the sort of leisurely company that a pinstriped or chalk-striped version couldn't.

TROUSERS
Dark suit trousers liberated from their jacket set the tone for a casual but still elegant outfit.

(faQ) HOW DO I LOOK LIKE THE BOSS?
Quality accessories like an alligator belt, suede shoes, and a vintage watch speak authority without an attendant power suit.

JEANS
Because of their crispness and color, dark blue or black Levi's have a degree of sophistication that their more broken-in brethren lack.

> "Business is a combination of war and sport."
>
> ANDRÉ MAUROIS

IT'S NOT JUST OUR CLOTHES THAT ARE CHANGING; IT'S THE WAY WE WORK, THE WAY WE LOOK AT WORK, AND HOW WE DEFINE WORK IN THE FIRST PLACE. TO GAIN SOME

perspective we turned to those who are always watching the horizon: Faith Popcorn, who monitors the shifting patterns of today for their future impact; Ken Auletta, a writer who seizes the moment and places it in the perspective of the future; and Alvin Toffler, who we swear creates the future.

Faith Popcorn

Faith Popcorn has emerged as one of the most definitive voices of the 1990's business culture. Her marketing consultancy firm, BrainReserve, advises companies from American Express to RJR Nabisco. Her first book, The Popcorn Report, *predicted the massive trend toward "cocooning," home-based offices, and telecommuting. The following excerpts are from* Clicking: 16 Trends to Future Fit Your Life, Your Work, and Your Business, *written by Popcorn and her co-author, Lys Marigold.*

One recent change in corporate dress codes has come almost totally from employee pressure. • 77 percent of American employees are estimated to be wearing more easygoing clothes for work. • Contributing to this casualization is the replacement of so many face-to-face meetings with fax, modem, e-mail, and conference calls. • The jacket may become identified with important events only, like meeting with the big boss, award events, formal signings, and weddings. The necktie is already getting obsolete, giving way to turtlenecks, banded collars, or open-collared shirts. • Comfort is the password • Blue jeans, which had been in a slump for a few years, went back up to over $400 million in 1993. And in a recent study for a men's fragrance, 82 percent of the men interviewed said they'd rather be wearing jeans than a suit.

Ken Auletta

Ken Auletta in the New Yorker *wrote the seminal piece on Barry Diller (post–Fox network) that created the new model of the entrepreneurial global executive: sans office, an Apple Powerbook his faithful companion. Auletta, a columnist for the* New York Daily News *and the best-selling author of* Greed and Glory on Wall Street *and* Three Blind Mice, *has recently been*

spending time among the denizens of two distinct working cultures: the world of Hollywood and the mother source of software in Seattle.

IS THERE A HOLLYWOOD UNIFORM OR DRESS CODE? If you go to Hollywood, you rarely see people below the level of Rupert Murdoch in a jacket and tie. Essentially, the uniform is casual—studied casual, not Microsoft casual—khakis with a sport shirt and sweater, sometimes a jacket. Jeans, and even the sneakers are expensive. SO, THEN, WHERE ARE THE SUITS? The Suits are in New York, and they refer only to someone you don't see all the time— people who control the business but aren't in the business. It's semi-pejorative DO YOU WORRY THAT YOUR STYLE WILL FIT IN AT ONE BUSINESS BUT NOT ANOTHER? I know enough now to check on a dress code. When I was at Microsoft recently, I found out that people don't wear ties, or don't even have jackets with them. The first day, I wore a turtleneck and a pair of slacks, nothing fancy. Someone said to me, "God, you're overdressed."

Truth is, most people were wearing Bermuda shorts and T-shirts—they're oblivious to everything. IS THE CASUALNESS IN DRESSING A REFLECTION OF BEING ABOVE "SURFACE" TREATMENTS? You can make an argument that people in their studied casualness are more aware of what people are wearing, and that people in New York who have a suit uniform don't pay attention to what they wear.

Alvin Toffler

People pay attention to social commentator Alvin Toffler when he predicts the future, unlike the sad case of Cassandra. His far-sighted trilogy Future Shock, The Third Wave, *and* PowerShift *should be mandatory reading for anyone interested in the growth curves of our society. In the 1990 bestseller* PowerShift, *Toffler draws a clear picture of the coming changes in both work and the workplace:*

In The Third Wave we wrote about such innovations as flexible hours, flexible fringe benefits, and other "flex" arrangements that begin to treat workers as individuals and, at the same time, give the firm far greater flexibility too…. What companies have not yet grasped, however, is that flexibility must cut far deeper—right to the very structure of the organization. • …in today's fast-change environment, says [University of Tsukuba Professor Teruya] Nagao , rules …need to be changed more frequently than in the past, and workers need to be encouraged to propose such changes. • And in the fast-growing, leading-edge industries, the old authoritarian command structure is phasing out, replaced by a new, more egalitarian or collegial style of work. Seen in its historical context, this represents a significant shift of power in the workplace. • The new hero is no longer a blue-collar worker, a financier, or a manager, but the innovator (whether inside or outside a large organization) who combines imaginative knowledge with action.

SPORT COAT

THE SPORT COAT WAS INVENTED WHEN KING GEORGE DARINGLY ORDERED A JACKET without matching trousers to wear while shooting at the Duke of Norfolk's estate. It took decades more for the coat to migrate to business use. And until recently it was acceptable businesswear only when said business was being conducted over gin and tonics at the club. Nowadays, though, sport coats are as important to some men as the suit. They allow a man to give up his uniform without giving up a uniform. You can have coats in tweeds of herringbone, Donegal, and houndstooth. You can have them in flannels, meltons, and gabardines, and in madras, hopsack, and linen for the summer. You can wear them everywhere from M.B.A. class to cocktails to hostile-takeover meetings. And count the ways that you can use them: dressy with gray flannels and tie; casual with jeans and a polo shirt, or with tweedy trousers and a button-down shirt. Name another garment in the masculine wardrobe that can be worn with so many different things. (Besides underwear.) Do the accounting: one sport coat and something like sixteen outfits. Let your number crunchers chew on that one.

 BLAZER. A navy or black blazer is the most basic of a man's dress basics, yet choosing one can be as complicated as picking 401k options. Single or double breasted? A boxy cut or the sharp-shouldered, nipped-waist silhouette? The traditional hopsack, or do you want doeskin, linen, cashmere, or just about any other fabric? And what about buttons—dark horn or shiny brass? What's right is what you decide. Try them on and pick what feels best—both physically and mentally.

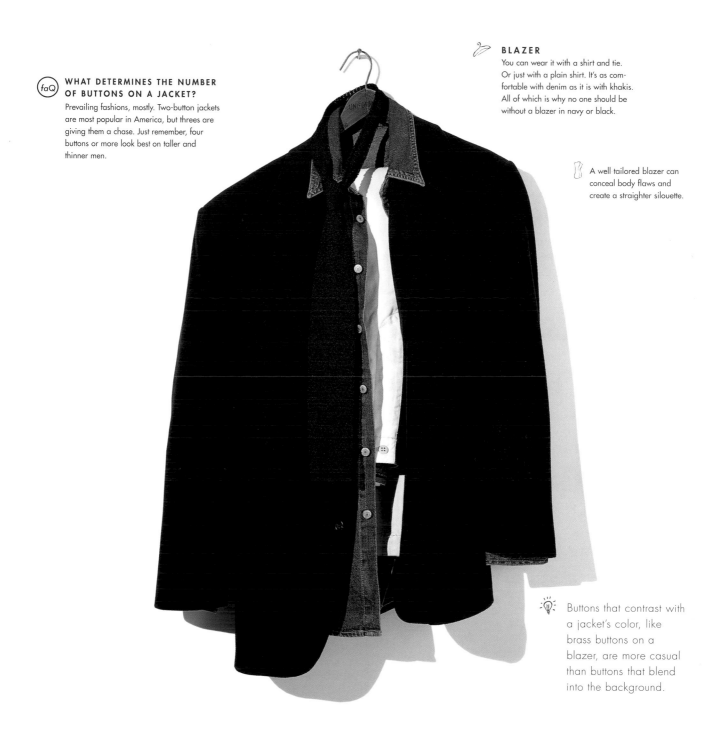

WHAT DETERMINES THE NUMBER OF BUTTONS ON A JACKET?

Prevailing fashions, mostly. Two-button jackets are most popular in America, but threes are giving them a chase. Just remember, four buttons or more look best on taller and thinner men.

BLAZER

You can wear it with a shirt and tie. Or just with a plain shirt. It's as comfortable with denim as it is with khakis. All of which is why no one should be without a blazer in navy or black.

A well tailored blazer can conceal body flaws and create a straighter silouette.

Buttons that contrast with a jacket's color, like brass buttons on a blazer, are more casual than buttons that blend into the background.

evolutionary stages the sport coat

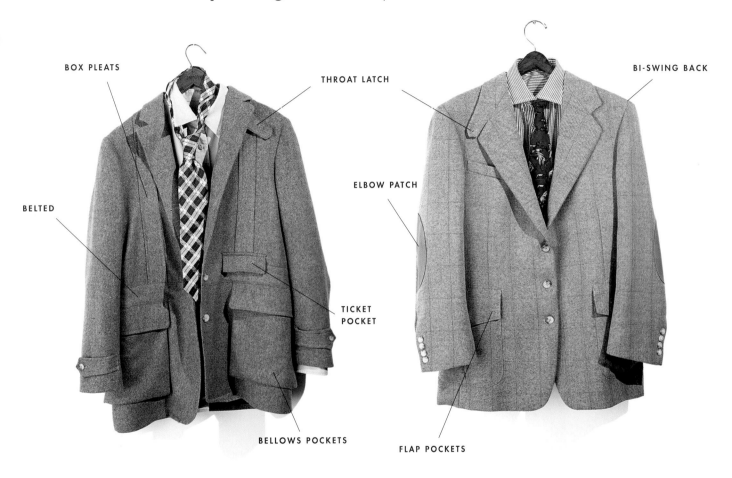

BOX PLEATS

THROAT LATCH

BI-SWING BACK

ELBOW PATCH

BELTED

TICKET POCKET

BELLOWS POCKETS

FLAP POCKETS

Norfolk. The original sport coat, with box pleats in front and back to provide for ease of gun-swinging movement and bellows pockets for shotgun shells. On the street, it's an outdoor look with a strong sense of style. But skip the knickers.

Shooting/Hunting. Not just for Norfolk anymore, but a throat latch remains for the Highlands chill. Still with a bi-swing back for ease of movement, in a warm tweed that hides dirt. Elbow patches announce you've worn it for ages.

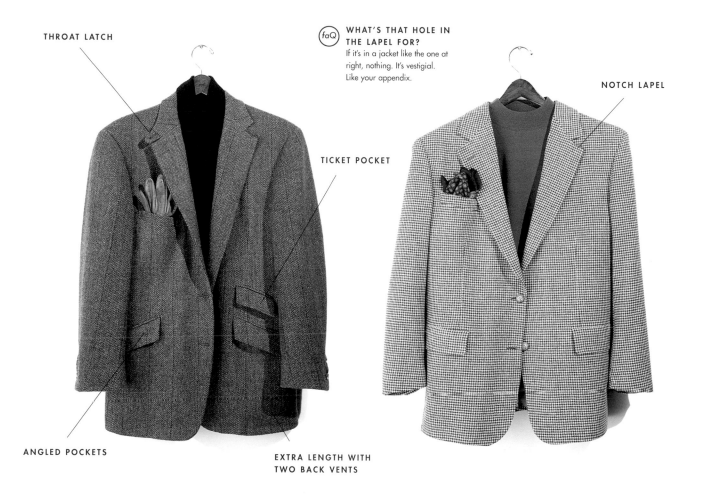

THROAT LATCH

faQ WHAT'S THAT HOLE IN THE LAPEL FOR?
If it's in a jacket like the one at right, nothing. It's vestigial. Like your appendix.

NOTCH LAPEL

TICKET POCKET

ANGLED POCKETS

EXTRA LENGTH WITH TWO BACK VENTS

Hacking. The angled pockets of this one-time English riding coat are fashioned for access when you're pitched forward in the saddle. Today, paired with a turtleneck, its simple detailing fits in at even the most conservative office.

Sport Coat. Today, it might be better called the spectator coat; climate control has obviated the need for a lapel closure and lightened the weight. It's a jacket that, with the right trousers, will take you anywhere the wilderness isn't.

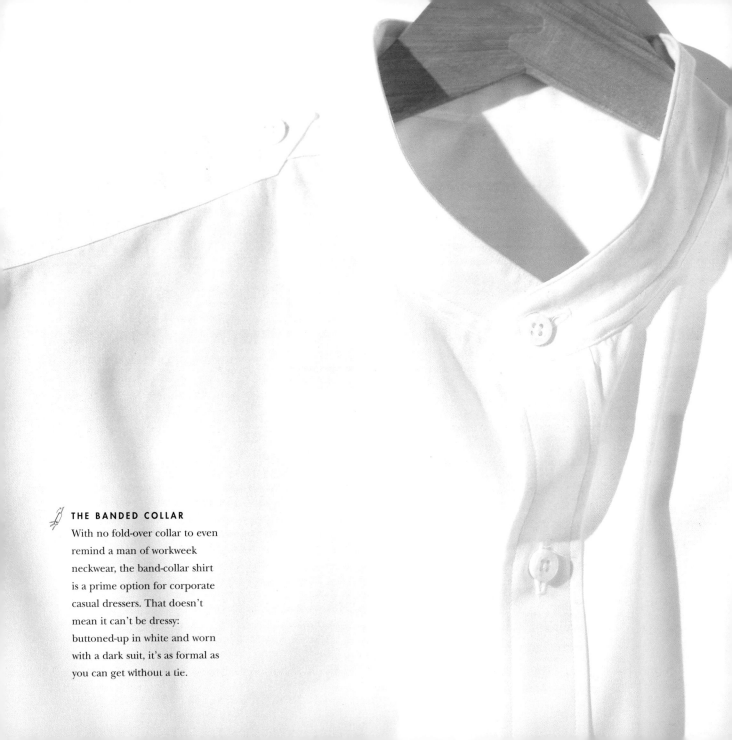

THE BANDED COLLAR

With no fold-over collar to even
remind a man of workweek
neckwear, the band-collar shirt
is a prime option for corporate
casual dressers. That doesn't
mean it can't be dressy:
buttoned-up in white and worn
with a dark suit, it's as formal as
you can get without a tie.

WHITE COLLAR

WHETHER HE'S IN DENIM OR A DARK DRESS NUMBER, TODAY'S BUSINESSMAN HAS AN EVEN GREATER variety available to him than that inveterate showboat Gatsby did. Casual dress allows for a wider selection of fabric, pattern, and color. Often these shirts have two chest pockets instead of one, and sometimes untraditional buttons, like metal or tagua nut. Also, in most cases the collar won't be the traditional spread variety. (But make sure it fits—you don't want to feel or look uncomfortable.)

CAN I WEAR A T-SHIRT ON A CASUAL WORKDAY?

To tee or not to tee, that is the question. And for most of us the answer should be not to tee. Especially if the garment in question comes emblazoned with concert dates, beer slogans, or team names, not to mention if it's something you'd wear while washing the car. Of course, if the tee you're talking about is made of a substantial material (heavyweight cotton, say) and happens to be free from all of the above, you might be able to wear it to work under a sport coat (which you don't remove).

HOW DO YOU KNOW FOR SURE?

As in all matters of dress, let common sense and your business environment be your guide. Usually if you have to ask, the answer is no.

Actually, you need not have a collar at all, which in the past, at least metaphorically, provided the perfect handle for authority figures to grab you by. A band-collar shirt offers a hip alternative to the more traditional shirt and tie while harking back to the old detachable versions. It's also versatile—undeniably sporty, always proper (perhaps owing to its vaguely clerical feel), and even capable of traveling nicely under a tuxedo. But no matter which type of collar you use, remember to keep it clean.

OPTIONAL

AS NECKWEAR HAS BECOME LESS A NECESSITY AND MORE A NOW-AND-AGAIN ACCESSORY, IT'S LOST ITS CONFORMIST ATTITUDE. A STYLISH man, however, knows it should still con-form—to his personality. For starters, that probably means banishing the red foulard power tie and picking something less uni-form. Which, of course, doesn't mean you should be known around the office as the guy who wears the naked-lady neckwear. Like the rest of your wardrobe, your ties should reflect your personal good taste. Classics and their just-offbeat brethren are still best. Pick carefully, particularly if you're not going to have a whole stash of them (and if you don't have to wear one every day, why would you?). Much like a well-cho-sen shirt that's worn with a variety of suits, ties should perform as wardrobe extenders.

LOOSEN UP

1. Begin with a particularly neck pinching knot at the start of a particularly nerve-pinching day.

2. Pull the wide end of the tie up and out of the knot. Take a deep breath. Feels better already.

3. Unwind the wide end. At this point, you may unbutton the top button of your shirt.

4. Undo the final coil. Slip tie out of collar, fold tie into fourths, and place in nearest potted plant.

 THE SIMPLE TIE. Cary Grant wore it with a suit, meaning it's impeccably stylish. James Bond wore it trotting round the globe, meaning it's acceptable in any situation. Add to that bonus points for the nonwrinkling, dirt-hiding nature of knit, and whether you're in a denim shirt or a double-breasted suit, this basic knit black cravat is an indispensable tie to tie on.

[🧳 ON THE ROAD—*page 154*]

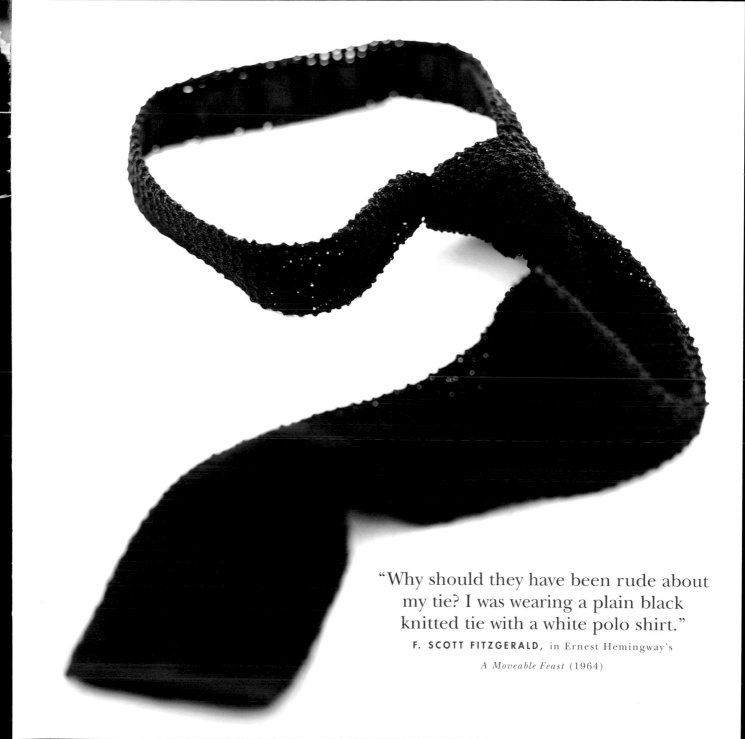

"Why should they have been rude about my tie? I was wearing a plain black knitted tie with a white polo shirt."

F. SCOTT FITZGERALD, in Ernest Hemingway's

A Moveable Feast (1964)

D E N I M

IT'S THE ORIGINAL WORKWEAR FABRIC, BUT CAN YOU WEAR IT TO WORK? WELL, THAT DEPENDS ON YOUR COMPANY'S POLICY. IF NOT, THERE'S ALWAYS SATURDAY. IF SO,

don't confuse denim—whether jeans or a shirt—that might be acceptable for Saturday with denim that'll carry you well covered during the week. Even though it's the symbol of the wide-open, freedom-loving American frontier, there are some rules regarding the wearing of this fabric. As with all office-suitable garments, jeans and denim shirts should have a certain level of appropriateness. They shouldn't look as if you've just moved ten thousand head of cattle over the Santa Fe Trail—keep 'em clean and

OFF THE CUFF

Cuff links are usually worn only with the dressiest clothes. But rules are made to be broken, and whether your cuff links are made of sterling or old typewriter keys, the cuff is a great place for remarks.

Once you've judiciously applied the rule of thumb, it's all a matter of personal taste. The rule of thumb, by the way, states you should never wear a pair of links much bigger than your thumbnail.

free of the abuse. (Ladies: Unlike Brooke Shields, you should allow room for something to come between you and your denim. Gentlemen: You shouldn't put your middle-management butt in Brad Pitt pants.) For work you need jeans you can move in. Stick to classics. There are all those bastardizations of the blue jean—acid washes, oddly colored, intentionally pumice-stone frayed—and none are right for the office. Never. Look at it this way: why mess with something that's got a 150-year track record?

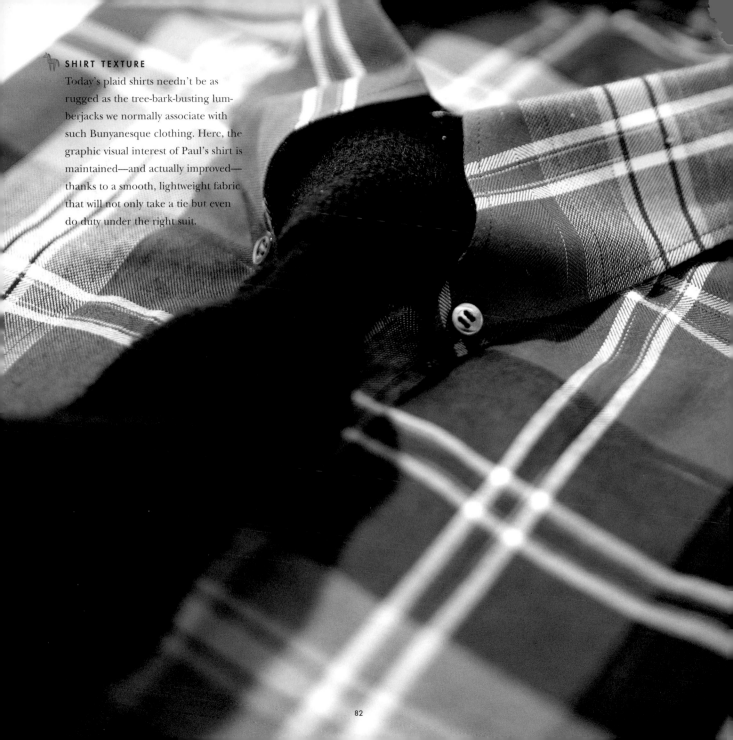

🐎 SHIRT TEXTURE

Today's plaid shirts needn't be as
rugged as the tree-bark-busting lum-
berjacks we normally associate with
such Bunyanesque clothing. Here, the
graphic visual interest of Paul's shirt is
maintained—and actually improved—
thanks to a smooth, lightweight fabric
that will not only take a tie but even
do duty under the right suit.

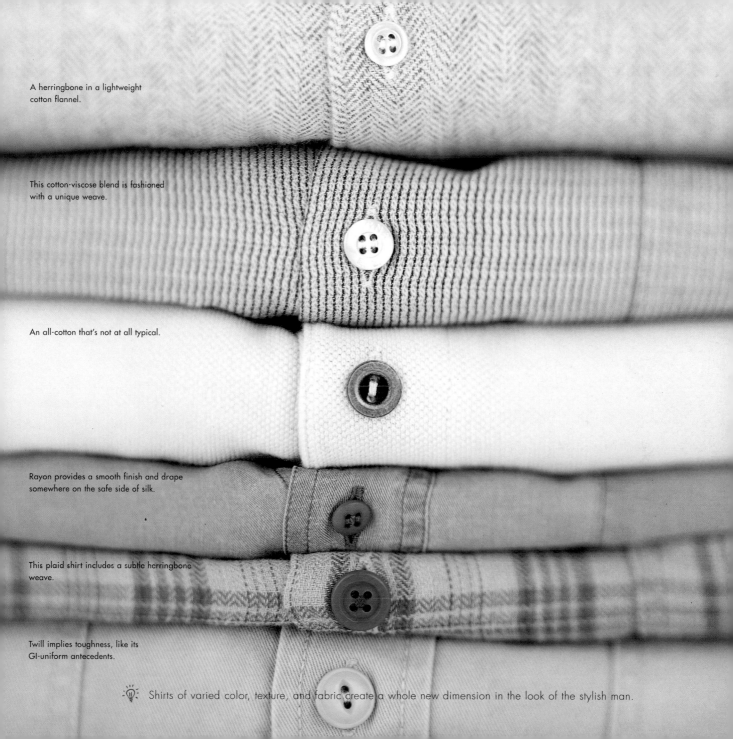

A herringbone in a lightweight cotton flannel.

This cotton-viscose blend is fashioned with a unique weave.

An all-cotton that's not at all typical.

Rayon provides a smooth finish and drape somewhere on the safe side of silk.

This plaid shirt includes a subtle herringbone weave.

Twill implies toughness, like its GI-uniform antecedents.

Shirts of varied color, texture, and fabric create a whole new dimension in the look of the stylish man.

Rugged. Go ahead, wear that Italian silk crepe tie with a tough denim shirt on Friday—and it'll look about as ridiculous as that frilly little wisp of parsley garnishing a 32-ounce sirloin. While a lightweight tie might complement cotton broadcloth, a heavy cotton twill demands something a bit more substantial. Meat needs potatoes, friend. In the case of neckwear, the spuds blessedly come in a wide variety. Silk can still work, but think wovens and knits instead of the delicate numbers you'd wear with that sleek suit. Wool ties are an option, too; their heft and the knot they make are appropriate to flannel shirts, suede vests, and nubby tweed sport coats. This is a chance to be bold: opt for in-your-face masculine checks and bold geometrics in autumnal colors.

UNDERDRESSED OVERACHIEVERS

Julius Caesar Gertrude Stein *Daniel Boone*
Alexander the Great *Buddha* Steven
Spielberg *Albert Einstein* Sonny Mehta
George Lucas Richard Branson *David Geffen*
Bill Gates *Pablo Picasso* Ghandi
Jann Wenner S. I. Newhouse *Mick Jagger*
Albert Einstein *Phil Knight* Scott McNeally
Woody Allen Anita Roddick

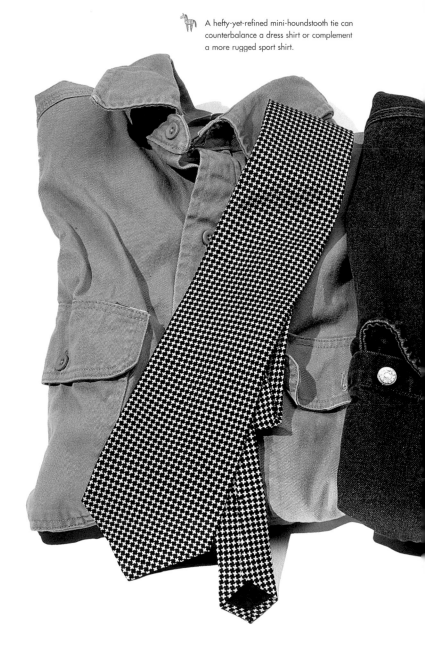

A hefty-yet-refined mini-houndstooth tie can counterbalance a dress shirt or complement a more rugged sport shirt.

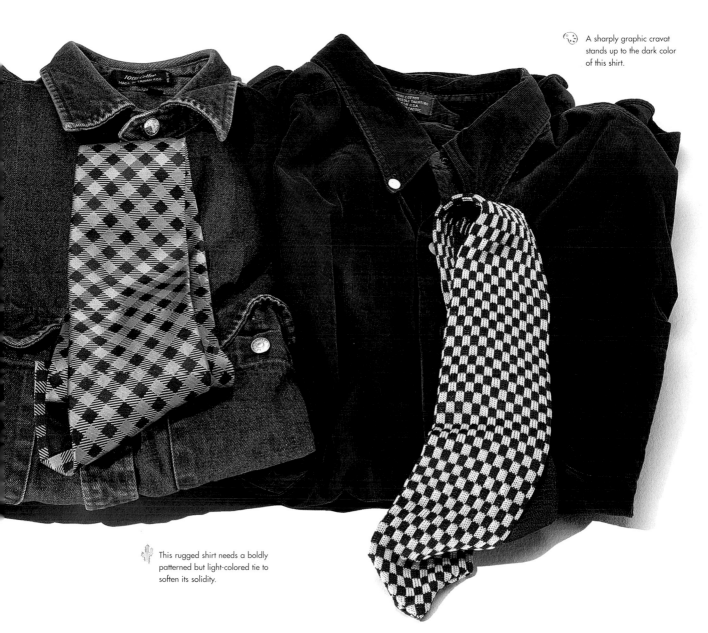

A sharply graphic cravat stands up to the dark color of this shirt.

This rugged shirt needs a boldly patterned but light-colored tie to soften its solidity.

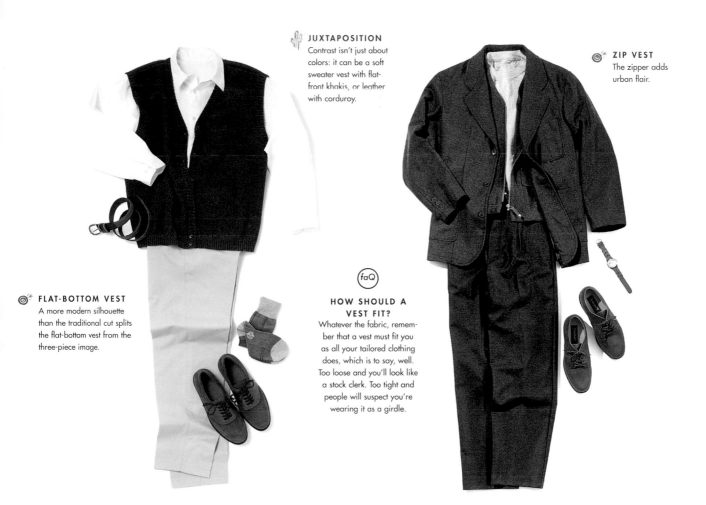

JUXTAPOSITION

Contrast isn't just about colors: it can be a soft sweater vest with flat-front khakis, or leather with corduroy.

ZIP VEST

The zipper adds urban flair.

FLAT-BOTTOM VEST

A more modern silhouette than the traditional cut splits the flat-bottom vest from the three-piece image.

(faQ)

HOW SHOULD A VEST FIT?

Whatever the fabric, remember that a vest must fit you as all your tailored clothing does, which is to say, well. Too loose and you'll look like a stock clerk. Too tight and people will suspect you're wearing it as a girdle.

Fully Vested. There was a time when vests were necessary—back when Mr. Scrooge was meting out only half a lump of coal per day for the only stove in the middle of his very drafty counting room. A vest kept the trunk toasty and freed up the arms to do all that totaling. Central heating made them unnecessary for decades—until today. Now they're required in order to get more style mileage out of a suit. Under a matching jacket, it's überformal. Mismatched, it suggests the wearer is a man with a creative eye. Alone with a shirt, it makes for relaxed dressiness. Not a bad investment.

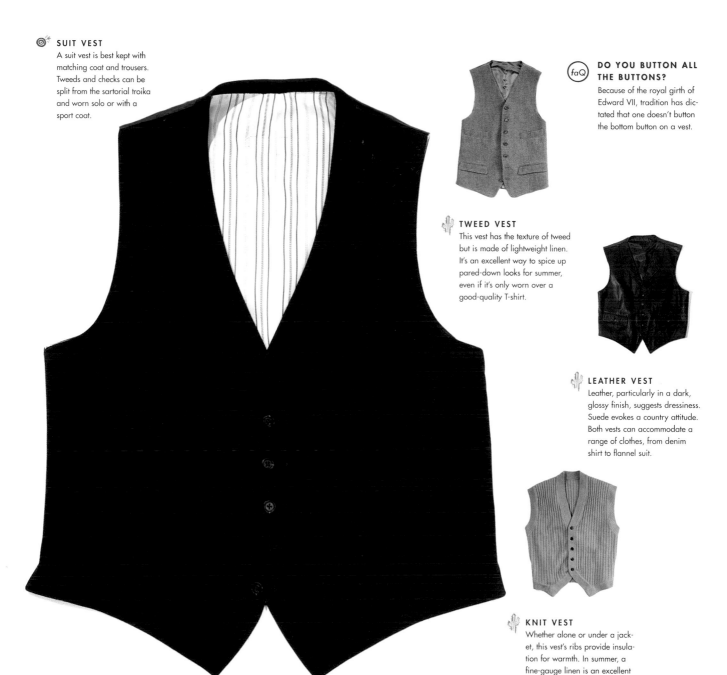

SUIT VEST

A suit vest is best kept with matching coat and trousers. Tweeds and checks can be split from the sartorial troika and worn solo or with a sport coat.

DO YOU BUTTON ALL THE BUTTONS?

Because of the royal girth of Edward VII, tradition has dictated that one doesn't button the bottom button on a vest.

TWEED VEST

This vest has the texture of tweed but is made of lightweight linen. It's an excellent way to spice up pared-down looks for summer, even if it's only worn over a good-quality T-shirt.

LEATHER VEST

Leather, particularly in a dark, glossy finish, suggests dressiness. Suede evokes a country attitude. Both vests can accommodate a range of clothes, from denim shirt to flannel suit.

KNIT VEST

Whether alone or under a jacket, this vest's ribs provide insulation for warmth. In summer, a fine-gauge linen is an excellent way to add a dash of style.

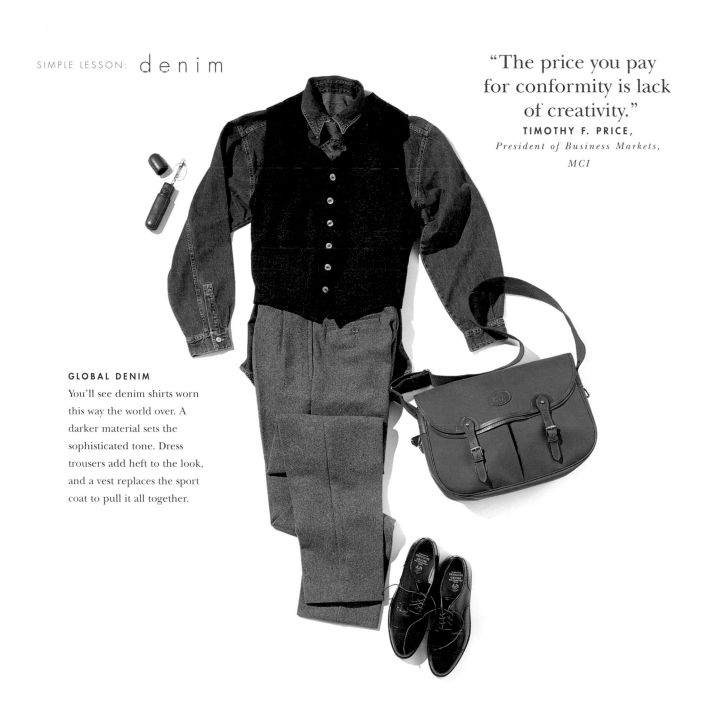

SIMPLE LESSON: denim

GLOBAL DENIM

You'll see denim shirts worn
this way the world over. A
darker material sets the
sophisticated tone. Dress
trousers add heft to the look,
and a vest replaces the sport
coat to pull it all together.

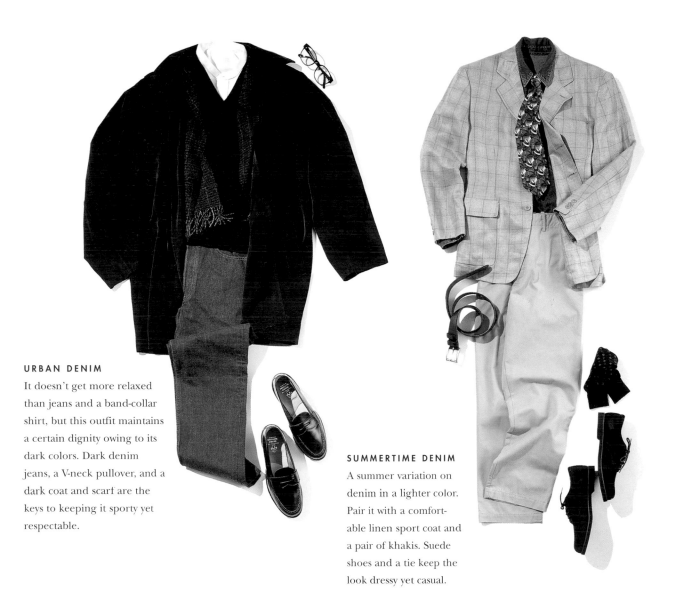

URBAN DENIM

It doesn't get more relaxed than jeans and a band-collar shirt, but this outfit maintains a certain dignity owing to its dark colors. Dark denim jeans, a V-neck pullover, and a dark coat and scarf are the keys to keeping it sporty yet respectable.

SUMMERTIME DENIM

A summer variation on denim in a lighter color. Pair it with a comfortable linen sport coat and a pair of khakis. Suede shoes and a tie keep the look dressy yet casual.

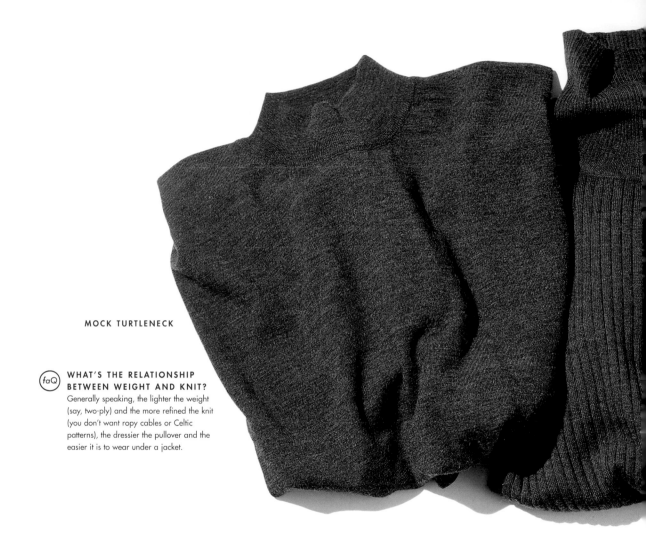

MOCK TURTLENECK

(faQ) **WHAT'S THE RELATIONSHIP BETWEEN WEIGHT AND KNIT?** Generally speaking, the lighter the weight (say, two-ply) and the more refined the knit (you don't want ropy cables or Celtic patterns), the dressier the pullover and the easier it is to wear under a jacket.

THE KNITTING FACTORY

A good businessperson likes options, and when it comes to wardrobe, knit pullovers provide them. In fine fabrics like merino wool or cashmere for cold weather and Sea Island cotton for warm, they offer excellent alternatives to the shirt and tie. With no patterns and few if any buttons, the mock turtle, turtle- neck, and polo are the essence of pared- down style. Each has the versatility to take you comfortably from four cramped hours in business class to the

[🧳 ON THE ROAD *page 154*]

TURTLENECK

POLO

most formal of engagements. A black turtleneck can even be worn under a tuxedo—a look the designer Tommy Hilfiger has been known to don at the most high-fashion affairs. Any of these pieces look good on their own with jeans, corduroys, or flannel trousers, but they'll also work nicely under a sport coat. And when it is worn with a sharp suit in place of the conventionally expected tie, the look can be slimming, not to mention incalculably chic.

BLACK

BEING IN THE BLACK. IT'S A DESIRABLE FINANCIAL CONDITION, NOT TO MENTION A STYLISH ONE, AS JEWEL THIEVES, COSMOPOLITAN WOMEN, AND TITANS OF BUSINESS

throughout history will tell you. At one time, in fact, black was the only color for business. The uniform of the Victorian city man, it had the necessary gravitas for the serious task of empire-building in the early years of the Industrial Revolution. It spoke power, and still does, even if it's not worn as much as it should be these days. It also says creativity. And plugged-in hipness. In a black turtleneck, sport coat, and sharp accessories, you're the entrepreneurial type who's well appointed for after-hours club-hopping. With a white shirt and black tie, a black suit gives you Young Turk muscle. With a tab-collar shirt, cuff links, and patterned tie, the look is power-brokering Hollywood agent. Daytime, with a blue shirt and tie, it's the height of propriety; come nightfall, a crisp white band-collar shirt transforms it into formal wear. Black, it's clear, fills the versatility quotient, correct for just about any situation (short, perhaps, of a visit to the field office, where folks may wonder if you're in mourning).

"I wear clothes in only two colors, black and gray. . . . These colors are appropriate for any occasion . . . and they go well together, should I mistakenly put on a pair of gray socks with my black trousers."

MICHAEL CRICHTON, *Jurassic Park* (1990)

[🧳 ON THE ROAD—*page 154*]

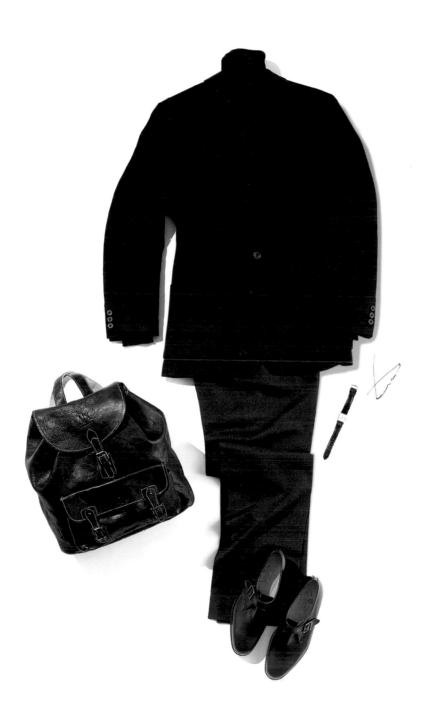

GRAY FLANNELS

They are the more formal man's khakis. Just as versatile. Just as indispensable. Just as storied. Invariably they're cuffed and have such touches as pleats and a hook-and-button flap at the waistband, and they go quite nicely with a blazer and tie. They can range from a light slate to a dark charcoal and aren't necessarily even flannel anymore (as with khakis, we're talking generalities rather than specifics). They're the trousers most guys wear with a navy blazer, white button-down, and rep tie, but as Italian men will tell you, they also look great with a denim shirt. Just like khakis.

WHAT'S A WARM-WEATHER ALTERNATIVE TO FLANNELS?

You're better off with a less heavy worsted gray in a lighter shade. It's both more comfortable and more practical.

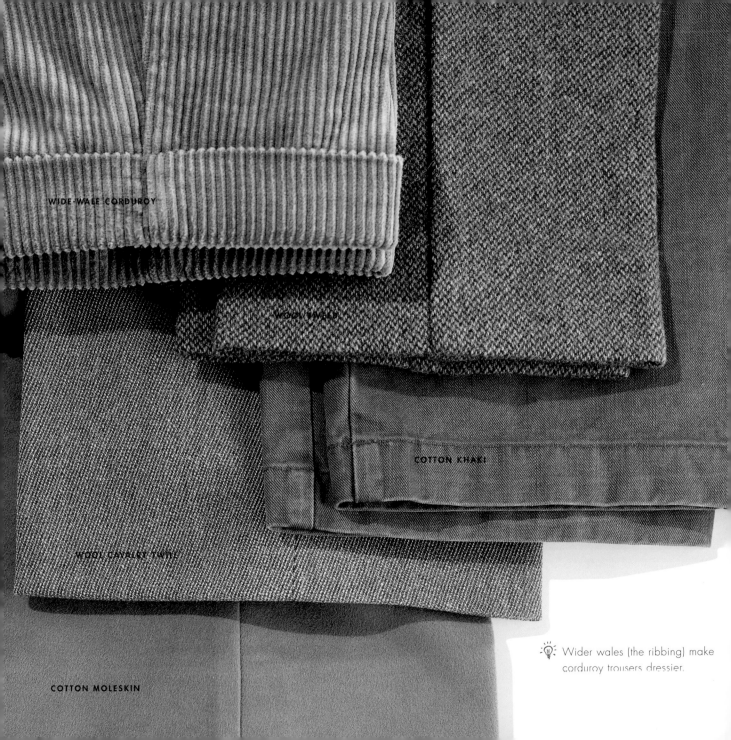

WIDE-WALE CORDUROY

WOOL TWEED

COTTON KHAKI

WOOL CAVALRY TWILL

COTTON MOLESKIN

Wider wales (the ribbing) make corduroy trousers dressier.

P A N T S

THESE ARE CASUAL DAYS IN THE OFFICE, NOT CONFORMIST DAYS. SO WHY DO YOU WEAR ONLY KHAKIS? THERE ARE, YOU KNOW, OTHER PANTS OUT THERE TO BE PULLED

on one leg at a time. And we're not just talking jeans or suit trousers. Bottoms for both men and women come in all sorts of fabrics, seasonal weights and colors, and degrees of formality. There are richly textured tweeds and corduroys for fall, simpler lightweight linen and poplin in colors for summer. There are the fuller, dressier cuts of trousers that look best with dressier shirts and sport coats (they should be cuffed and probably come pleated). Then there are the simpler, more pared-down pants that do just fine when worn with a polo shirt. (On those you don't want cuffs, and more often than not they're plain-fronted.) How do you know which ones to lay away in that stockroom you call a closet? You've got to cover all contingencies. Try a pair of each: start with khakis and corduroy for more casual days but salt away a pair of gray flannels and something a bit dressier—linen, say—for summer. A note to women: the kick-around nature of casual pants will more quickly rob you of authority than your male counterparts, so you may want to stick to more formal, equally stylish trousers. For women, black is the equivalent of gray flannel.

> "My dad's pants kept creeping up on him. By 65 he was just a pair of pants and a head."
>
> **JEFF ALTMAN**

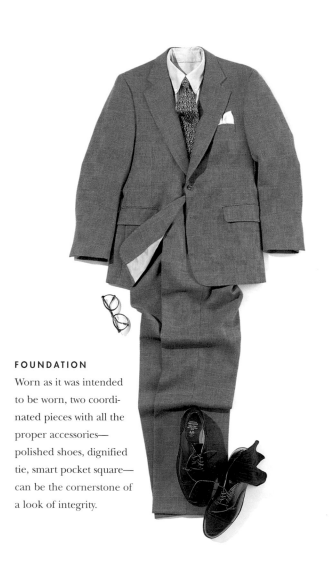

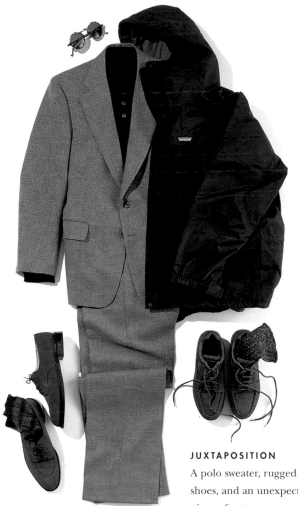

FOUNDATION

Worn as it was intended to be worn, two coordinated pieces with all the proper accessories—polished shoes, dignified tie, smart pocket square—can be the cornerstone of a look of integrity.

JUXTAPOSITION

A polo sweater, rugged shoes, and an unexpected piece of outerwear—something a bit high-tech, perhaps—dresses down the two pieces of a suit in much the same way a sport coat or cardigan would.

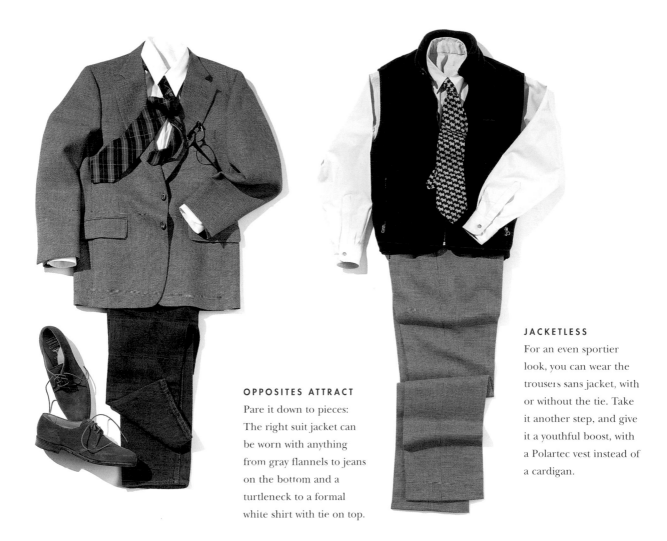

OPPOSITES ATTRACT

Pare it down to pieces: The right suit jacket can be worn with anything from gray flannels to jeans on the bottom and a turtleneck to a formal white shirt with tie on top.

JACKETLESS

For an even sportier look, you can wear the trousers sans jacket, with or without the tie. Take it another step, and give it a youthful boost, with a Polartec vest instead of a cardigan.

A good example of one suit used for three different destinations.

REAL TIME

APOLOGIES TO NEGROPONTE, BUT BEING DIGITAL
ISN'T THE ONLY GAME IN TOWN, REGARDLESS OF HOW
COMPUTER LITERATE WE ALL MUST BECOME. ANALOG, AT LEAST IN

terms of wristwatches, still does quite nicely, thank you. In fact, those sweeping hands can be a wonderful, sophisticated reassurance in a world of pulsing cursors, self-totaling spreadsheets, and easy-access databases. None of which is to say that keeping the precisely correct time isn't important. In fact, today time is not only money, but minutes can mean millions. Just make sure your watch is a good watch. When selecting a timepiece think simple and versatile (you don't want

"You haven't owned a watch in years. Knowing the time at any given moment might be a good first step towards organizing the slippery flux of your life. You've never been able to see yourself as the digital type of guy. But you could use a little Cartier in your act."

JAY McINERNEY,
Bright Lights, Big City
(1984)

to switch watches as, it's hoped, you do underwear). A dignified band and uncomplicated face will do best. Think classic. If not a vintage ticker, at least one that has a timeless appeal. And, please, no garishly colored plastic watches—ones with more buttons than hours on their faces, or ones that make any sort of noise besides tick, tick, tick. Those are best worn by athletes or A.V. squad members and millennial computer-pundit authors. With apologies to Negroponte.

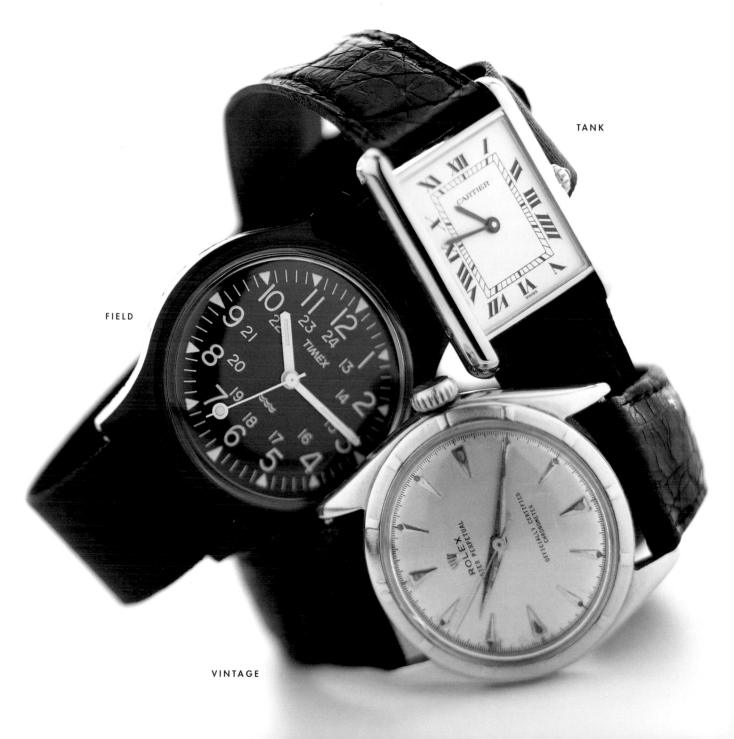

TANK

FIELD

VINTAGE

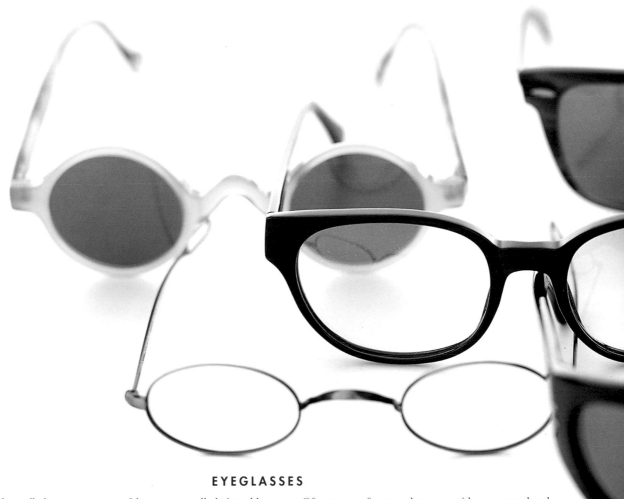

EYEGLASSES

Recall when all those actors wore fake glasses to be taken more seriously at their "poetry" readings? Absurd, but those brat-packers were onto something: glasses can make you look smart. And that perception can be as important in the office as actually being able to see. Of course, no one's suggesting you get a new pair just so you can dress down on Fridays. You may, however, think about a new style next time you change the ever-increasing strength of your prescription. Consider frames about as wide as your head. Round is better for angular faces, and angular is better for round faces. Wire, horn, and tortoise rims are just the right degree of subtle. Avoid buying anything you saw on an Elton John album cover.

[👜 ON THE ROAD—*page 154*]

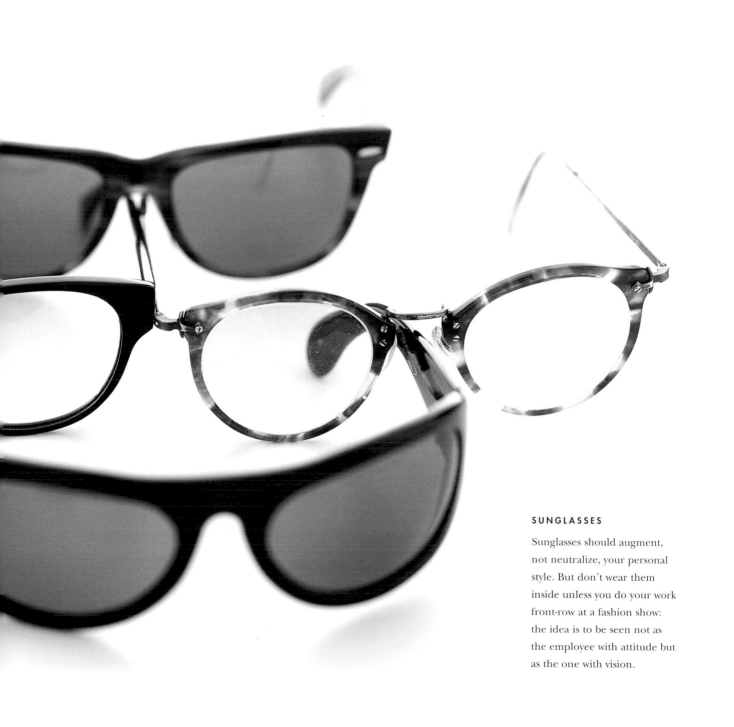

SUNGLASSES

Sunglasses should augment,
not neutralize, your personal
style. But don't wear them
inside unless you do your work
front-row at a fashion show:
the idea is to be seen not as
the employee with attitude but
as the one with vision.

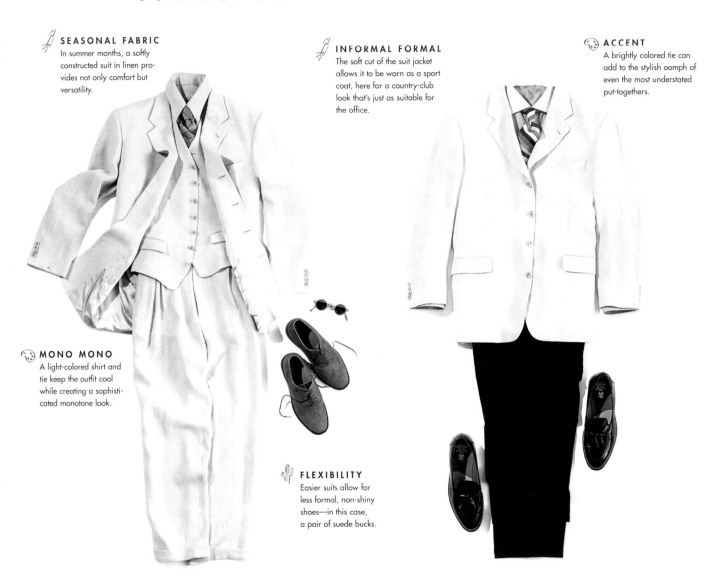

SEASONAL FABRIC
In summer months, a softly constructed suit in linen provides not only comfort but versatility.

INFORMAL FORMAL
The soft cut of the suit jacket allows it to be worn as a sport coat, here for a country-club look that's just as suitable for the office.

ACCENT
A brightly colored tie can add to the stylish oomph of even the most understated put-togethers.

MONO MONO
A light-colored shirt and tie keep the outfit cool while creating a sophisticated monotone look.

FLEXIBILITY
Easier suits allow for less formal, non-shiny shoes—in this case, a pair of suede bucks.

Linen and travel just don't mix.

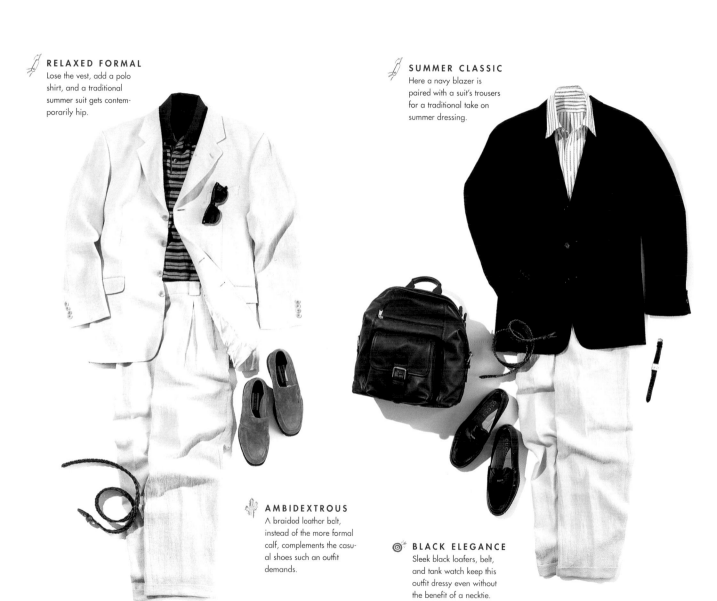

RELAXED FORMAL
Lose the vest, add a polo shirt, and a traditional summer suit gets contemporarily hip.

SUMMER CLASSIC
Here a navy blazer is paired with a suit's trousers for a traditional take on summer dressing.

AMBIDEXTROUS
A braided leather belt, instead of the more formal calf, complements the casual shoes such an outfit demands.

BLACK ELEGANCE
Sleek black loafers, belt, and tank watch keep this outfit dressy even without the benefit of a necktie.

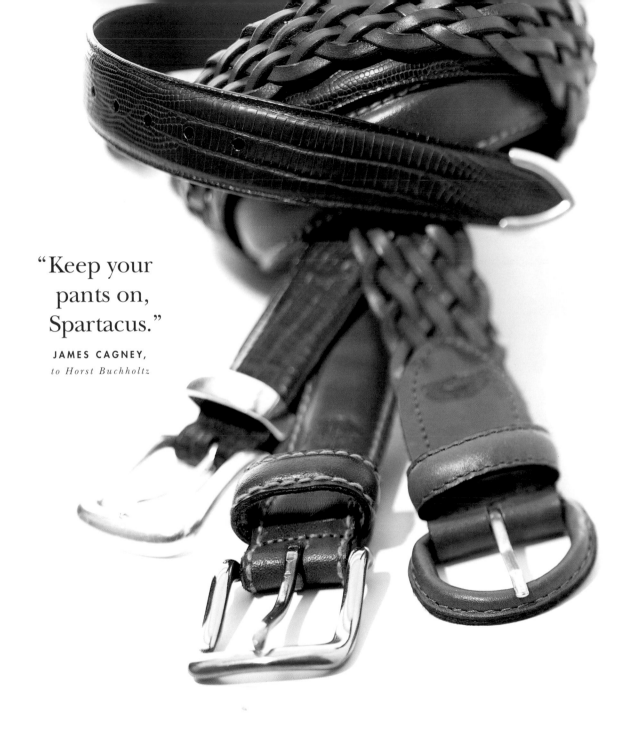

"Keep your
pants on,
Spartacus."

JAMES CAGNEY,
to Horst Buchholtz

W A I S T E D

NOT TOO LONG AGO, BOOKS WOULD TELL YOU THAT YOUR BELT SHOULD BE CONSTRUCTED OF UN-ADORNED BLACK CALF, MEASURE NO MORE THAN ONE AND ONE-quarter inches wide, and have only the simplest silver or, preferably, gold buckle. Nowadays, with the new corporate casual code, belts allow for almost as much expression of personality as neckties. Of course, you'd do well to avoid hubcap-sized buckles with inlaid jewels or engraved beer slogans, but that's okay—there are still plenty of choices. Woven leather straps. Straps with contrasting top-stitching. Grains from pebble to snake to alligator. Buckles in brass, silver, or gold, or leather-covered. About the only hard-and-fast belt rule is that you should wear one. It might be good business sense to keep costs down, but as you surely know by now, a guy's gotta keep his pants up.

 ORIGINS An unusually hot summer at the end of the nineteenth century introduced suspender-wearing businessmen to the belt, which they adopted to remove the straps from their shoulders in the interest of keeping cool. Shortly thereafter, belt-wearing businessmen were introduced to the belt loop. **MATCHING** In all but the most casual of outfits, your belt should be a bit darker than your trousers and match your shoes in color and material. **OPTIONS** The more casual your outfit, the greater the range of choices you have. Belts can be lighter in color and made of canvas or stretch twill. Generally speaking, the strap of a casual belt is a little wider than a formal one. **SKINS** Alligator belts might be costly, but if you own one in black and one in brown, you'll never need to turn to another belt to keep your pants up—they look great with anything from tuxedo trousers to jeans and are made to last.

FOOT NOTE

BACK WHEN BUSINESS WAS AT ITS MOST FORMAL—AT THE END OF THE NINETEENTH CENTURY—IT DIDN'T MATTER WHAT KIND OF SOCKS YOU WORE, AS LONG AS THEY WERE

of the proper seasonal weight. No one would see them under the boots that were then de rigueur. Now, when business is at its most informal—and most shoes are a bit lower on the ankle—you've got to watch your step. For formal business suits a man should wear over-the-calf socks—a strip of pale, hairy leg peeking out from beneath a pant

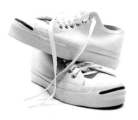

SNEAKERS AND BOAT SHOES

As comfortable as sneakers and boat shoes can be, they lack the authority of leather shoes. Wear them at your peril—you can't take up the boss's surprise invite to lunch in basketball shoes. If you must, stick with plain white canvas ones like the Jack Purcells above and pair them with khakis.

leg is, after all, a bit undignified. The more formal your outfit, the cleaner looking you want your hose to be: black silk for tuxedos, black, gray, or navy wool for suits. Mid–calf-length socks and ones with patterns work best with your more casual clothing. Of course, as in all dressing, the simpler choices are the best choices—for versatility's sake.

"Your socks should never be funnier than you are."

HAL RUBENSTEIN, *Paisley Goes with Nothing* (1995)

[🧳 ON THE ROAD—*page 154*]

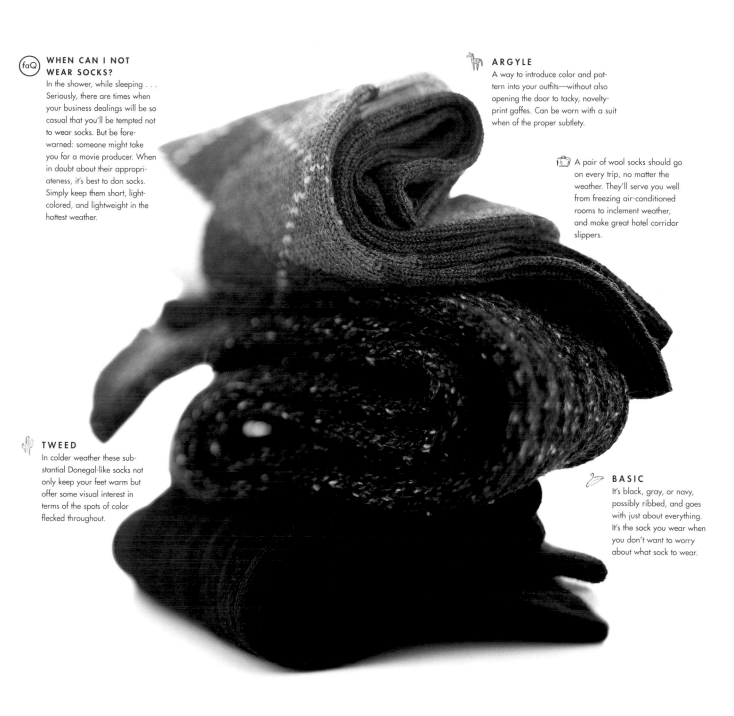

WHEN CAN I NOT WEAR SOCKS?
In the shower, while sleeping . . . Seriously, there are times when your business dealings will be so casual that you'll be tempted not to wear socks. But be fore-warned: someone might take you for a movie producer. When in doubt about their appropri-ateness, it's best to don socks. Simply keep them short, light-colored, and lightweight in the hottest weather.

ARGYLE
A way to introduce color and pat-tern into your outfits—without also opening the door to tacky, novelty-print gaffes. Can be worn with a suit when of the proper subtlety.

A pair of wool socks should go on every trip, no matter the weather. They'll serve you well from freezing air-conditioned rooms to inclement weather, and make great hotel corridor slippers.

TWEED
In colder weather these sub-stantial Donegal-like socks not only keep your feet warm but offer some visual interest in terms of the spots of color flecked throughout.

BASIC
It's black, gray, or navy, possibly ribbed, and goes with just about everything. It's the sock you wear when you don't want to worry about what sock to wear.

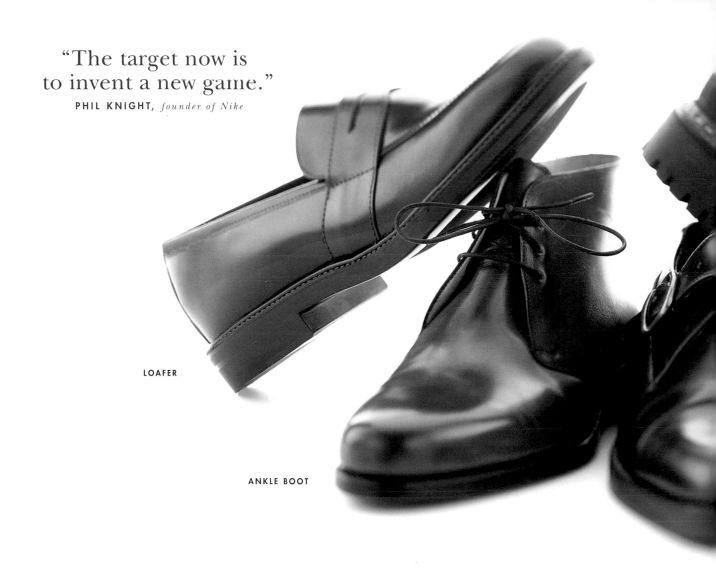

> ## "The target now is to invent a new game."
> **PHIL KNIGHT,** *founder of Nike*

LOAFER

ANKLE BOOT

Casual shoes. What makes a casual shoe a casual shoe? If it doesn't lace up—unless we're talking about patent-leather, red-velvet-lined opera pumps—it's guaranteed casual. If a shoe has a rugged lug sole, it's casual. If it's got visible contrast stitching, it's casual. If you can't shine it (meaning its upper is nubuck, suede, or a matte-finish leather), you can almost bet it's casual.

[🧳 ON THE ROAD—*page 154*]

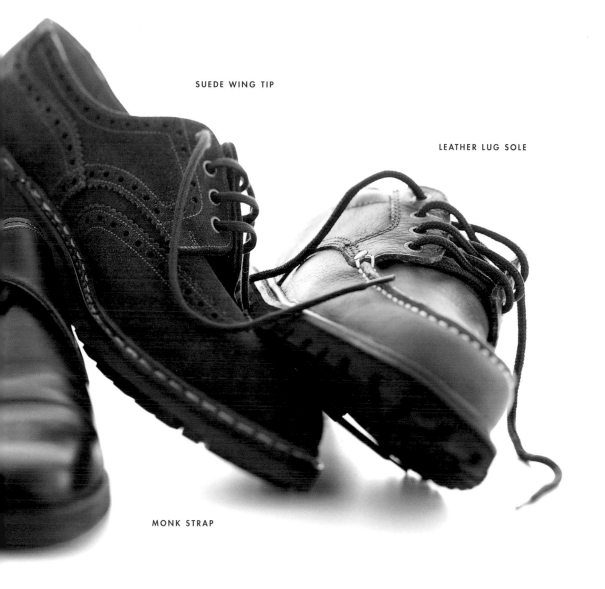

SUEDE WING TIP

LEATHER LUG SOLE

MONK STRAP

LOAFER The ultimate in classic slip-on casual, the loafer has never come with any strings, or at least laces, attached. **ANKLE BOOT** An ankle boot looks great with anything from jeans to khakis, or even a tweed suit. **MONK STRAP** Before there were shoelaces—even before there were left and right shoes—there were straps. Today, they provide a bit of attitude, especially when worn with a suit. **SUEDE WING TIP** The Duke of Windsor preferred to wear the original dress-down shoe with a navy-blue suit. This more rugged version sports contrast stitching, metal eyelets, and a lug sole. **CAMP SHOE** Rawhide laces and visibly cut-and-stitched leather identify this casual shoe.

WORK BAGS

ARE YOU A PERSON OR A PACK MULE? PROBABLY, LIKE MOST MEN AND WOMEN TODAY, YOU'RE A HYBRID, TOTING WITH YOU A BROWN-BAG LUNCH, KEYS, AND A BIT OF

homework every time you leave the house. Long gone are the days when a simple leather attaché suited the Main Line suit wearer. Businessfolk today need something adaptable, freewheeling, and able to swallow up whatever comes its way. Fortunately, there's a range of bags to hold everything, whatever our needs. They've loosened up just like our clothes—they're a bit more rugged, too. You've got more than the once-standard black leather to choose from. All manner

AGENDA

What's your agenda? Paper between leather or canvas covers? Or maybe you're a digital type, punching the buttons. No matter what your preference, such a perfect union of function and style says a lot about how you reconcile your personal and professional sides.

of hides will work, though you should stay away from ostrich and lizard skins, which are best reserved for cowboy boots. Canvas and nylon are good functional options, and, thanks to modern technology, as tough as leather at a much more user-friendly price. Plus, like your clothes, they work after work. As a tote for your gym clothes. As a weekender for that Friday-night getaway. As an airline carry-on. Sure, we all carry baggage—smart folk just make theirs more useful.

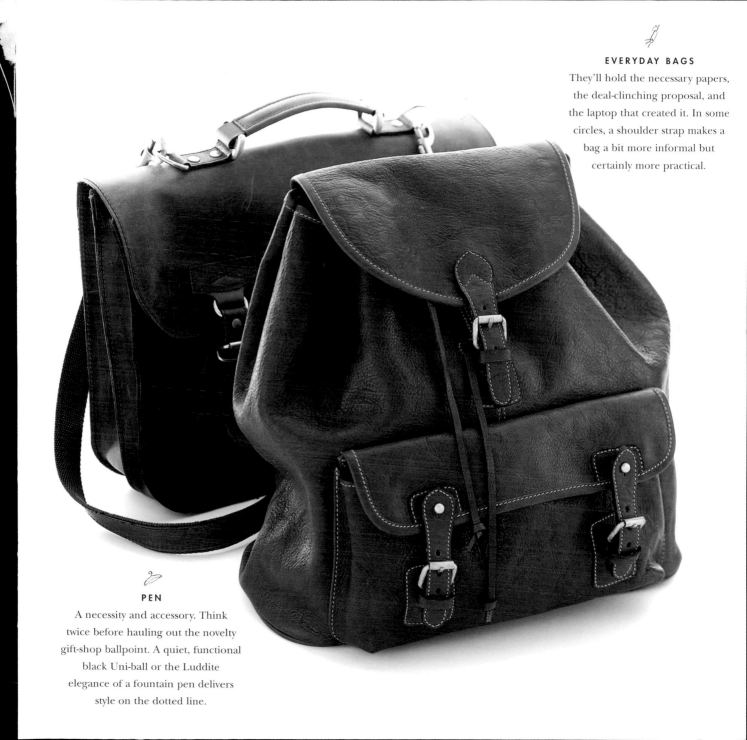

They'll hold the necessary papers,
the deal-clinching proposal, and
the laptop that created it. In some
circles, a shoulder strap makes a
bag a bit more informal but
certainly more practical.

PEN
A necessity and accessory. Think
twice before hauling out the novelty
gift-shop ballpoint. A quiet, functional
black Uni-ball or the Luddite
elegance of a fountain pen delivers
style on the dotted line.

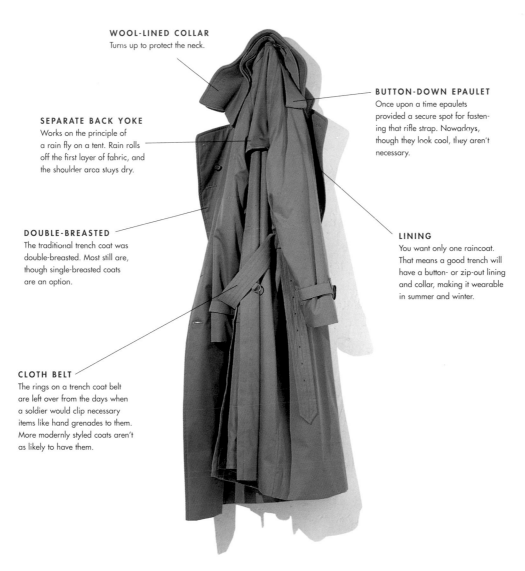

WOOL-LINED COLLAR
Turns up to protect the neck.

SEPARATE BACK YOKE
Works on the principle of
a rain fly on a tent. Rain rolls
off the first layer of fabric, and
the shoulder area stays dry.

DOUBLE-BREASTED
The traditional trench coat was
double-breasted. Most still are,
though single-breasted coats
are an option.

CLOTH BELT
The rings on a trench coat belt
are left over from the days when
a soldier would clip necessary
items like hand grenades to them.
More modernly styled coats aren't
as likely to have them.

BUTTON-DOWN EPAULET
Once upon a time epaulets
provided a secure spot for fasten-
ing that rifle strap. Nowadays,
though they look cool, they aren't
necessary.

LINING
You want only one raincoat.
That means a good trench will
have a button- or zip-out lining
and collar, making it wearable
in summer and winter.

Trench Coat. Strikes you as a bit of the old work wardrobe, doesn't it? The thing is, these coats were originally worn in the trenches in the First World War, which makes them rugged (hence good for a casual wardrobe). It also means they're proven. Trench coats still exist nearly a century after their introduction because they work. They keep you dry. And look good while they're doing it.

Leather Car Coat. A casual cut in luxe material makes this short coat a sophisticated, all-purpose topper, as correct with jeans and a sweater as it is with a gray flannel power suit.

Barn Coat. A livestock-tending pedigree and the corduroy cuffs and collar of the canvas coat prove its rugged pastoral heritage. Best worn with the more casual clothes in your wardrobe.

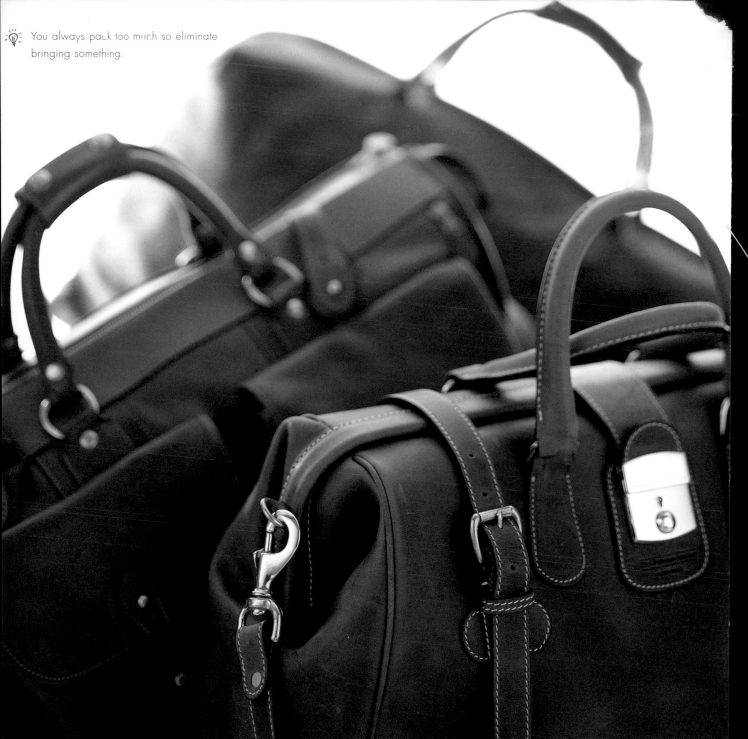

You always pack too much so eliminate bringing something.

BAGGAGE

LONG GONE ARE THE DAYS WHEN CAPTAINS OF INDUSTRY TRAVELED LIKE ROYALTY ON TOUR, WITH retainers to pack clothes, carry steamer trunks, and iron at the destination. Today it's one man or one woman on his or her own. And that's why packing for a business trip should be a natural extension of your whole philosophy of dress. You want only pieces that will serve you in all situations, pieces that all coordinate with each other, pieces that don't wrinkle and do wear well. One suit that wears four different ways: with a tie, with a sweater, the coat with khakis, the trousers with a blazer. Nothing should be optional in that suitcase—because the weight of the bag isn't an option.

PACKING. For most business trips, the multisuit garment or rolling overhead bag is ideal. Suits and trousers on hangers, shirts folded—it'll hold all you need, and you won't have to check it. If you use a hard case, you'll have to fold your suit jackets (see below). Pack two shirts per day. Take care to match all your shirts, sweaters, and ties to all the jackets or suits you're bringing—you don't want to worry about whether you coordinate when you should be worrying about whether you can coordinate that acquisition. Keeping all your clothes in the bags they returned in from the dry cleaners minimizes wrinkles. Extra shoes in bags, too, please—you don't want to soil a suit with schmutz. Toilet kit goes in your carry-on, and in plastic—you don't want toothpaste on a tie, and a broken cologne bottle could break a deal if you show up smelling like the main floor at Saks.

1. Holding the jacket facing you, place your hands inside the shoulders.

2. Turn the left shoulder (but not the sleeve) inside out.

3. Place the right shoulder inside the left shoulder. The lining is now facing out and the sleeves are inside the fold.

4. Fold the jacket in half, put it inside a plastic bag, and place it in your bag.

[🧳 ON THE ROAD—*page 154*]

SURVIVAL GEAR

IN THE FILM *HEAT*, NEIL, ROBERT DE NIRO'S

BAD-GUY CHARACTER, BUILDS HIS ENTIRE LIFE AROUND

ONE SIMPLE RULE: IF YOU SEE THE HEAT COMING AROUND THE

corner, you have to be ready to walk away without looking back. No attachments allowed. Of

course, he has his own reasons for espousing Buddha's central tenet, which we won't get into.

But the rule applies to clothes, too (and, for the record, Neil dressed pretty well). If you've pared

your wardrobe down to its foundation, to a small set of versatile, well-constructed articles that

play off each other and work by themselves, you could shake the heat, too. The everyday heat of having too much stuff and paying too much money for, and mind to, it. Here's all you technically need to look good in a multipurpose, multiclimatic world—and it should all fit into one bag. You'll just have to do the laundry every couple of days.

INSTANT WORK, INSTANT DRESS

Here's a pretty safe recipe for looking appropriate in most work climates. Even if your office has adopted a casual, no-tie dress code, it's a good idea to have these items somewhere on hand in the event of a spur-of-the-moment meeting, or in case someone unexpectedly gives you tickets to the opera, theater, or the Second Coming of Elvis.

- [] navy-blue "soft" suit in a year-round fabric, like high-performance wool
- [] sport coat: black or navy for starters, tweed next
- [] white cotton shirt with point collar (easier to dress up for last-minute appointments than a button-down collar)
- [] black knit tie
- [] black leather belt
- [] dark, neutral-colored wool or cotton socks
- [] black shoes: oxfords with rubber soles (leather for more formality)
- [] watch of choice

INSTANT CASUAL

These are the foundations that you can build your kingdom on. Easy to care for (just don't put the sweater into the dryer), easy to wear, easy to fit into a casual workplace or into your everyday life.

- [] denim or chambray shirt
- [] fine merino wool or Sea Island cotton polo shirt
- [] turtleneck (black) or mock turtleneck
- [] solid-color crewneck sweater
- [] vest
- [] khaki pants
- [] gray or black trousers
- [] dark-blue denim jeans
- [] brown leather belt
- [] dark, neutral-colored wool or cotton socks
- [] brown or black leather loafers
- [] watch of choice
- [] satchel or backpack in leather, nylon, or canvas
- [] trench coat, parka, or field jacket
- [] rugged boots for inclement weather

. . . AND INSTANT TROUBLE

Sadly, for every little thing that we do right, there's an infinite world of things to do wrong. Such is life. Here's a brief but gentle list of clothing issues that are best to avoid in the office.

- [] clothing that doesn't fit well or is poorly tailored
- [] wrinkled clothing, unless you're wearing linen—even then, easy does it
- [] ripped or frayed clothing (suede elbow patches are acceptable on sweaters and sport coats)
- [] clothing that's too tight or too loose; this is for your comfort as well as for the comfort of others
- [] pilling, especially in sweaters
- [] shirts, jackets, or vests with missing buttons
- [] scuffed, unpolished shoes
- [] stained shirts and ties
- [] sneakers, open-toe sandals, and work boots
- [] going sockless
- [] gym, athletic, and sweat clothes
- [] faded, overly lived-in jeans
- [] shorts
- [] T-shirts with any kind of message or image on them
- [] leather clothes, unless it's a vest or outerwear
- [] excessive jewelry—best to keep it narrowed down to watch, cuff links, wedding ring, and class ring
- [] exposing your chest, unless you work lounge gigs in Vegas
- [] wearing a traditional suit and tie if your office policy is a casual one, unless you have a meeting with a firm that dresses that way

ENVIRONMENTAL ADAPTATION: FEMALE

"In place of ruthless self-assertion it [the practice of that which is ethically best] demands self-restraint; in place of thrusting aside, or treading down, all competitors, it requires that the individual shall not merely respect, but shall help his fellows; its influence is directed, not so much to the survival of the fittest, as to the fitting of as many as possible to survive."

T. H. HUXLEY, *The Struggle for Existence in Human Society* (1888)

". . . A woman is asked out as much for her clothes as for herself. The clothes are the background, the frame, if you like: they don't make success, but they are a part of it. Who wants a dingy woman? We are expected to be pretty and well-dressed till we drop—and if we can't keep it up alone, we have to go into partnership."

EDITH WHARTON, *The House of Mirth*

1905

EQUAL BUT SEPARATE

From a nun's all-concealing habit to Lady Godiva's all-revealing non-habit, a woman's clothes (or lack thereof) have always sent powerful social and political messages. In fact, in less gender-equal ages, her mode of dress was oftentimes the only manner of expression she had. And while the new millennium might find more women in positions of power, the power of their clothes to speak for them hasn't really diminished. And the messages women send in a corporate-casual world are more subject to misinterpretation than ever. The rule to remember when playing it casual is to still dress professionally.

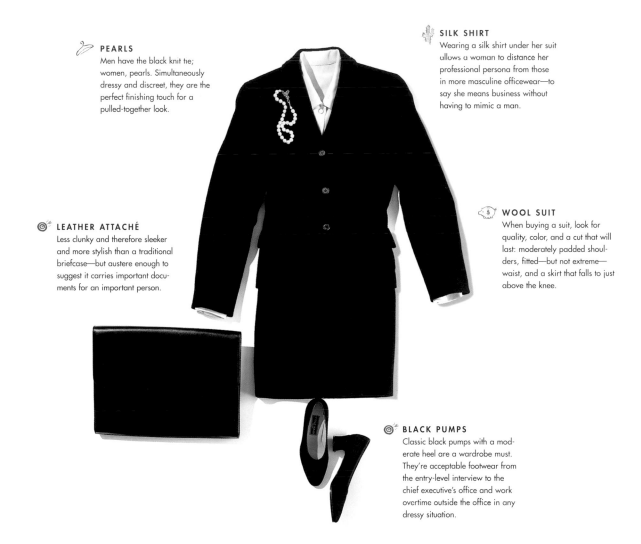

PEARLS
Men have the black knit tie; women, pearls. Simultaneously dressy and discreet, they are the perfect finishing touch for a pulled-together look.

SILK SHIRT
Wearing a silk shirt under her suit allows a woman to distance her professional persona from those in more masculine officewear—to say she means business without having to mimic a man.

LEATHER ATTACHÉ
Less clunky and therefore sleeker and more stylish than a traditional briefcase—but austere enough to suggest it carries important documents for an important person.

WOOL SUIT
When buying a suit, look for quality, color, and a cut that will last: moderately padded shoulders, fitted—but not extreme—waist, and a skirt that falls to just above the knee.

BLACK PUMPS
Classic black pumps with a moderate heel are a wardrobe must. They're acceptable footwear from the entry-level interview to the chief executive's office and work overtime outside the office in any dressy situation.

Traditional. Unlike when women first entered the work force, the best traditional business suits nowadays lend necessary authority without the unflattering dowdiness of the old frumpy knee-length skirt. Some even come with trousers. This suit has softer shoulders and a fitted jacket that falls short of where a man's would. And it's worn with a silk shirt, not cotton broadcloth. What does it say? Running the show, without running away from femininity.

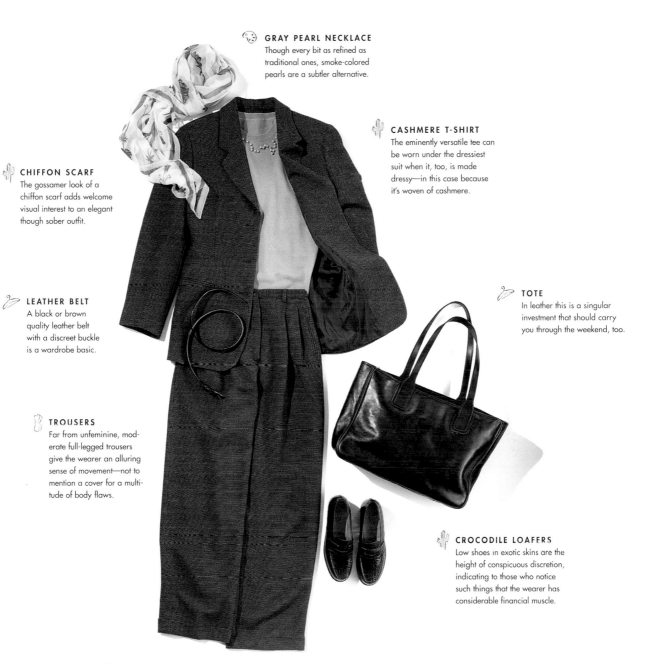

GRAY PEARL NECKLACE
Though every bit as refined as traditional ones, smoke-colored pearls are a subtler alternative.

CASHMERE T-SHIRT
The eminently versatile tee can be worn under the dressiest suit when it, too, is made dressy—in this case because it's woven of cashmere.

CHIFFON SCARF
The gossamer look of a chiffon scarf adds welcome visual interest to an elegant though sober outfit.

LEATHER BELT
A black or brown quality leather belt with a discreet buckle is a wardrobe basic.

TOTE
In leather this is a singular investment that should carry you through the weekend, too.

TROUSERS
Far from unfeminine, moderate full-legged trousers give the wearer an alluring sense of movement—not to mention a cover for a multitude of body flaws.

CROCODILE LOAFERS
Low shoes in exotic skins are the height of conspicuous discretion, indicating to those who notice such things that the wearer has considerable financial muscle.

A neutral-colored suit with a matching skirt and pant is a primary investment.

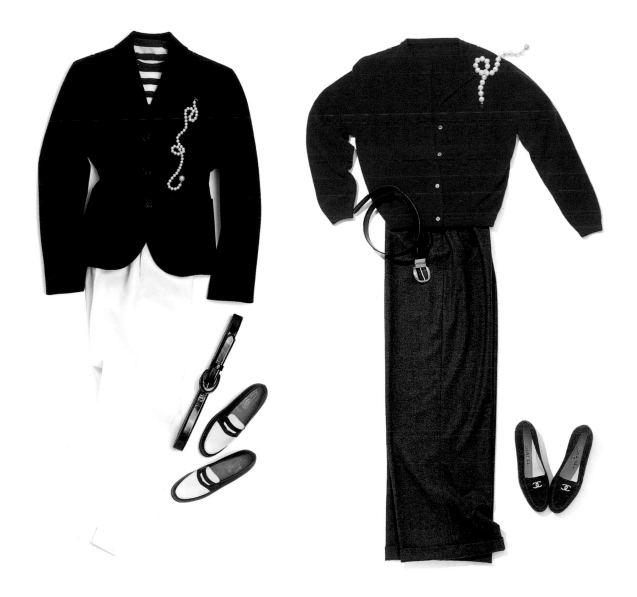

P A N T S

IN ALL BUT THE MOST CONSERVATIVE ORGANIZA-
TIONS THESE DAYS, PANTS ARE ACCEPTABLE. OF COURSE,
IT WASN'T ALWAYS SO. IN THE EARLY DECADES OF THIS CENTURY,
good citizens were driven nearly to apoplexy when avant-garde women started wearing pants about town. Today, appropriate office bottoms can be wide-legged and feminine, straight and formal-looking, cigarette-slim and modern. The correct pants should make a woman appear as Maggie Thatcher did in her old-fashioned skirt suits: competent and professional at her job. And that, despite what some might see as gender-bending dress, is only fitting—after all, if Prince Charles will one day rule the Commonwealth in a plaid skirt and knee socks . . .

 PANT SUIT. Pant suits are now an acceptable alternative to the skirted suit and certainly more appropriate for casual workdays. In fact, their liberating comfortable bottom half has made them almost mandatory in progressive arenas. And far from looking mannish, wide trousers lend the suit a feminine but commanding look that recalls Lauren Bacall or Katharine Hepburn. And no matter how commanding you might be, couldn't you use a little more of that?

"Would you be shocked if I put on something more comfortable?"

JEAN HARLOW, to Ben Lyon in *Hell's Angels* (1930)

BLAZER

With dark buttons, a woman's double-breasted blazer trades the yacht captain look for one long on chic that can be worn correctly with almost anything—even a nautically inspired striped shirt.

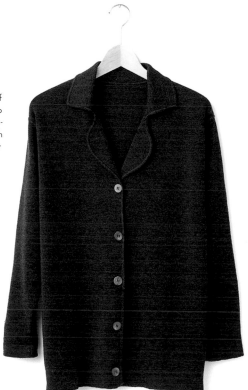

(faQ) **WHAT KIND OF BLAZER
SHOULD I GET?**
If you're going to own only one,
make it a classic. You want it to be of
a cut and fabric that will allow you to
wear it anywhere, any time. A season-
less wool in a single-breasted cut with
dark buttons would be a good starter
choice.

UNSTRUCTURED BLAZER
Like all tailored clothing, even
some blazers have had their starch
removed. This knit is as much
cardigan as sport coat, and sends
a softer, more relaxed message
than its structured counterpart.

B L A Z E R

A black or navy blazer is so nec-
essary to business life, they
should hand one out when you
get your M.B.A. And that's more
true than ever in the casual cor-
porate office place. As with men,
a blazer adds instant respectabil-
ity to any outfit, from gray flan-
nel skirt and crisp blouse to
jeans and a tee. What's that? You
never got your M.B.A.? Doesn't
matter. Degrees aren't worth as
much as ideas anymore, and
when you're wearing a blazer
with all the proper professional
accessories people will get the
idea that you're the 100-percent
master of any kind of business.

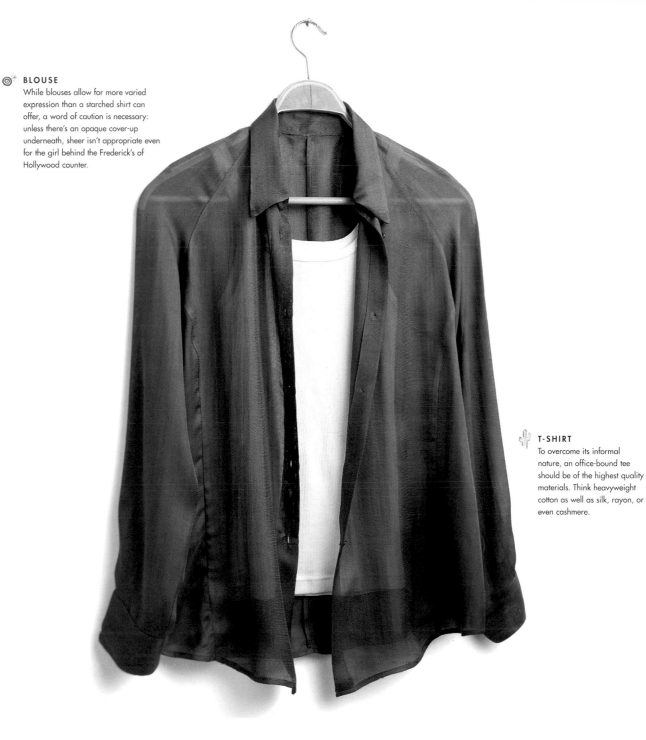

BLOUSE

While blouses allow for more varied expression than a starched shirt can offer, a word of caution is necessary: unless there's an opaque cover-up underneath, sheer isn't appropriate even for the girl behind the Frederick's of Hollywood counter.

T-SHIRT

To overcome its informal nature, an office-bound tee should be of the highest quality materials. Think heavyweight cotton as well as silk, rayon, or even cashmere.

UPPER MANAGEMENT

RECALL, IF YOU WILL, THE DAYS WHEN A WOMAN WOULD WEAR ONLY A SOFT SHIRT WITH MATCHING BOW TIE UNDER THE NAVY-BLUE SKIRT SUIT IN WHICH SHE WENT TO

work. Makes you shudder, doesn't it? Thankfully, you've come a long way, ba—er, boss, and having made the strides you have in the last couple of decades, you've got more sophisticated clothing options. Blouses, shirts, and other tops can provide those. Such chemises are the transformers of a wardrobe, dressing up sport coats, dressing down suits, or looking quite nicely modern on their own.

TWIN SET

With a knee-length skirt and pearls, sweater sets conjure up images of Doris Day propriety. With a pair of slacks, the knit duo conspires to create a look that's a bit more professional—somewhere between the informality of a sweater worn solo and the gravity of a blazer.

Any morning might bring a choice between silk shirts, fine cotton blouses, simple tees, turtlenecks, crewnecks, and sweater sets, or just about any other kind of torso cover you can think of. It's almost overwhelming, which is why you've got to practice the philosophy you use when making all wardrobe decisions: If you keep it simple and keep it quality, it will keep you well dressed.

Fabrications. It's all in the mix, the message you send. Wardrobe pieces in tried-and-true suit fabrics can transmit very different signals depending on how they're put together. Paired with a discreet sweater set, flannel trousers have the look of relaxed authority. Cut into a wrap skirt and worn with a leather vest, a chalk stripe can come across as a bit more iconoclastic. In both cases, the essence of these outfits is competent and seasoned—yet they never lose that all-important sense of spirit.

> "Owning too many [clothes] confuses me and I find I end up wearing the same wisely chosen outfits over and over again."
>
> ELSA KLENSCH

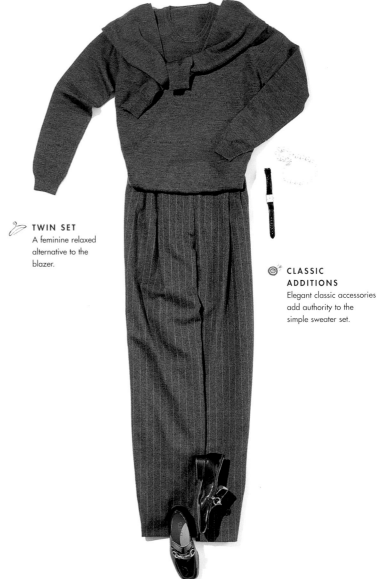

TWIN SET
A feminine relaxed alternative to the blazer.

CLASSIC ADDITIONS
Elegant classic accessories add authority to the simple sweater set.

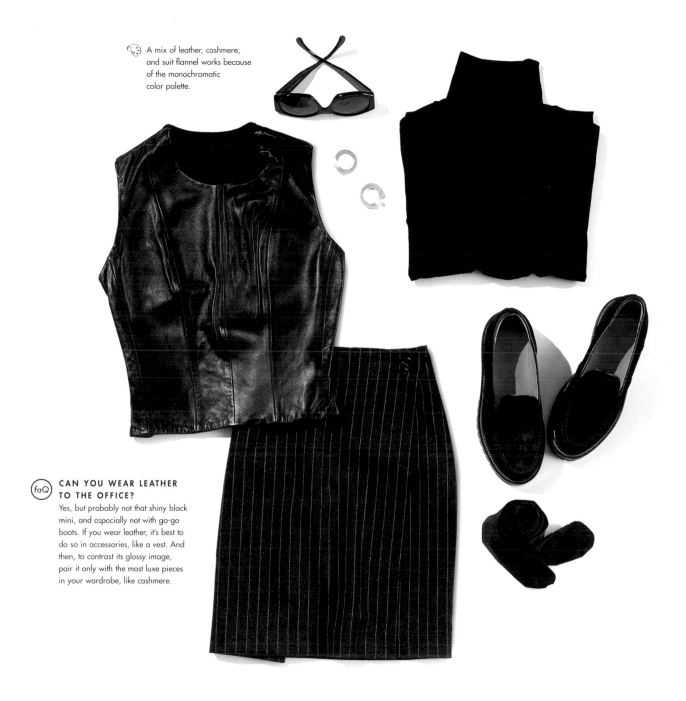

A mix of leather, cashmere, and suit flannel works because of the monochromatic color palette.

(faQ) **CAN YOU WEAR LEATHER TO THE OFFICE?**

Yes, but probably not that shiny black mini, and especially not with go-go boots. If you wear leather, it's best to do so in accessories, like a vest. And then, to contrast its glossy image, pair it only with the most luxe pieces in your wardrobe, like cashmere.

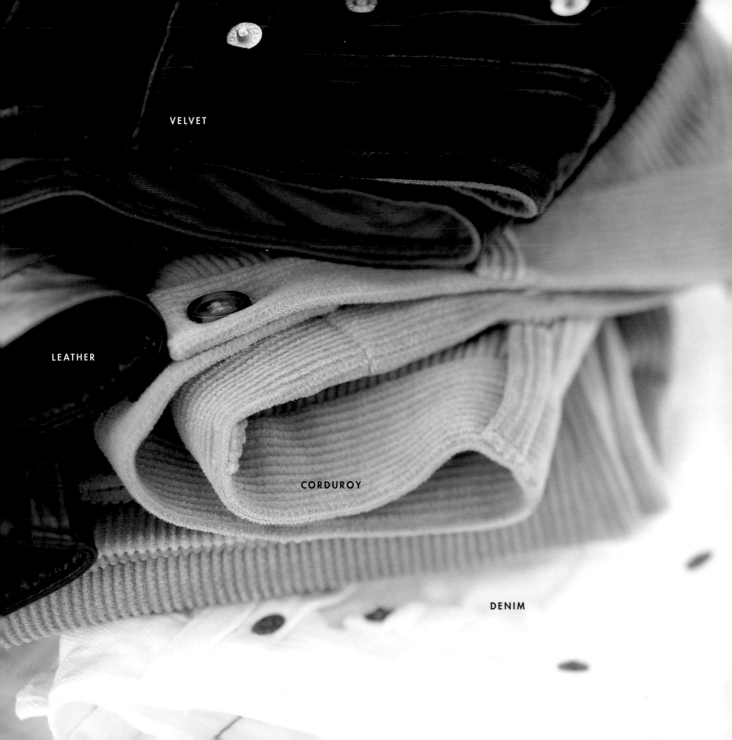

VELVET

LEATHER

CORDUROY

DENIM

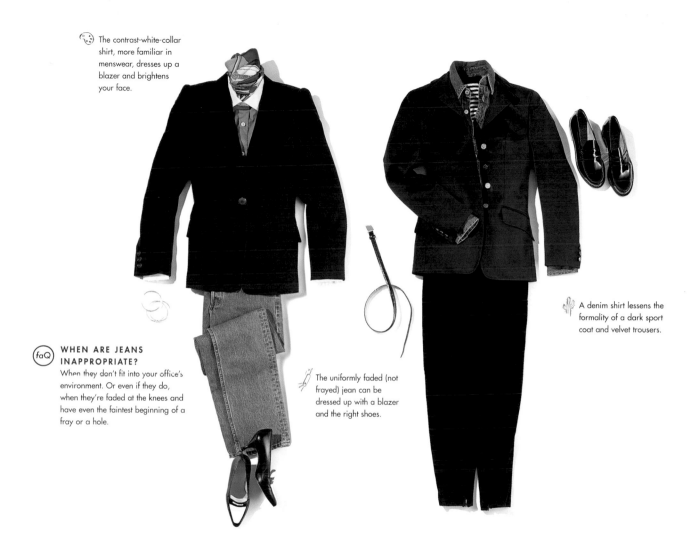

The contrast-white-collar shirt, more familiar in menswear, dresses up a blazer and brightens your face.

WHEN ARE JEANS INAPPROPRIATE?
When they don't fit into your office's environment. Or even if they do, when they're faded at the knees and have even the faintest beginning of a fray or a hole.

The uniformly faded (not frayed) jean can be dressed up with a blazer and the right shoes.

A denim shirt lessens the formality of a dark sport coat and velvet trousers.

Jean Cut. As we all know, jeans needn't only be blue. They don't even have to be denim. Jeans are jeans because of the cut—straight legs and five pockets. It's color and fabric that determines how, and if, you can wear them at the office. White denim? Spring sporty. Black leather? Fits a creative climate where irreverence is a job requirement. Velvet? With a tweed blazer, it's dressed-up casual. Corduroy? With a navy blazer, you're the height of preppy propriety.

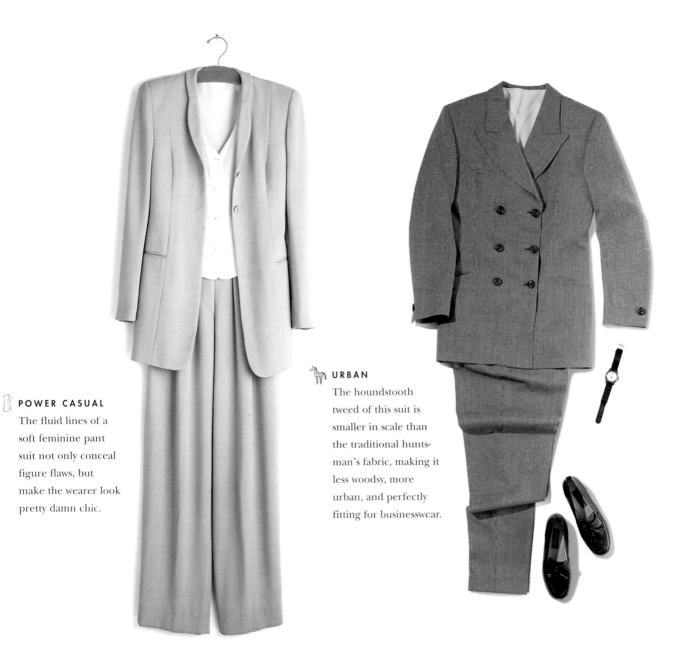

POWER CASUAL

The fluid lines of a
soft feminine pant
suit not only conceal
figure flaws, but
make the wearer look
pretty damn chic.

URBAN

The houndstooth
tweed of this suit is
smaller in scale than
the traditional hunts-
man's fabric, making it
less woodsy, more
urban, and perfectly
fitting for businesswear.

Accessories are the key to dressing an outfit up or down.

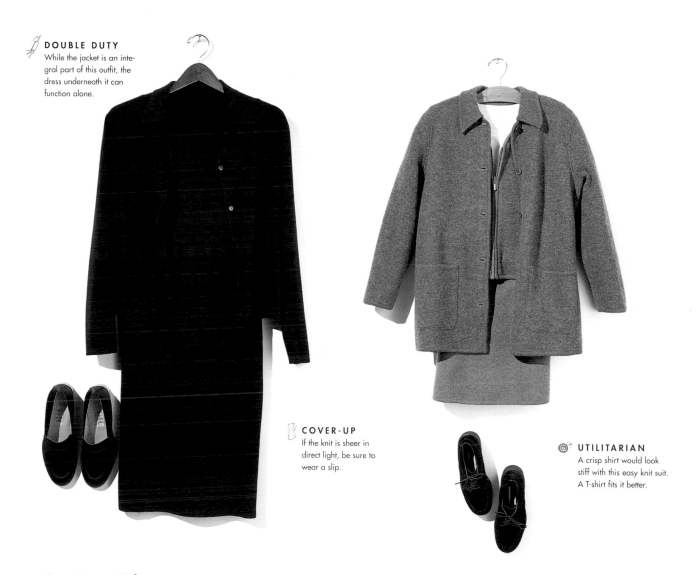

DOUBLE DUTY
While the jacket is an integral part of this outfit, the dress underneath it can function alone.

COVER-UP
If the knit is sheer in direct light, be sure to wear a slip.

UTILITARIAN
A crisp shirt would look stiff with this easy knit suit. A T-shirt fits it better.

Cutting Edge. These knit outfits, with their easy, unconstructed cuts, break more than a few typical wardrobe precepts, but they work because they obey the cardinal rule of simplicity: simple cut, simple color. Both have the added bonus of comfort because of the easy drape of their knit construction—a plus when you're into hour ten at the office. And finally, there's adaptability. These outfits can be deconstructed in more ways than an AT&T division.

[ON THE ROAD—*page 154*]

DETAILS

MOST DISCUSSIONS OF SCARVES SEEM TO BEGIN WITH THEIR VERSATILITY. THIS ONE WON'T. SURE, THEY MAY BE THE CLOTHING EQUIVALENT OF BALLOON ART (THE RIGHT

twist here, fold there, bit of a knot there, and one long balloon can give you ten different animals), but the office is no place for a blue air-filled giraffe, or a skimpy batik-print sarong. A scarf at work needs to be worn as a man would wear his tie: simply, as an accent. Of course, outside the office, a smart woman will make every use she can of the right scarf, from the aforemen-

HEAD QUARTERS
Casual hair accessories such as barrettes and hairbands can be a bit less refined than your usual business bauble, but don't overdo. The key, as with your jewelry and makeup, is to keep the trinkets to a minimum.

tioned sarong to shawl and sash. Think of turning a handkerchief into a pocket square. Or wearing a silk-print square at the neck, ascotlike. Or rolling an Hermès number and sliding it through the belt loops of your jeans with a navy blazer. The idea is to add to the outfit, not overwhelm it—or the folks you work with. Unless you don't mind being known as the sales-staff Salome.

SCARF WARDROBE
LARGE SQUARE (48-inch-plus) shawl, pareo, sarong, or halter. **SMALL SQUARE** (16- x 18-inch) pocket square or handkerchief. **OBLONG** (14- x 54-inch) cravat, muffler, sash, stole, or turban. **CLASSIC SQUARE** (36-inch) kerchief or neckerchief.

TRAVEL TIPS. A shawl is the most versatile scarf for traveling, great for chilly airplanes. Knot a scarf and use it as an evening bag.

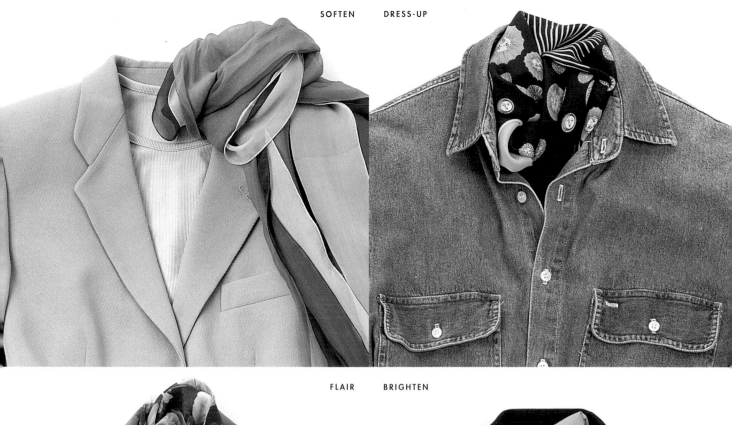

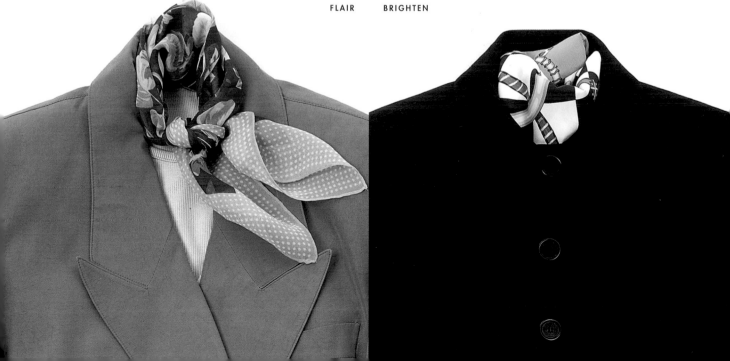

MIDDLE MANAGEMENT

In traditional business attire, women, like men, should have those simple leather belts that go with anything in their closets, from suit to shorts. In corporate casual attire, though, you've got room around the waist for a bit more expression. Suedes, skins, and some variety in color are more acceptable, and so is a more ornate buckle. In fact,

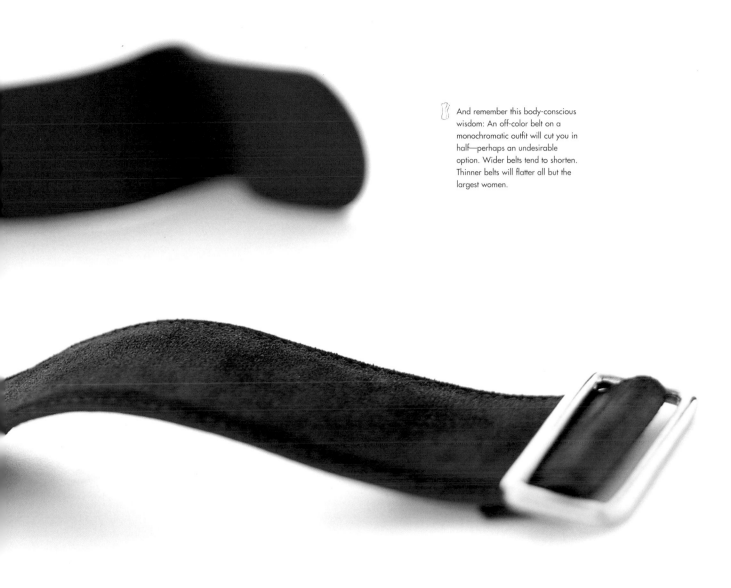

And remember this body-conscious wisdom: An off-color belt on a monochromatic outfit will cut you in half—perhaps an undesirable option. Wider belts tend to shorten. Thinner belts will flatter all but the largest women.

an unusual—though always tasteful—buckle can even function as a sort of jewelry. Whatever waist wrapper you choose to gird yourself with, apply the same criteria in purchasing it as you would to any important article in your wardrobe: you want something that's well made of only the best materials, and it has to have that all-important versatility.

UPS AND DOWNS

TO BARE OR NOT TO BARE? THAT IS THE QUESTION THAT PLAGUES SO MANY OTHERWISE DECISIVE WORKING WOMEN. THE PROBLEM IS THAT WHILE IT'S S.O.P. NEVER TO SHOW

your hand when it comes to commercial intercourse, there's no such rule regarding legs. Worse, the prevailing fashion goes up and down like Third World stocks. How do you decide what length skirt is appropriate? Let the personality of your office, the folks you do commerce with, and the physical properties of your own kneecaps be your guide. The idea is to be noticed more for what you

faQ

DO YOU HAVE TO WEAR STOCKINGS?
When in doubt, wear them. Unless your office policy is extremely casual and allows for bare legs on hot summer days. Avoid fishnets, seams, shimmery stockings, and bright colors.

accomplish than for what you reveal. Get dressed. Look in the mirror. Be a stern judge. And no matter how lovely your legs might be, keep it reasonable. In other words, go a good few inches longer than the minis favored by the girls in fashion glossies. You don't ever want to be walking to work and hear some punk howl, "Yeeooow!" Then again, you don't want him to mutter "Yeesh," either.

LONG. A silhouette that falls well below the knee can offer just as much freewheeling freedom as its shorter sisters if it's cut full and loose. In fact, a long skirt can be even more informal than a short one when it's worn sportily. **IF SHORT.** On the other hand, if you choose to wear a number that ends well above the knee, pick a traditional fabric and accessories to avoid attracting the kind of attention a black Lycra mini over bare legs would. A blazer will keep such a leg-revealing look dignified, and opaque tights worn with flat shoes will add some more conservatism. Because, let's face it, how short do you want to sell yourself?

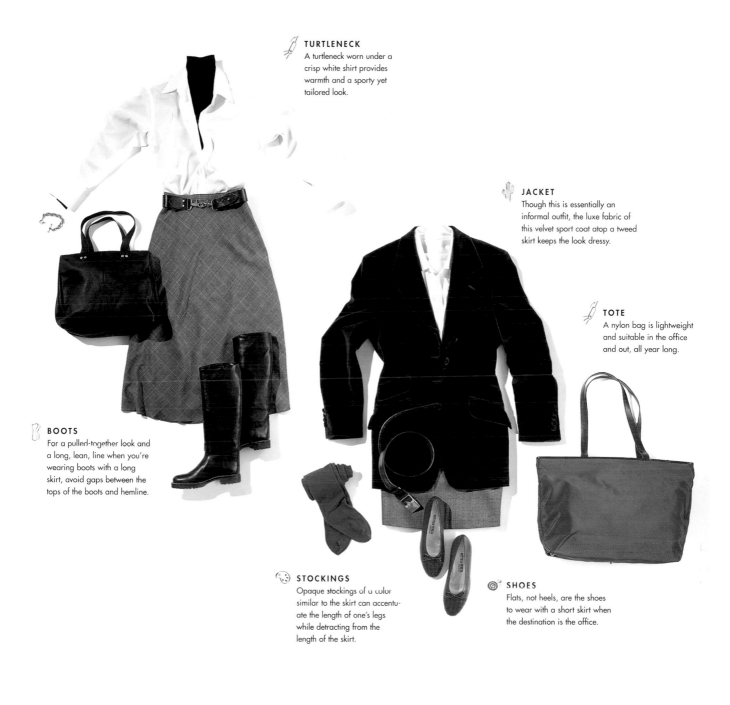

TURTLENECK
A turtleneck worn under a crisp white shirt provides warmth and a sporty yet tailored look.

JACKET
Though this is essentially an informal outfit, the luxe fabric of this velvet sport coat atop a tweed skirt keeps the look dressy.

TOTE
A nylon bag is lightweight and suitable in the office and out, all year long.

BOOTS
For a pulled-together look and a long, lean, line when you're wearing boots with a long skirt, avoid gaps between the tops of the boots and hemline.

STOCKINGS
Opaque stockings of a color similar to the skirt can accentuate the length of one's legs while detracting from the length of the skirt.

SHOES
Flats, not heels, are the shoes to wear with a short skirt when the destination is the office.

ONE PIECE

ONCE UPON A TIME, MEN OF INDUSTRY WORE GOLD BROCADE COATS, SILK BREECHES, AND KNEE-HIGH STOCKINGS, AND NO ONE WONDERED, YOU KNOW, IF THOMAS Jefferson couldn't run the plantation at Monticello. Yet women's clothes have often marked them as unsuitable for positions of power. Just think of how those shirtwaist dresses kept women in the typing pool from rising to the president's office in the fifties. Fortunately, today's corporate ladders can be ascended in a dress and heels. In fact, far from stealing authority, the well-chosen dress speaks of self-assured style. The right cut and color sends the message that you're someone who knows she doesn't have to wear one of those boxy old skirt suits to call the shots. A long, lightweight dress in silk or rayon is just one conveyor of that message—and it provides unparalleled comfort at the same time. Just jot yourself a memo: never wear anything to the office that's too low cut, sheer, or curve-clinging.

JEWELRY. "She had rings on her fingers and bells on her shoes…." If you hear your coworkers humming that tune when you walk by, you can bet you're wearing too much jewelry. Casual days are all about dejunking, not loading yourself down. Sure, you can broaden your range, wear pieces that are a bit more rustic, slip on that heirloom necklace. But remember, as with your most precious piece, the idea is to highlight one's natural gifts, not overwhelm them.

> "I get the feeling that American women dress for their jobs. French women, however, even if they are career women, dress to please men."
>
> **THIERRY MUGLER**

simple cut + accessories = versatility

T-Shirt Dress. For ease, nothing surpasses this piece. As long as it's not sheer or too clingy, it's the perfect attire for summer and early Friday getaways. (And again for Saturday afternoon over your bikini with flip flops.) In the winter, in a lightweight wool or knit, it's a staple that can be paired with a cardigan or blazer and tights. In either case, it's feminine but not frilly.

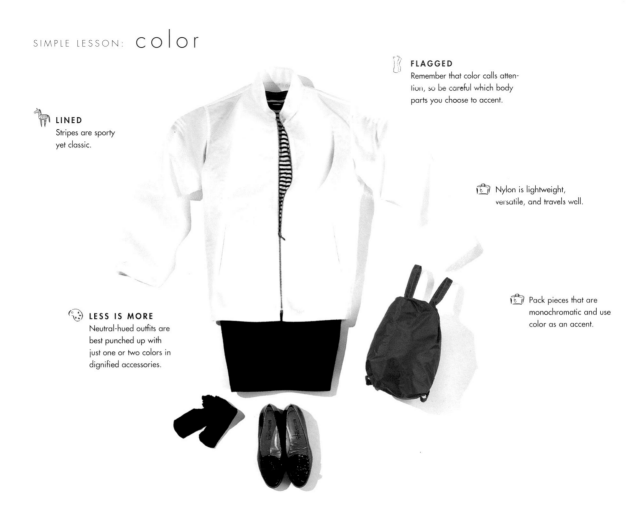

FLAGGED
Remember that color calls attention, so be careful which body parts you choose to accent.

LINED
Stripes are sporty yet classic.

Nylon is lightweight, versatile, and travels well.

LESS IS MORE
Neutral-hued outfits are best punched up with just one or two colors in dignified accessories.

Pack pieces that are monochromatic and use color as an accent.

Palette. Think of yourself as a business presentation. Would you take seriously—no matter how sober its contents—a report with a calico cover, paisley pie charts, and a rainbow assortment of bar graphs all printed on polychromatic construction paper? Yes, well, the same goes for you. When used properly and judiciously, color can be a powerful tool that highlights, emphasizes, and makes its point. Use it indiscriminately and you'll look like you're wearing the comics.

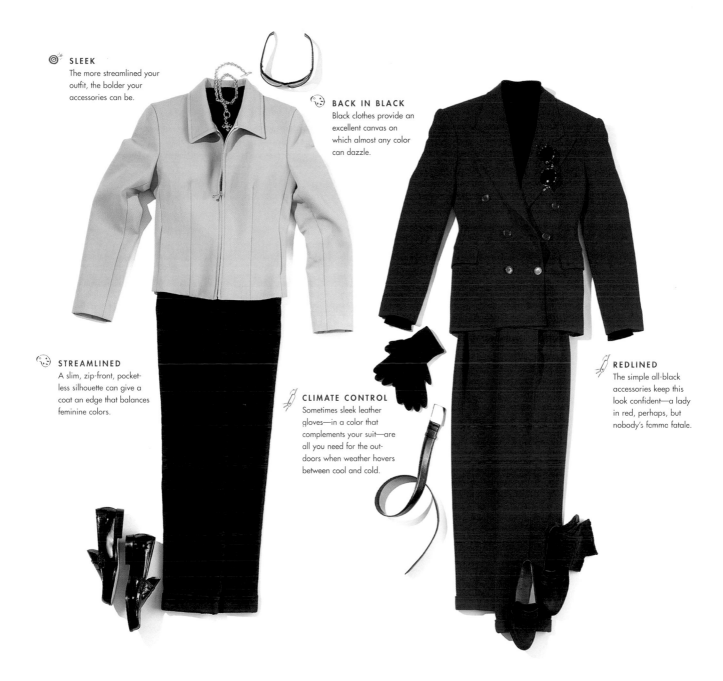

SLEEK
The more streamlined your outfit, the bolder your accessories can be.

BACK IN BLACK
Black clothes provide an excellent canvas on which almost any color can dazzle.

STREAMLINED
A slim, zip-front, pocketless silhouette can give a coat an edge that balances feminine colors.

CLIMATE CONTROL
Sometimes sleek leather gloves—in a color that complements your suit—are all you need for the outdoors when weather hovers between cool and cold.

REDLINED
The simple all-black accessories keep this look confident—a lady in red, perhaps, but nobody's femme fatale.

S H O E S

JUST SAY NO TO HEELS. NOT ALWAYS, OF COURSE, BECAUSE THERE ARE TIMES WHEN they're absolutely necessary—for all the right reasons. But the simple fact of the matter is you can get just as much of a leg up on the competition in flats. And they don't tire your feet, a perk when you've got to think on them. The key to looking professional in casual shoes is mak-

HUSH PUPPIES
"Been there, done that," does not always apply. Case in point: Hush Puppies, the seventies footwear icon, are quintessentially comfortable, cheap, and back in a big way. They come in dozens of designer colors and are the darlings of the celebrity set, covering the dogs of everyone from boy-next-door David Duchovny to David Bowie and his wife, the model Iman.

ing sure they're clean. Making sure they're polished, if they're calf. Making sure they're of the same high quality as your inch-and-a-half interview pumps. You've heard it before, but casual doesn't mean sloppy. And a word on athletic footwear for the office: no. No matter how competitive you are, when you wear a pair of sneakers, the message you send is "I am not a player."

SHOE WARDROBE. **BALLET SLIPPER** Even without a heel, this flat shoe is distinctly feminine. That makes it ideal with a dress or short skirt and tights, though it looks just as right with jeans and leggings, too. **PATENT-LEATHER LOAFER** Take the quintessential casual shoe and make it in the most formal of leathers, and what do you have? Footwear that's adaptable. Wear it with jeans and a sweater set or a tailored pant suit. **SPLIT-TOE OXFORD** Borrowed from menswear, this substantial shoe has an authoritative but comfortable attitude. Think khaki in summertime and gray flannel come winter. **JODHPUR BOOT** In brown suede, it's ideal with tweeds or jeans. In black calf, it's a boot that can be worn under a slim legged pant suit for a sophisticated look with a little attitude.

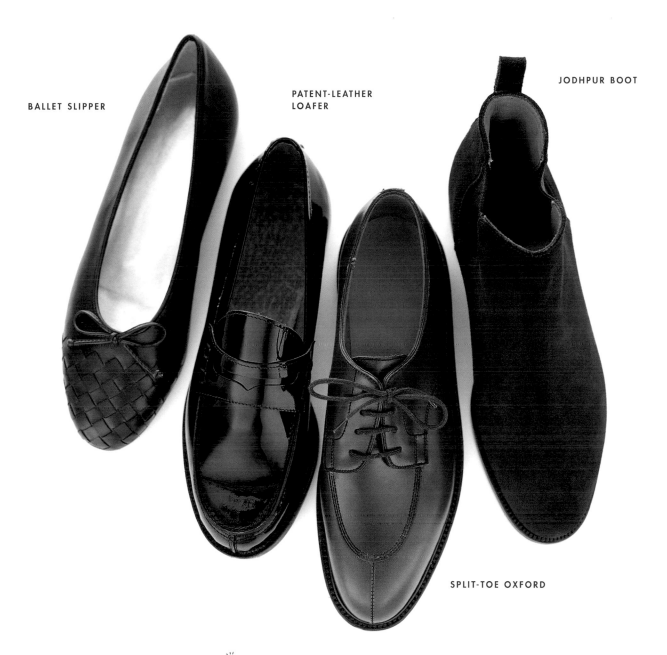

BALLET SLIPPER

PATENT-LEATHER
LOAFER

JODHPUR BOOT

SPLIT-TOE OXFORD

 The better the shoe, the better the look.

SILVER LININGS

IT'S ON THE STREET THAT YOU CAN TELL IF SOMEONE'S WELL DRESSED. CHECK OUT her coat. Is it the one she wore while painting the front porch last fall? While there's room for plenty of stylistic variety when it comes to a casual coat, it should still be just as smart, well made, and clean as the one you'd wear over a formal business suit. Think camel's hair, which is amazingly versatile. Think field jacket in a fine fabric and perhaps an offbeat color. Think brightly colored pea coat or microfiber. For painting the porch, think overalls.

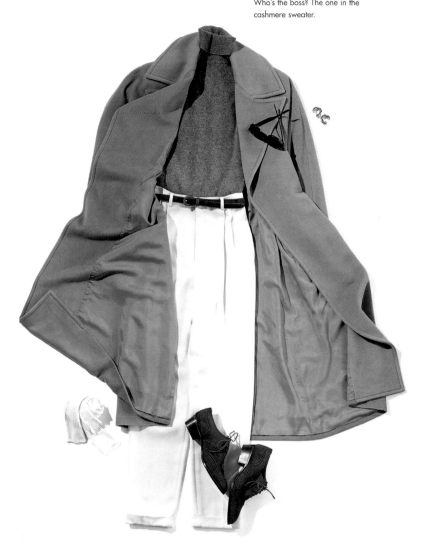

SUPERIOR SOFTNESS
Who's the boss? The one in the cashmere sweater.

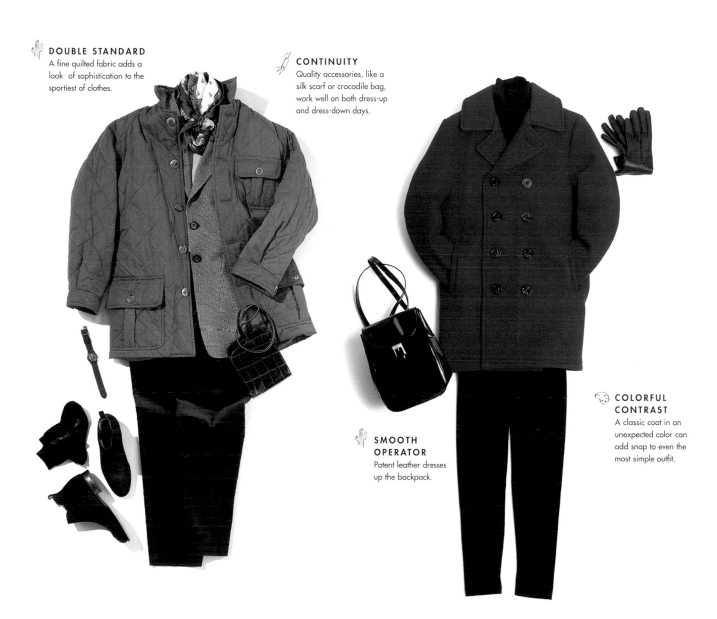

DOUBLE STANDARD
A fine quilted fabric adds a look of sophistication to the sportiest of clothes.

CONTINUITY
Quality accessories, like a silk scarf or crocodile bag, work well on both dress-up and dress-down days.

COLORFUL CONTRAST
A classic coat in an unexpected color can add snap to even the most simple outfit.

SMOOTH OPERATOR
Patent leather dresses up the backpack.

No matter how interesting or stylish a coat is, if it isn't functional, it's foolish at work.

SURVIVAL GEAR

THEM THAT GOTS NEVER SEEM TO KNOW HOW GOOD THEY HAVE IT. TAKE THE LADY KANGAROO, WITH HER PERSONALIZED, MOBILE POUCH. SHE'LL USE IT ONLY TO STASH the kid. Tell the truth—if it were yours, you'd probably squeeze in an entire overnight bag, a bottle of Evian, and a couple of sales reports. Sadly, the pouch isn't yours. But that doesn't mean you can't be as selective with your possessions as the kangaroo is. The following list of essential items will serve as a good starting point.

INSTANT WORK, INSTANT CASUAL

Here's a list of safe items that you could bend to fit any situation.

- [] seasonless suit, in a fabric like wool crepe; should consist of a jacket, pants, and skirt in black, navy, or beige; all other color choices should coordinate with the color of your suit
- [] white shirt
- [] white T-shirt in cotton, silk, or fine wool
- [] turtleneck in a fine wool, silk, or fine cotton
- [] sweater set
- [] black pants
- [] khaki pants
- [] dark-blue denim jeans
- [] black or brown leather or nylon tote bag
- [] black or brown flats
- [] black or brown leather belt
- [] sheer nude stockings, sheer and opaque black stockings
- [] dark nylon, cotton, or wool knee socks
- [] watch of choice
- [] vest for layering
- [] boots for inclement weather
- [] the extras: scarves, jewelry

. . . AND INSTANT TROUBLE

Even in the hippest, most casual office, there will be a lot of fine lines between appropriate work clothes and items best left at home hanging in the closet. Sometimes, protocol means that you need to appear nonthreatening to people who might not be as stylistically adventurous as you are. It's not an issue of sacrificing your individuality—just look neat, and one day you'll be the boss and you'll make the rules yourself. Until then, avoid the following office-clothing no-nos:

- [] clothes that fit poorly or are improperly tailored
- [] clothes that are too tight or too baggy
- [] clothes that are low-cut, sheer, or glittery
- [] skirts and dresses that are very short
- [] skirts and dresses that fall to the ankle
- [] clothes that swish and flutter when you move
- [] gym, athletic, and sweat clothes
- [] shorts
- [] wrinkled clothes, unless you're wearing linen
- [] T-shirts with any kind of message or image on them
- [] wearing hats in the office
- [] holes, frays, pilling
- [] jewelry that makes noise
- [] too much jewelry
- [] too much makeup—or too little makeup, if you look unkempt without any
- [] too much perfume
- [] hair that's too big
- [] hair that's in your face
- [] shiny or glittery stockings, fishnet stockings, and stockings that have a rear seam, are brightly colored or overly patterned
- [] open-toed sandals, sneakers, boat shoes, espadrilles, plastic shoes, clogs, or rugged hiking boots, unless your office policy states otherwise

"Sometime during the two-year curriculum, every MBA student ought to hear it clearly stated that numbers, techniques, and analysis are all side matters. What is central to business is the joy of creating."

PETER ROBINSON, *The Red Herring*

Casual dressing is here to stay. It's not a trend or a one-minute solution. Companies are evolving from once-a-week summer policies to year-round casual days, and some are using an even more relaxed standard of dress all week long. But if your company is more formal, what can you do? Share the facts: Beyond the business and fashion stories, there lies real data supporting the benefits and practicality of the new shift in workplace wear. Since 1992, Levi Strauss & Co. has been researching the change in corporate dress through mailings, in-depth interviews with human resource managers across America, and feedback

top

five

responses

to casual

day

1. Improves morale at my office. **2.** I feel I'm judged more on my job performance than on my appearance when I'm dressed casually at the office. **3.** I feel more camaraderie with my managers and coworkers when we're dressed casually. **4.** I do my best work when I'm casually dressed. **5.** When my boss is dressed casually, I feel he/she is more approachable.

FROM THE 1994 CAMPBELL SURVEY OF U.S. EMPLOYEES
COMMISSIONED BY LEVI STRAUSS & CO.

BENEFITS OF CASUAL DRESS AS CITED BY HUMAN RESOURCE MANAGERS

FROM THE 1992 AND 1995 EVANS RESEARCH SURVEYS, COMMISSIONED BY LEVI STRAUSS & CO.

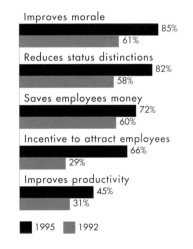

Improves morale 85% 61%
Reduces status distinctions 82% 58%
Saves employees money 72% 60%
Incentive to attract employees 66% 29%
Improves productivity 45% 31%

■ 1995 ■ 1992

"Individuality has become the thing. . . dressing to look like you belong to a company. . . doesn't even enter the consciousness anymore. Clothes are more about having a life."

JUDY MCGRATH, *President of MTV*

from employee target groups. All this creates a picture of real benefits both for the companies and the employees. The graphs tell part of the story, but another key factor is realizing that change in dress is part of a larger call for change in how we do business. On this constantly changing playing field, flexibility, comfort, and creativity are essential. Today, respect stems from your credibility and potential, not from your surface appearance. People want to be more integrated—the same at work and at play—not the person in the gray flannel suit from 9 to 5, and someone else at 5:01. Besides, no one goes home at 5 anymore.

PERCEIVED DEBITS VERSUS ACTUAL CREDITS	
START-UP COST: If you've only got a closetful of pinstripes, yes, there will be an initial investment.	**LONG-TERM SAVINGS:** The replacement clothes are more versatile and cost less to maintain.
COMMUNICATION BREAKDOWN: Concern you won't be taken as seriously in khakis and a crewneck as you would in a suit.	**IMAGE ENHANCEMENT:** Reduces status distinctions and creates more open communication and team work.
MASS MARKET: Sweaters, sport coats, button-downs, loafers, bucks—how do you know what to choose?	**TARGET MARKET:** Great opportunity to make simpler wardrobe decisions and add more versatile pieces that work together.
SECURITY CONCERNS: Wearing a suit is easy, but putting together casual outfits is much more complicated.	**OPEN-DOOR POLICY:** Using basic wardrobe essentials as building blocks allows the same ease as wearing a suit.
UNIFORM DISRUPTION: Everyone in different outfits will create distractions and reduce their professional image.	**THRIVING INDEPENDENCE:** Encourages creativity and teamwork by providing a more comfortable work environment.

"For many of us who work, there exists an exasperating discontinuity between how we see ourselves as persons and how we see ourselves as workers. We need to eliminate that sense of discontinuity and to restore a sense of coherence in our lives."

MAX DEPREE, *Leadership Is an Art*

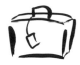

ON THE ROAD

"Lord, I was born a ramblin' man," the Allman Brothers sing. Anyone in business might as well sing it, too. Despite telecommunications, e-mail, video conferencing, faxes, and Net surfing, business travel will always be a fact of life. Road-warrior status emerges as your bags get smaller and you walk by the long lines. A seven-day road show will always be a seven-day road show, but with a little preparation, you won't come home gibbering with the smell of airline peanuts on your breath.

Packing

TRIP PREPARATION. Going on a trip no longer means steamer trunks, porters, and the custom Louis Vuitton china case. Today, more than ever, you need to bring a wide spectrum of life-support items—but you need to fit them into as small a space as possible. The problem is compounded when this spectrum of stuff is scattered by function throughout your abode. Toiletries in the bathroom, electronic supplies and office items in your home desk area, mineral water (or flask) in the kitchen, suitcase in the hall closet. Each trip, then, is an occasion ripe for forgetting to make one last trip into the home office, leaving your computer recharger at home where it will be safe, sound, and useless. **Trip shelf.** Set aside one shelf that has all you need to ensure comfort and efficiency on the

road. Your toilet bag (fully packed); office and stationery items; electronic gear; small bottles of mineral water; your portable CD player and camera; your lucky rabbit's foot. When you get home from a trip, the dirty laundry goes in the hamper and the travel items go back on the shelf. **Bag it.** On this shelf should also be a box of Ziploc heavy-gauge gallon bags—the most versatile weapon in your travel arsenal. Wet bathing suits, smelly running shoes, leaking bottles, loose paraphernalia picked up on the trip—they collect and store it all where you can see it.

HOW TO PACK. The famous tissue-paper method yields the most wrinkle-free results. Place tissue paper or a plastic dry cleaner's bag between each layer of clothes. Garments will slide over each other, not settle and rub. **Packing a jacket.** Empty all pockets. • Turn jacket, but not sleeves, inside

out. • Place right shoulder inside left shoulder, then fold in half and place in plastic bag. **Packing pants.** Empty all pockets. • In a hard suitcase, pants should be packed first, waist band to waist band, with the legs hanging over the case's edge. Continue packing, fold the legs over your other clothes, then add one last layer to hold everything in place. • Interlock your belts and run them along the circumference of the suitcase—never pack them in the belt-loops, or both pants and belt could change shape. **Packing shirts and blouses.** Button all buttons. • Lay shirt face down and fold sleeves back at shoulder seam. • Fold tail up from a point just below the button below your waistline (to avoid a crease along your stomach). **Packing shoes.** Pack shoes in cloth or plastic bags along the edge of your suitcase. • Stuff shoes with under-wear, socks, a coiled belt, or overflow

from your medicine kit. **Packing ties.** Fold the tie in half, then place it on a sheet of tissue paper or plastic. • Roll it up, and secure it loosely with a rubber band. **Packing a duffel.** Tissue paper is especially useful in duffel-packing to evade wrinkles. • Roll up cottons and knits, including underwear, sweaters, T-shirts, and pants, and pack them as bumpers against each other. • Pack shoes at the bottom and hard items, like books or an umbrella, along the edges.

WHILE EN ROUTE. Airplanes, trains, taxis, and hotel lobbies are generally hot and stuffy. Wear lightweight clothes while you're on the road. • This is not the time to break out the linen suit—stick with wrinkle-free, breathable, comfortable. • Be careful taking your shoes off while you're on a long plane trip. Feet will swell in the pressurized cabin, and it might not be as easy putting those shoes back on.

WHY MAKE A PACKING LIST? 1. To simplify and organize the packing process. **2.** To prevent the omission of vital items. **3.** To guard against overpacking. **4.** To help clarify clothing options and combinations. **5.** To assist with claims of lost luggage.

BUSINESS-TRIP CHECKLIST

- [] address and appointment books
- [] airline tickets
- [] briefcase
- [] business cards
- [] calculator
- [] computer, power and modem cords, batteries and accessories
- [] confirmations (hotel, car, etc.)
- [] correspondence
- [] credit cards, money

- [] expense forms
- [] files, notebooks, pad
- [] highlighters, markers, pencils, pens
- [] letters of credit
- [] meeting materials
- [] paper clips, rubber bands, stapler
- [] passport
- [] portfolio and presentation materials
- [] price lists and time records
- [] proposals and samples
- [] reading material
- [] reports
- [] stationery, envelopes, stamps
- [] tape recorder, tapes

BASIC CLOTHES: MEN

- [] belt
- [] black knit tie
- [] black or brown shoes
- [] business suit
- [] dress shirts (two white, three solid colors)
- [] denim or sports shirt
- [] jeans
- [] khaki or corduroy pants
- [] navy blazer
- [] sleepwear
- [] sneakers
- [] socks and underwear
- [] sports clothes
- [] swimsuit
- [] trench coat
- [] vest
- [] watch
- [] white T-shirt

BASIC CLOTHES: WOMEN

- [] belt
- [] black dress
- [] black shoes
- [] leggings
- [] handbag

- [] hosiery and underwear
- [] jeans
- [] jewelry
- [] raincoat
- [] scarf
- [] shorts
- [] sleepwear
- [] sneakers
- [] sports clothes
- [] suit with pants and skirt
- [] sweater
- [] swimsuit and sarong
- [] T-shirt
- [] vest
- [] walking shoes
- [] watch
- [] white shirt

BASIC TRAVEL KIT

- [] adapter kit
- [] aspirin, Band-Aids
- [] baggies for spillables
- [] birth control/condoms
- [] body lotion
- [] cleanser
- [] cotton balls/cotton sticks
- [] deodorant
- [] foot powder
- [] hair care: coloring, comb, dryer, shampoo, conditioner
- [] lip balm
- [] moisturizer
- [] mouthwash
- [] perfume/cologne
- [] razor, blades
- [] sewing kit
- [] soap (in soapbox)
- [] sunscreen
- [] Swiss army knife
- [] tissues
- [] tooth care: brush, toothpaste, dental floss, dentures, case, cleaner
- [] tweezers

Extras for men:
- ☐ Shaving kit: after-shave lotion, shaving cream, styptic pencil

Extras for women:
- ☐ Cosmetics kit: blush, compact, concealer, eye pencil, eye shadow, eyelash curler, eyeliner, foundation, lip liner, lipstick, mascara, nail polish, emery boards, eye cream, eye-makeup remover, makeup remover, nail-polish remover pads, night cream, perfume
- ☐ Hair care: bobby pins, curlers, curling iron, rubber bands, scrunchies, hair spray, shower cap
- ☐ Tampons

TRAVEL TIPS

Pack your small camera, film, personal stereo, or travel alarm clock into shoes for protection. • Always take more socks and underwear than you think you'll need. • Pack more pants than sport coats • Either leave space for return items or pack a collapsible case. • It's hard to tell if a checked shirt is wrinkled. • Khaki pants and black jeans will save you over and over. • The best way to pack less is to buy a smaller suitcase. • You should be able to carry your bag at least half a mile. • A photocopy of your birth certificate can speed the replacement of a lost passport.

MAKING A PACKING CHART

First, map out the days you will be traveling in a vertical column. Then make three adjacent columns, to designate what to wear in the a.m. and p.m. of each day, plus a column for extras.

In the extras column, note the clothing and equipment you will need for special activities like tennis or a formal occasion, and list other basic items like nightwear, underwear, and an umbrella.

In the a.m. column, designate the first day and last day as travel days. Choose clothes that are comfortable and versatile enough to be worn during your trip. Record them in the appropriate slots.

Next, determine the type of clothes you will need for your trip. Try to limit yourself to a neutral color scheme that can be accented with colorful accessories.

Then choose one wardrobe basic, perhaps a suit, that can achieve different looks with accessories. Determine the days and nights it can be worn. Record it in the appropriate slots.

If needed, choose a second wardrobe basic. Try to fill in the remaining slots.

Next, choose accessories: shirts, sweaters, ties or jewelry, scarves or vests that will complement each wardrobe basic and help to create a variety of looks.

At this point, it should be easy to determine if an extra garment is needed to complete your travel-wardrobe needs.

Now look at the chart and decide on shoes—they're bulky and heavy, so choose wisely.

Pack this chart in your bag. It will remind you of your wardrobe scheme and help you recognize the unnecessary and the essential.

DAY	A.M.	P.M.	EXTRAS
MONDAY - *travel day*			
TUESDAY			
WEDNESDAY			
THURSDAY			
FRIDAY			
SATURDAY			
SUNDAY - *travel day*			

ON THE JOB

THE JOB INTERVIEW. You have two objectives here: survive the interview and get the job. • Wear something you don't have to worry about, no wrinkle-prone fabrics. • Beyond that, wear a suit. It's fine to be overdressed at the interview, but serious trouble if you're too casual. You can't show too much respect. • Keep the jewelry subdued. • Avoid excessively high or clunky shoes. Leather is best. • Women: Keep an extra pair of hose in your purse. • Safe suits: charcoal, beige, gray, navy, black. • Safe hair: neat, and out of your face. • Scrutinize yourself in the mirror before you go. How do you look when you sit down? Do you look at ease in your clothes? • Try to fit your style to the place where you're interviewing, but don't wear something you would never normally wear—your discomfort will show. • Don't worry if you look more formal than your interviewer. He or she has a job, and you don't. • Don't assume that one gender is more forgiving of sartorial indiscretions than the other. Both sexes can be brutal. **Traditional fields.** Business, law, medicine, insurance, banking: Tailored, conservative outfits are best. Nothing should distract from your main purpose: to do the job well and efficiently. **Creative fields.** Journalism, publishing, multimedia, advertising, graphics, art galleries: Your own style is more important here. You are being hired for your creative talents, so dress with personal flair. While on the job, journalists in particular should learn to match their wardrobe to their assignments. **Service-oriented jobs.** Retail, restaurants: These jobs are all about looking presentable and well groomed. Try to get a sense of what the company's style is before you go in for your interview.

PUBLIC SPEAKING AND TELEVISION APPEARANCES. Appear at ease. Wear comfortable clothes that you feel look good on you. • Wear safe colors: Neutrals like navy and beige show well on television. Dark colors are always slimming. Black can give definition if there is shape to the garment, or it can be accented with a bright-colored tie, blouse, handkerchief, or scarf. • White is too bright for television. • On-camera, bright red may cause some dissolution in a garment's silhouette, but the color does attract attention and signal self-assurance. Warm, rich colors like blues, magenta, and bronze are attractive and friendly looking. Overly bright colors like taxi yellow and orange will detract from your face and possibly your message. • Patterned fabrics may create a moiré pattern on the television screen. Muted vertical stripes, however, can have the effect of elongating your body, and don't wreak havoc on the screen. • Wear sleeves—bare arms catch the light and distract. • Avoid hats. • Wear glasses with a non-glare coating. • Jewelry should not be too shiny. • Hair looks best off the face. • Television makeup is more dramatic than everyday makeup. The camera adds weight to your face, so use make-up to accentuate your best features and contour your cheeks.

GETTING THE MESSAGE ACROSS. Don't fidget—even small movements are noticeable, especially on television. • Watch your posture. It can affect everything from how your suit looks to the strength of your voice. • Maintain eye contact with the interviewer, not the camera. This adds sparkle to your face. Try to remain calm enough to remember, and respond to, what others are saying. Scripted phrases will sound insincere and robotic. • End your sentences on a solid note, so that they have the air of statements, not questions.

[Experts consulted: Kathleen Ardleigh, Senior Vice President, Ailes Communications, New York, and Dorothy Sarnoff, Chairman, Dorothy Sarnoff Speech Dynamics, New York]

> ## "A woman who acts like a man in the workplace is as silly as a man who acts like a woman in the workplace."
> ROGER AILES

SHOP TALK

CLOTHES

BARREL CUFFS: Shirt cuffs that close with a button.

BELLOWS PLEAT: Deep fold of fabric along an article's sides to allow for more flexibility.

BELLOWS POCKET: Pleated jacket pocket that expands.

BIAS (CUT ON THE BIAS): The diagonal of a woven fabric; cut on the diagonal. When expertly done, the drape is exquisite.

BI-SWING BACK: Sport jacket cut in which extra pieces of fabric are sewn along the sides, often accompanied by a sewn-in belt.

BOX PLEAT: Double pleat used on shirts and jackets.

CARDIGAN: Knitted button-front sweater without collar or lapels.

CLUB TIE: Silk tie with a repeating pattern of small emblems.

CREWNECK: Pullover neck opening without collar.

DART: Small pleat along body of garment to make a cleaner fit.

DOUBLE-BREASTED: Overlapping closure on a jacket or coat.

FRENCH CUFFS: Dressy shirt cuffs that fold over themselves and require cuff links.

INSEAM: Length of leg from bottom of pants to crotch.

KNIT TIE: The most versatile tie, especially in black. Wool is more casual than silk.

PATCH POCKET: A pocket made of a piece of fabric stitched onto the outside of a jacket.

PLACKET: Fabric strip on which shirt buttons are sewn; gives a shirt a clean center line.

SINGLE-NEEDLE STITCHING: Stitching in which a single needle is used to sew one side of the garment at a time. It produces durable seams that fit better against the body than double-needle stitching.

SLASH POCKET: A pocket set into a jacket with either a vertical or diagonal slash.

SPLIT-SHOULDER YOKE: A yoke made of two pieces, which allows for greater range of shoulder movement.

SPREAD COLLAR: More formal shirt collar, spread to allow for the larger Windsor tie knot.

FABRICS

ALPACA: Fleece from animal related to the camel. Soft and shiny, much like mohair; made into jackets and coats.

ANGORA: Soft, warm, delicate fabric made from the hair of Angora rabbits; used in coats and often blended with wool.

BEDFORD CORD: Sturdy wool weave ideally suited for sport suits.

BEMBERG™: A trademark name for a type of treated rayon, usually used in jacket linings, that is stronger than silk and requires less maintenance.

BIRD'S-EYE: Semiformal wool weave characterized by tiny alternating light and dark threads.

CAVALRY TWILL: Medium-weight, closely woven, slightly elastic wool weave suited for sport suits and military uniforms.

CASHMERE: Extremely soft wool fabric from Tibetan, Mongolian, or Iranian goats; worsted cashmere is stronger and purer than carded cashmere.

CAMEL'S-HAIR: Hair usually from the Bactrian camel, either from the coarse outside coat or the soft undercoat. Used in coats and jackets.

CHEVIOT: Heavyweight wool weave characterized by fishbone pattern intersected by bright silk threads.

CORDUROY: The warmest version of cotton. Ridged, velvet-like material used in pants and casual suits.

CREPE: Lightweight, loose-fitting weave with a matte finish. Wool crepe is well suited for year-round wear, as well as travel.

DENIM: Heavy cotton weave originally from Nîmes, France *("de Nîmes")*; found its niche in American jeans.

FLANNEL: Soft twill weave in wool (chalk-striped suits) or cotton (button-down shirts) with a matted texture.

GABARDINE: Tightly woven, high-maintenance wool or cotton weave with diagonal thread lines. Good for spring and summer suits.

GAUZE: Lightweight, elastic cotton in a loose weave. Used for summerwear and curtains.

HIGH-PERFORMANCE WOOL (SUPER 100S): Super-light worsted wool fabric developed in Italy and used in suits.

HOUNDSTOOTH: Wool twill weave with a checkered pattern of four dark threads and four light threads.

IRISH LINEN: Tight-woven linen used in solid-color summer suits; heavier, stiffer, and less easily creased than Italian linen.

LIGHTWEIGHT WORSTED SUITING: A fine wool weave with a silky finish.

LODEN: Heavy twill weave made with coarse wool and sometimes blended with mohair. Water-repellent and especially suited for outdoor use.

MADRAS: Lightweight plaid cotton weave, used in pants, shirts, and jackets.

MELTON: Heavyweight wool weave especially suited for pea coats. Tends to attract dust.

MOHAIR: Shiny, soft hair from the Angora goat, usually used in long-hair sweaters or woven into summer suits.

POPLIN: Lightweight cotton in a tiny horizontal weave; used mostly for summerwear.

SEERSUCKER: Lightweight, striped, cotton-based fabric, often blended with silk or polyester for a rippled effect.

TARTAN: Originally one of thirty-three Scottish Highland plaid-patterned wool weaves; warm, but tends to shed.

TROPICAL: Lightweight, usually wool, weave for summer and the tropics, sometimes blended with mohair.

TWEED: Wool weave for jackets and coats based on any of dozens of local Scottish patterns. Rough-textured and long-lasting (except on the elbows).

TWILL: Characteristically diagonal wool or cotton weave; the classic blue blazer is one famous example. Sometimes blended with silk for summer.

VELVET: Formerly silk, now usually cotton weave prepared with extra threads, which are clipped short.

VICUNA: Soft, rare fabric, much like camel's-hair, woven from the hair of a mammal native to the upper Andes; but bear in mind that vicuna must be trapped for their pelts.

SHOES

ANKLE BOOT: Usually a two-eyelet boot with a leather sole and dressier leather than its chukka counterpart.

BUCK: Low, casual shoe with a rubberized sole and simple construction. Different colors and materials make it an extremely versatile shoe.

CAP-TOE: Low, lace-up shoe resembling an oxford with an extra piece of leather sewn over the toes.

CHUKKA BOOT: Also known as the desert boot. A sturdy, two-eyelet ankle boot with a rubberized sole.

LOAFER: The ultimate slip-on casual shoe; low-heeled, with tassels or stitching (to hold the penny) in front.

LUG SOLE: Soles with rubber cleats or ridges for added traction. Lug soles dress down many otherwise formal shoe designs.

MONK STRAP: Casual, plain shoe that fastens with one side buckle and strap.

NUBUCK: Material typically made from cowhide through a process that abrades the hide's outer grain to make it mimic the look and feel of buckskin. It tends to feel rougher than suede.

ORTHOTICS: Any device that helps correct, support, or relieve skeletal problems in the feet. Commonly used to refer to specially designed inner soles for the shoes of those suffering from chronic foot pain.

OXFORD: A flat, low-cut shoe that laces up.

PADDOCK: Lace-up boot for adjustable ankle support used for horse riding. The sole of the authentic paddock boot is always sewn, never glued or bonded.

SADDLE OXFORD: An oxford with an extra piece of leather sewn over the shoe's midsection, often in a different texture or color.

SPECTATOR: Any two-toned shoe; the style first became popular in the twenties but has had many revivals since.

VAMP: The toe box of the shoe, covering the toes and instep.

VIBRAM SOLE: Lightweight rubbery outsole that adds spring and slip resistance.

WELT: Extra pieces of fabric or leather that reinforce seams. A welt on a shoe is usually an extra piece of leather between the upper and the sole.

WING TIP: Classic men's dress shoe with decorative toe tip in the shape of a flying bird. Suede wing tips are slightly less formal than those in leather.

FIRST AID

By now, you may have a better idea of what you'd like to have in your ideal wardrobe. But there is still the somewhat sticky issue of finding the perfect fit, and, once you've found that, figuring out how to take care of your new clothes so they'll last. Then, of course, there's the whole matter of taking care of yourself, so that you'll look as good as your clothes inevitably will. This section will guide you through all these subjects and more, and will help make your days at an only-sometimes-casual office—or your meetings with only-sometimes-casual people—as relaxing as they can possibly be.

Wash and Dry

WASHING. Get ahead of the laundry-sorting dilemma by hanging mesh laundry bags in the closet or bathroom for sorting whites, colors, darks, and garments that must be dry-cleaned or washed by hand. • Be sure to unbutton garments before putting them in the washing machine. • Wash dark colors, anything with lettering, and fleece garments inside out. • Anything elastic, and undergarments of all kinds, should be washed in cold or lukewarm water, then hang-dried or dried in a machine on a no-heat setting. • Hang-drying is better than machine-drying for preserving the richness of dark-colored clothes. • Don't overcrowd clothes in the washer and dryer: they won't get clean and will wrinkle excessively. • Always remove clothes promptly from the washer and dryer.

BLEACH. Use to whiten white fabrics. Check the care label on colored and synthetic fabrics before washing with bleach. • Never bleach garments containing silk, wool, or other specialty hair fibers. Spandex, leathers, and some nylons also should not be bleached. • Always add bleach with a detergent, to the hottest water allowed for that item of clothing. Never apply to dry garments.

DECIPHERING CARE LABELS. When washing a garment for the first time, be sure to check its care label. Some labels do list all the satisfactory care methods, but a manufacturer or importer is required only to list one method of safe care, even if other safe methods exist. If a garment has a care label with washing instructions, it may or may not be dry-cleanable, and vice versa. If a garment is marked "Dry-Clean" as opposed to

"Dry-Clean Only," and it is constructed simply, you may have the option of laundering it after you have tested it for colorfastness. Washing in cold water and hanging to dry is a good rule of thumb.

CLEANING CASHMERE. Cashmere can be washed in a gentle soap suited for cold water, then rolled in a towel to remove excess moisture, and then spread flat to dry on a towel. Cashmere can also be dry-cleaned, even if the label doesn't specifically mention it.

CLEANING SILK. Generally, silk should be dry-cleaned. If it is washed, its consistency may be altered, depending on the finishing treatment used to give it sheen, and colors may run. Chlorine bleach damages silk and causes it to yellow. • Prewash treatments have made some silks washable—see the care label. Roll in a towel to remove excess mois-

ture, then hang to dry on a padded hanger. Machine-drying silk will cause it to disintegrate. Instead, iron it on a low setting while slightly damp.

CLEANING WOOL. Chlorine bleach will damage wool fibers. Dry-clean, or unless otherwise noted, hand-wash woolens in a gentle soap suited for cold water. Roll garments in a towel to remove excess moisture, then lay out to dry on a flat surface away from direct heat or sunlight. Steaming woolens can refresh them.

HOW TO CHECK FOR COLORFASTNESS. To check for color-bleeding on dyed fabrics, run this simple test. Find an inconspicuous area on the garment (inside hems are good places), wet the fabric, and blot it with a white cloth. Allow it to air-dry to determine if the dye and sizing are disturbed. If any color bleeds onto the cloth or the fabric seems damaged once it's dry, dry-clean only.

DRY-CLEANING. Always dry-clean all pieces of an outfit that are the same material, even if one part is not dirty. • Be sure to check with your dry cleaner before cleaning precious items (getting your money back for a ruined garment is something you can't count on). Items known to be troublesome include sequins, metallics, acetates, decorative buttons, and permanent pleats. • Recycle hangers by returning them to your dry cleaner.

IF YOUR CLOTHES COME BACK SHINY. Dry-cleaning doesn't make clothes shiny, but when clothes are pressed incorrectly at too high a heat, the cloth can become glazed. Some fabrics, such as dark gabardines, can become glazed

by wear alone (especially at stress points such as the seat and the elbows). The only way to correct the situation is for an expert to work over the garment with a very fine grade sandpaper to restore a more matte appearance. Unfortunately, this remedy is only temporary.

Stains

Success in stain removal, professionally or at home, is determined by the degree to which dyes and sizings (the finish applied to fabric in manufacture) are colorfast when wet. Do not try to remove a stain yourself if the care label says "Dry-Clean Only" or if the garment is not colorfast. Because dyes and sizings tend to discolor with moisture, attempting to remove stains with water is not recommended without first testing the garment for colorfastness. Removal of a concentrated food or beverage stain is difficult. Try to absorb stains before they set by using the tip of a white paper towel to soak up excess liquid. Never scrub or press; doing so could ruin the fabric's texture. To assist in the professional removal of stains from nonwashable fabrics, take a stained garment promptly to the dry cleaners and tell them what caused the stain. It is sometimes possible to restore areas damaged by attempts to remove stains at home.

Ironing

To avoid back pain, adjust your ironing board to the best height for you. • Use a plant mister to dampen the clothes you intend to steam-iron. A little spray starch can work wonders on cotton

shirts. • Iron items that require a cooler iron, such as silk, first. • Iron non-showing parts of garment (underside of cuffs and collar) first. • Pull fabric taut as you go along; it makes for smoother ironing. • Iron around buttons, not on top of them.

Repairs

SEWING ON BUTTONS. Buttons have a way of breaking or coming off just when you're late for dinner or on the road. So it's a good idea to know how to sew a button back on. Most good-quality clothes come with extra buttons, so don't panic. • Use a piece of thread one to two feet long that matches the thread of the other buttons, and thread the needle. Some people find it easier to move the needle toward the thread. • Pull both ends of the thread even and tie them in a knot. (The double-thread thickness adds strength.) • Start by sewing underneath the fabric, pushing the needle up through the button. • With each stitch, cross to the buttonhole diagonally opposite (for a four-hole button). Do the same for the other two holes. Two or three times through each pair of holes should do the trick. • Then poke the needle through the fabric without going through the buttonhole and wind the thread around the stitches under the button several times before pushing it through once more to the back. This will reinforce the button. Finally, knot on the inside.

FIXING HEMS. Pin the hem to the correct height. • Thread the needle (see directions above) and knot the thread.

Use a single thread if you're working with a delicate fabric. • Working from the inside of the garment, start by pushing the needle through the edge of the hem. Then sew it to the desired height by catching just a few threads. Check the outside of the garment to make sure you didn't make too visible a stitch. • Then return to the edge of the hem. • Repeat this process until finished, then knot on the inside.

Quality Control

JACKETS. Rub first the lapel, then the body of the jacket, between your thumb and forefinger. You should feel three layers: the outer shell, an inner facing, and the lining. • The collar should lie flat against the neck, the lapels flat against the breast. • Look for dense hand-stitching at the buttonholes, around the inside of the armhole, and under the collar at the back of the neck. • Be sure that there's no puckering at the shoulder or sleeve seams. • If the jacket's fabric has a pattern, it should match up across the pockets and seams • The pockets should be roomy and lined in cotton. • The fabric should be resilient after being crumpled. **Fit.** Expect to need alterations. • Consider what you might be wearing under the jacket besides a shirt—vest, sweater—and compensate accordingly. • If the jacket is uncomfortable when you sit down with it buttoned, it's too small. • The lower part of the armhole should not quite touch your armpit. • The jacket should be just long enough to cover the curve of the buttocks.

TROUSERS. Look for a lining sewn inside the pants where the crotch seams meet, to disperse stress and reduce chafing. • There should be a fully constructed, cotton-lined waist band that doesn't curl in on itself. • Genuine horn buttons denote quality.

SHIRTS. Tight stitching is best—at least eighteen stitches per inch (if your vision is that good). • Look for single-needle stitching, where one side of each seam is sewn at a time. • Make sure that buttons (at least seven down the front) are firmly secured. • Look for a center pleat or placket where the buttons close; it's stronger than a straight closing. • A vertical shoulder yoke seam in back gives the shoulders more mobility. • Be sure that collar points are identical in length. • Avoid shirts with "average" sleeve lengths, like 31/32 or 33/34. They won't fit as well. • A second button to close the sleeve gap above the wrist is useful. **Fit.** The last thing you want is a collar that's too tight. Give yourself about a quarter inch of space at the front of the neckband. • Shirt sleeves should show one-half inch past jacket sleeves and should still show a bit even when you bend your elbows. • Tails should be long enough to cover the seat, but not so long that they make the front of the pants bulge.

TIES. There should be a 100-percent wool lining. The more gold bars stitched onto the lining, the thicker it is. • Hold the tie over your hand and let it fall. The narrow end should fall directly in the middle of the wide end. • Good ties are often rolled and hemmed by hand, and made with three pieces of fabric. • Look for a slip stitch in the lining; a string, which allows you to pull the tie together; and a bar tack, which holds the two ends in place. **Fit.** Once it's tied, the ends of a tie should just reach the waist band. • If you use a Windsor knot, you may need a longer tie. • Tie width fluctuates all the time, but 3¼ inches is a safe middle ground. • Always untie your tie in reverse of how you tied it. • Hanging a knit tie causes it to lose its shape. Fold or coil it instead.

Shoes

BUYING TIPS. Quality. Smooth, even, and close stitching throughout. A soft lining with inverted seams. A smooth insole. No traces of glue. Bends freely when flexed, then resumes shape. **Exotic skins** (such as lizard, ostrich, and alligator) are many times more durable than leather; reptile skins can be ten times tougher. **Oiled natural finishes** may nick and scratch, but they are more durable than polished finishes and ideal for work boots. **Patent leather** resists dirt but can easily dry out and crack. **Polished leather** is the most practical material for dress shoes; it resists dirt, and a good polishing job can compensate for a lot of minor scratches. **Suede** does not hold up as well as leather over time. Rain can stain, while sand and salt on the roads can outright decimate. **Fit.** Feet never shrink, so don't buy tight shoes. Lined shoes are even less likely to give than unlined ones. Buy shoes at the end of the day, when your feet have naturally swelled to their full size (which can be up to a 10-percent increase). Also keep in mind that feet can widen with age, during pregnancy, and from inactivity (sitting on a plane or at a desk). Be sure that you're trying on shoes with the kind of

socks or stockings you'll be wearing with them. **MAINTENANCE.** Leather breathes and needs a day or two after being worn to dry out. The same shoes should not be worn day after day if you want them to last. Polishing leather helps to keep it from cracking. Disposable inner soles cushion each step and absorb odor and sweat. Reheel and resole when necessary. Avoid wearing down heels by having taps placed on them immediately after buying (this costs a lot less than having to fix the heels later). **Patent leather.** Wipe clean with a soft cloth. Use shoe products made specifically for patent leather to prevent cracking. **Polishing leather.** 1. Place shoes on a sheet of newspaper. Brush off surface dirt with a rag, paper towel, or soft brush. 2. With a piece of paper towel, apply a thin layer of cream polish in the appropriate color or neutral. Use circular strokes, rubbing in the polish as you go. Do not leave an excessive amount on the surface. 3. When polish is dry, buff with a brush or clean cloth. 4. In between shoe shines you can buff with a soft cloth. If there is a grease stain on polished leather, blot with a dry cloth; if the stain remains, try lifting it with a little vinegar. **Suede.** Apply silicone weatherproofing spray before wearing suede shoes for the first time; the spray can trap dirt once it's present on the shoe. Respray several times a season with nonsilicone spray. If a bald spot develops on shoes, use a very fine grade (00) sandpaper gently on the area until the nap lifts. You can also lift the nap by holding shoes over a boiling kettle and brushing them gently with an old toothbrush.

STORAGE. Store shoes with shoe trees (which helps the shoe keep its shape) or pack with tissue to preserve the shape as they dry after wearing. Never store near a heat source because it will dry out the leather. Leather can mildew; store in a dry, ventilated place. A packet of salt placed in the shoe box can absorb excess moisture.

Grooming

MEN. Hair. It's generally advisable to avoid a stylish hairdo; better to have a simple cut that can be combed a few different ways. • Using the same shampoo every time you wash your hair may cause buildup. Have a few brands on hand so that one can wash the other's buildup away. • Using a conditioner a couple of times a week is plenty. Used more often, it may make your hair limp (depending on your hair type). • If you use a mousse or gel, apply it sparingly and comb it through damp, not wet, hair. **Sideburns.** It's up to you to determine where in the retro time spectrum you fall; but if you wish to remain safely chronistic, trim your sideburns square and don't let them creep below the bottom of your cheekbone. If your face is wider, you can get away with wider sideburns. **Facial hair.** If you decide to grow facial hair, make sure it fits your face. Small mustaches go better with small noses, and large with large. • A short but full beard can make a thin face look fuller; a longer beard can lengthen a full face. • Your beard should be as hirsute as your head. If you're balding or have a short haircut, trim the beard short. If you have long hair, the beard can be bigger.

Cologne. It's nice if it makes you smell good up close, but the whole room doesn't need to breathe your cologne. Be especially sure not to overdo it when you know you'll be in a confined place— theater, boardroom, airplane, car pool.

WOMEN. Hair. Casual work does not allow for unkempt, dirty, or overly dramatic hair. Keep it clean, neat, and out of your way; pulling it back or letting it simply hang naturally should be acceptable. If casual hair means not bothering with the rituals of blow drying and setting, so be it. Big hair or hair with lots of ornamentation should be saved for evening events or your wedding day. • If your office's casual dress code allows for bare legs in the summer, keep them free of hair, and consider applying self-tanning makeup for an even tone. • Underarm hair should never be exposed on the job. **Nails.** They should always be clean and well kept; nail polish is not necessary. Decals or other expressive designs should be saved for Halloween. If your toes show, they too should be clean and well kept. A pedicure at the beginning of the summer will get them into good shape, making maintenance a lot easier. **Makeup.** Casual does not necessarily mean no makeup. Not everyone has that smooth, evenly pigmented, glowing skin. You may still have to put on some light foundation, concealer, or powder, mascara for eye definition, and perhaps some glossy or sheer lipstick. **Fragrance.** Yes, you still need to wear some sort of deodorant. Keep the perfume light. Too much perfume is just as bad as bad body odor.

WHERE

It's hard enough to know what you want. Transforming that "what" into a "where" can seem downright impossible. This list should make that step a little easier. It's filled with places where you can find high-quality merchandise to fit your most specific needs. All of them with phone numbers, too, so you don't even have to go to the "wheres" to find your wares.

FREEDOM OF CHOICE

Mail-Order Catalogues

ANGORA SPORT
203/699-1789
(Washable angora wool and cotton blend garments)

CARTIER
800/CARTIER
(Fine jewelry and watches)

COACH
800/262-2411
(Handbags and other leather goods)

COLE-HAAN
212/421-8440
(Designer shoes)

EDDIE BAUER
800/426-8020
(Casual and outdoor wear and gear)

JACK PURCELL/CONVERSE
800/428-2667
(Classic shoes and sportswear)

JCPENNEY
800/222-6161
(Wide variety of clothing)

J. CREW
800/782-8244
(Sportswear and accessories)

J. PETERMAN COMPANY OWNER'S MANUAL
800/231-7341
(Clothing and accessories)

LANDS' END
800/356-4444
(Sportswear for men and women)

L. L. BEAN RETAIL STORE
800/543-9071
(Outdoor wear and gear)

OLIVER PEOPLES
310/657-5475
(Eyeglasses and accessories)

PATAGONIA
800/336-9090
(Activewear)

REMO (AUSTRALIA)
2/331-5007
inforemo@remo.com.au
(Classic clothing and accessories)

S&B REPORT
212/679-5400
($49 subscription to receive monthly mailer of designer sample sales)

SPIEGEL
800/345-4500
(Coats, lingerie, accessories, and clothes)

TALBOTS
800/825-2687
(Clothing and accessories)

TWEEDS
800/999-7997
(Fashionable basics, accessories, shoes)

WATHNE
800/942-1166
(Elegant clothing, accessories, and sporting gear)

National Listings

ADIDAS
800/4-ADIDAS
(Casual and sports shoes and apparel)

ANN TAYLOR
800/999-4554
(Clothing and accessories)

ARMANI A/X
212/570-1122
(Giorgio Armani denims and basics)

BANANA REPUBLIC
212/446-3995
(Sportswear)

BARNEYS NEW YORK
800/777-0087
(Upscale specialty store)

BASS/WEEJUN
800/777-1790
(Shoes)

BENETTON
800/535-4491
(Casualwear)

BLOOMINGDALE'S
800/777-4999
(Upscale department store)

BROOKS BROTHERS
800/444-1613
(Specialty store)

BURBERRY'S
800/284-8480
(Outerwear, clothing, and accessories)

CALVIN KLEIN
800/223-6808
(Designer clothes)

CASHMERE CASHMERE
800/763-4228
(Fine cashmere clothing and accessories)

CHANEL BOUTIQUE
800/550-0005
(Chanel clothes, accessories, cosmetics)

COUNTRY ROAD AUSTRALIA
201/854-8400
(Elegant tweeds, accessories, and workwear)

DAFFY'S
201/902-0800
(Discount designer clothing)

DAYTON HUDSON
MARSHALL FIELD
800/292-2450
(Upscale department store)

DILLARD'S PARK PLAZA
800/DILLARD
(Upscale department store)

DKNY/DKMEN
800/647-7474
(Fashionable clothes for men and women)

DOCKERS
800/DOCKERS
(Khakis and sportswear)

EASTERN MOUNTAIN
SPORTS
603/924-6154
(Activewear)

EILEEN FISHER INC.
212/944-0808
(Relaxed designer clothing)

FERRAGAMO
212/838-9470
(Designer clothing and accessories)

FILENE'S
617/357-2601
(Upscale department store)

THE GAP
800/GAP STYLE
(Clothing and accessories)

GHURKA
800/243-4368
(Luggage and fine leather goods)

GIORGIO ARMANI
201/570-1122
(Designer clothes)

GUCCI
800/234-8224
(Fine leather goods, scarves, and clothing)

HENRI BENDEL
212/247-1100
(Upscale specialty store)

HERMÈS
800/441-4488
(Fine leather goods, clothes, and jewelry)

HUSH PUPPIES
800/433-HUSH
(Shoes)

KEDS
212/935-0986
(Shoes and sneakers)

KENNETH COLE SHOES
800/KEN COLE
(Shoes)

KENNETH JAY LANE
212/868-1780
(Costume Jewelry)

LAURA ASHLEY
800/367-2000
(Women's clothing and accessories)

LEVI STRAUSS & CO.
800/USA-LEVI
(Jeans and sportswear)

THE LIMITED/EXPRESS
614/479-2000
(Sportswear)

LORD & TAYLOR
212/391-3344
(Upscale department store)

LOUIS, BOSTON
800/225-5135
(Designer clothes)

MACY'S/BULLOCK'S/
AÉROPOSTALE
800/45-MACYS
(Department store)

NAUTICA
212/496-0933
(Activewear)

NEIMAN MARCUS
800/937-9146
(Upscale department store)

NIKE
800/250-7590
(Sportswear and shoes for men and women)

NINE WEST
800/260-2227
(Women's shoes)

NORDSTROM
800/285-5800
(Upscale department store)

THE NORTH FACE
800/719-NORTH
(Outdoor wear and accessories)

PARISIAN
205/940-4000
(Upscale department store)

OLIVER PEOPLES
310/657-5475
(Eyeglasses and accessories)

POLO/RALPH LAUREN
212/606-2100
(Designer clothes)

PRODUCT
800/89-PRODUCT
(Designer specialty store)

RAGS
914/967-4144
(Contemporary women's clothing)

REI
800/426-4840
(Outdoor wear and accessories)

RICH'S
404/913-4000
(Better women's merchandise)

ROCKPORT
800/ROCKPORT
(Casual and outdoor shoes)

SAKS FIFTH AVENUE
212/753-4000
(Upscale department store)

SEBAGO
800/365-5505
(Shoes)

SLATES
800/SLATES-1
(Men's dress pants)

STUSSY
212/274-8855
(Unisex sportswear)

TARGET STORES
800/800-8800
(Discounted designer apparel)

TIFFANY & CO.
212/605-4612
(Fine jewelry and accessories)

TIMBERLAND
800/258-0855
(Casual and outdoor shoes)

TIMEX
800/367-8463
(Watches)

TJ MAXX
800/926-6299
(Discounted clothing and accessories)

TOMMY HILFIGER
212/840-8888
(Activewear)

TSE
212/472-7790
(Cashmere clothing)

URBAN OUTFITTERS
215/569-3131
(Casual wear)

VANS
800/750-VANS
(Sports shoes)

WOOLRICH
800/995-1299
(Casual and outdoor wear)

California

FRED SEGAL
8100 Melrose Avenue
Los Angeles, CA 90046
213/651-3342
(Specialty store)

L.A. EYE WORKS
7407 Melrose Avenue
Los Angeles, CA 90046
213/653-8255
(Eyeglasses)

MAXFIELD
8825 Melrose Avenue
Los Angeles, CA 90069
310/274-8800
*(European and American
designer clothes)*

RON ROSS
12930 Ventura Boulevard
Studio City, CA 91604
818/788-8700
(Designer clothing)

WILKES BASHFORD
375 Sutter Street
San Francisco, CA 94108
415/986-4380
(Designer clothing)

District of Columbia

BRITCHES OF GEORGETOWN
1357 Wisconsin Avenue, NW
Washington, DC 20007
202/337-8934
(Clothing and accessories)

Georgia

**SUMMERVILLE RAGS
& CLASSICS**
1502 Monte Sano Avenue
Augusta, GA 30904
706/738-4884
(Classic clothes and accessories)

Illinois

ULTIMO
114 East Oak Street
Chicago, IL 60611
312/787-0906
(Designer clothes)

Maine

CALVIN KLEIN OUTLET
11 Bow Street
Freeport, ME 04032
207/865-1051
*(Discounted Calvin Klein apparel
and accessories)*

**DONNA KARAN
COMPANY STORE**
42 Main Street
Freeport, ME 04032
207/865-1751
(Discounted Donna Karan apparel)

J. CREW OUTLET
31 Main Street
Freeport, ME 04032
207/865-3180
*(Discounted J. Crew apparel
and accessories)*

**JONES NEW YORK
OUTLET**
10 Bow Street
Freeport, ME 04032
207/865-3158
(Discounted Jones New York apparel)

**L. L. BEAN FACTORY
STORE**
150 High Street
Ellsworth, ME 04605
207/667-7753
(Outdoor clothes and gear)

THE PATAGONIA OUTLET
9 Bow Street
Freeport, ME 04032
207/865-0506
(Discounted Patagonia activewear)

Massachusetts

JOSEPH ABBOUD
37 Newbury Street
Boston, MA 02116
617/266-4200
(Designer sportswear and suits)

New Hampshire

L. L. BEAN FACTORY OUTLET
Route 16
North Conway, NH 03860
603/356-2100
(Outdoor wear and gear)

New York

AGNÈS B.
116 Prince Street
New York, NY 10012
212/925-4649
(Clothing and accessories)

A.P.C.
131 Mercer Street
New York, NY 10012
212/966-9685
(Clothing and accessories)

ARTWEAR
456 West Broadway
New York, NY 10012
212/673-2000
(Contemporary artisanal jewelry)

AT HAVEN'S HOUSE
Madison Street
Sag Harbor, NY 11963
516/725-4634
(Vintage and new clothing)

BELGIAN SHOES
60 East 56th Street
New York, NY 10022
212/755-7372
(Classic shoes)

BERGDORF GOODMAN
754 Fifth Avenue
New York, NY 10019
212/753-7300
(Upscale specialty store)

BOTTEGA VENETA
635 Madison Avenue
New York, NY 10022
212/319-0303
(Shoes and fine leather goods)

CANAL JEAN
504 Broadway
New York, NY 10012
212/226-1130
(Casual and vintage clothing)

CENTURY 21
22 Cortlandt Street
New York, NY 10007
212/227-9092
(Discounted clothing and accessories)

CHARIVARI
18 West 57th Street
New York, NY 10019
212/333-4040
(Designer collections)

C. P. COMPANY
175 Fifth Avenue
New York, NY 10010
212/260-1990
(Italian sportswear)

CYNTHIA ROWLEY
112 Wooster Street
New York, NY 10012
212/334-1144
(Designer clothing)

DIEGO DELLA VALLE
41 East 57th Street
New York, NY 10022
212/223-2466
(Designer shoes)

DOLLAR BILL
99 East 42nd Street
New York, NY 10017
212/867-0212
(Women's wear at discount)

EMPORIO ARMANI
110 Fifth Avenue
New York, NY 10011
212/727-3240
(Clothing and accessories)

EQUIPMENT
209 West 38th Street
New York, NY 10018
212/391-8070
(Silk and cotton shirts)

ERMENEGILDO ZEGNA
743 Fifth Avenue
New York, NY 10022
212/751-3468
(Designer clothing and accessories)

FRAGMENTS
107 Greene Street
New York, NY 10012
212/226-8878
(Designer jewelry)

H. KAUFFMAN & SONS SADDLERY
419 Park Avenue South
New York, NY 10016
212/684-6060
(Riding apparel and equipment)

INDUSTRIA
755 Washington Street
New York, NY 10014
212/366-4300
(Designer clothing and accessories)

JEEVES OF BELGRAVIA
39 East 65th Street
New York, NY 10021
212/570-9130
(Expert dry-cleaning)

JIM'S SHOE REPAIR
50 East 59th Street
New York, NY 10022
800/631-2022
212/355-8259
(Expert shoe repair)

J. M. WESTON
42 East 57th Street
New York, NY 10022
212/308-5655
(Shoes)

MAXMARA
813 Madison Avenue
New York, NY 10021
212/879-6100
(Designer clothing)

MORGANTHAL FREDERICS OPTICIANS
944 Madison Avenue
New York, NY 10021
212/744-9444
(Designer eyeglasses)

NORTH BEACH LEATHER
772 Madison Avenue
New York, NY 10021
212/772-0707
(Leather goods)

N. PEAL CASHMERE
118 East 57th Street
New York, NY 10022
212/308-0707
(Clothing and accessories)

OPTICAL AFFAIRS
5–9 Union Square West
6th Floor
New York, NY 10003
212/727-3080
(Christian Roth eyeglasses)

PAUL SMITH
108 Fifth Avenue
New York, NY 10011
212/627-9770
(Classic clothing and accessories)

PAUL STUART
Madison Avenue at 45th Street
New York, NY 10017
212/682-0320
(Classic shoes and menswear)

PRADA
45 East 57th Street
New York, NY 10022
212/308-2332
(Shoes and designer clothes)

ROBERT LEE MORRIS
409 West Broadway
New York, NY 10012
212/431-9405
(Contemporary jewelry)

SEARLE
609 Madison Avenue
New York, NY 10022
212/753-9021
212/719-4610
(Designer clothing and outerwear)

T. ANTHONY
445 Park Avenue
New York, NY 10022
212/750-9797
(Luggage and accessories)

TIME WILL TELL
962 Madison Avenue
New York, NY 10028
212/861-2663
(Contemporary and antique watches)

THE WATCH STORE
649 Broadway
New York, NY 10012
212/475-6090
(Watches and accessories)

International Listings

FRANCE

AGNÈS B.
3–6 rue du Jour
Paris 75001
140/03-45-00
(Clothes and accessories)

AU PRINTEMPS
64 boulevard Haussmann
Paris 75009
142/82-50-00
(Department store)

GALERIES LAFAYETTE
40 boulevard Haussmann
Paris 75009
142/82-34-56
(Department store)

HERMÈS
24 rue du Faubourg-Saint-Honoré
Paris 75008
142/17-47-17
(Clothing, accessories, jewelry, and luggage)

HERVÉ CHAPELIER
1 bis rue du Vieux Colombier
Paris 75006
146/08-22-35
(Nylon accessories and handbags)

INÈS DE LA FRESSANGE
14 avenue Montaigne
Paris 75008
147/23-08-94
147/23-64-87
(Classic clothing and accessories)

ROBERT CLERGERIE
5 rue du Cherche-Midi
Paris 75006
145/48-75-47
(Designer shoes)

GERMANY

JIL SANDER
Milchstrasse 13
2000 Hamburg
40/5530-2173
(Designer clothing)

LUDWIG BECK
Marienplatz 11
Munich
89/23-6910
(Upscale department store)

MEY & EDLICH
Theatinerstrasse 7
Munich
89/290-0590
(Upscale department store)

GREAT BRITAIN

AGNÈS B.
35–36 Floral Street
London WC2
171/379-1992
(Clothes and accessories)

BROWNS
23 South Molton Street
London W1Y 1DA
171/491-7833
(Designer clothing)

BURBERRY'S
18–22 Haymarket
165 Regent Street
London SW1
171/930-3343
(Outerwear, clothing, and accessories)

FLANNELS
Unit 10, Royal Exchange
Manchester M2
161/834-8669
(Designer clothing)

THE GAP
31 Long Acre
London WC2
171/379 0779
(Clothing and accessories)

HACKETT'S GENTLEMAN'S CLOTHIERS
138 Sloane Street
London SW1
SW1 X19N
(Men's clothing)

HARRODS
Knightsbridge
London SW1
171/730-1234
(Upscale department store)

HARVEY NICHOLS
109–125 Knightsbridge
London SW1
171/235-5000
(Upscale department store)

JONES
15 Floral Street
London WC2
171/379-4448
(Clothing and accessories)

JOSEPH
77–79 Fulham Road
London SW3
171/883-9500
(Designer clothing)

LIBERTY PLC.
210–222 Regent Street
London W1R 6AH
171/734-1234
(Clothing and accessories)

MARKS AND SPENCER PLC.
458 Oxford Street
London W1A
171/935-4422
(Department store)

MICHELE HOLDEN
42 Beauchamp Place
London SW3
171/581-8533
(Parisian dressmaker)

MUJI
26 Great Marlborough Street
London W1V 1HL
171/494-1197 for stores
(Natural-fiber clothing)

NEXT PLC.
160 Regent Street
London W1
171/434-2515
(Clothing and accessories)

OASIS
6 Kensington Barracks
Kensington Church Street
London W8
171/938-4019
(Clothing and accessories)

PATRICK COX SHOES
8 Symons Street
London SW3
171/730-6504
(Shoes)

PAUL SMITH
40–44 Floral Street
London WC2E 9DJ
171/379-7133
(Smart, hip fashion for men and women)

SPACE NK
41 Earlham Street
London WC2
171/379-7030
(Simple, modern clothes and accessories)

SWAINE, ADENEY, BRIGGS & SONS
185 Piccadilly
London W1
171/409-7277
(Riding clothes and accessories)

WHISTLES
12–14 St. Christopher Place
London W1
171/487-4484
(Classic, influential designs)

ITALY

ERMENEGILDO ZEGNA
Via P. Verri 3
Milan
2/7600-6437
(Designer clothing and accessories)

GIORGIO ARMANI
Via Sant'Andrea 9
Milan
2/7602-2757
(Designer clothes)

LA RINASCENTE
Piazza Duomo
Milan
2/7200-2210
(Department store)

MAS
Piazza Vittorio Emanuele
Rome
6/446-9010
(Discount shopping, bargain cashmere)

PRADA
Galleria Vittorio Emanuele 63–65
Via della Spiga 1
Milan
2/760-8636
(Designer clothing and accessories)

ZORAN
Corso Matteoti 1A
Milan
2/760-7958
(Simple, luxurious clothes)

JAPAN

ISETAN
3-14-1 Shinjuku
Shinjuku-ku
Tokyo
3/3352-1111
(Specialty store)

TAKASHIMAYA
2-4-1 Nihonbashi
Chuo-ku
Tokyo
3/3211-4111
(Designer clothing)

SWEDEN

PEAK PERFORMANCE
Jakobsberggatan 6
Stockholm
8/611-3400
(Outdoor clothes)

"Simplicity is making the journey of this life with just baggage enough."

CHARLES DUDLEY WARNER

RESOURCES

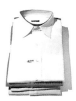

BROOKS BROTHERS' BUTTON-DOWN OXFORD

In the dark days before Brooks Brothers, men's shirt collars had the annoying habit of coming unglued in stiff winds and flapping in the faces of both the wearer and the utter neat respectability of Victorian-era fashion. That all changed when John Brooks returned from a trip to England in 1896 with a revolutionary design for a button-down collar, inspired by the unflappable duds of polo players. A century later, the Brooks Brothers button-down oxford has proved to be one of the most popular shirts in the history of menswear, almost unchanged from its original incarnation—the button behind the neck has been gone since 1946, but the BB tailors will sew one on if you wish. *(Brooks Brothers 800/444-1613)*

GHURKA BAG

Something doesn't have to be old to be classic. Example: The Ghurka bag, entirely hand-made in the United States with artisans' centuries-old techniques, is a perfect intersection of form and function that's been around for only a couple of decades. Ghurka starts with full-grained, vegetable-tanned, waterproofed saddle leather, solid-brass hardware, and 100-percent cotton twill linings, and stitches together a bag that becomes increasingly beautiful (and apparently indestructible) with the merciless march of time. Every bag is named, numbered, and registered at headquarters, because Ghurka means to carry your stuff for life. *(Ghurka 800/243-4368)*

61 **BLACK CASHMERE CARDIGAN**—N. Peal

66 **NAVY PINSTRIPED SUIT, SHIRT, TIE**—Polo/Ralph Lauren; **BLACK WINGTIP SHOES**—Edward Green/Paul Stuart

67 **WATCH**—Eddie Bauer; **COTTON VISCOSE SHIRT**—Ermenegildo Zegna; **NAVY SILK KNIT TIE**—Paul Stuart; **NAVY WOOL CREPE SUIT**—Emporio Armani; **BLACK LOAFERS**—Gucci

68 **WOOL CREPE SUIT**—Emporio Armani; **WHITE COTTON BAND-COLLAR SHIRT**—Dockers; **GLASSES**—Morganthal Frederics; **MONK STRAP SHOES**—J.M. Weston; **BLACK SOCKS**—Dockers; **BELT** Brooks Brothers

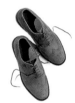

TIMBERLAND

Once upon a time, hiking/walking shoes weighed about fourteen pounds each, required that you slather on a quart of waterproofing grease every other day, and weren't all that attractive, to boot. All Timberland did was completely revolution-ize the outdoor shoe—and overnight, it seems now. One of the first Timberland cre-ations, the low day-walking shoe with the sturdy Vibram sole, remains an all-time clas-sic in the field. Since then, the company has advanced serious developments in waterproof leather (with Gore-Tex linings), and super-rugged outer soles to go along with hun-dreds of new designs that will keep you cov-ered everywhere from the Grand Tetons to Grand Central. *(Timberland 800/258-0855)*

69 **VINTAGE WATCH**—Rolex from Time Will Tell, NYC; **CASHMERE CARDIGAN POLO**—TSE; **WOOL CREPE SUIT PANTS**—Emporio Armani; **ALLIGATOR BELT**—Brooks Brothers; **SUEDE LOAFERS**—J.M. Weston; **WOOL CREPE SUIT JACKET**—Emporio Armani; **CASHMERE NAVY V-NECK SWEATER**—TSE; **WHITE T-SHIRT**—Levi Strauss & Co.; **501 JEANS**—Levi Strauss & Co.; **WATCH**—Swiss Army; **LOAFERS**—Brooks Brothers; **BLACK RIBBED SOCKS**—Dockers

73 **NAVY CASHMERE JACKET**—Polo; **DENIM BUTTONDOWN SHIRT**—Levi Strauss & Co.; **FLAT-FRONT KHAKIS**—Dockers; **BLACK KNIT TIE**—Polo/Ralph Lauren

74 **KHAKI PATCH-POCKET SHIRT**—Dockers; **SILK PLAID TIE**—Ermenegildo Zegna; **NORFOLK JACKET**—J. Peterman Co.; **WOOL TIE**—Paul Stuart; **WOOL SHOOT-ING JACKET**—J. Peterman Co.; **SPREAD-COLLAR DRESS SHIRT**—Brooks Brothers

75 **HACKING JACKET**—Polo/Ralph Lauren; **WOOL TURTLENECK**—Paul Stuart; **SPORT COAT**—Brooks Brothers; **MOCK-TURTLE MERINO WOOL SHIRT**—Searle

76 **WHITE BAND-COLLAR SHIRT**—Paul Stuart

79 **BLACK SILK KNIT TIE**—Polo/Ralph Lauren

80 **TYPEWRITER KEY CUFF LINKS**—Paul Smith; **GOLF BALL CUFF LINKS**—Brooks Brothers

81 **DENIM SHIRT**—Levi Strauss & Co.; **LIGHTWEIGHT DENIM SHIRT WITH SPREAD COLLAR AND FRENCH CUFFS**—Chic Simple; **CUFF LINKS**—Paul Smith

82 **BUTTONDOWN SHIRT**—Searle Blatt; **CASHMERE WOVEN TIE**—Polo/Ralph Lauren

83 **COTTON HERRINGBONE FLANNEL**—Searle; **COTTON AND VISCOSE SHIRT**—Ermenegildo Zegna; **COTTON SHIRT**—Dockers; **RAYON SHIRT**—Searle; **PLAID COTTON SHIRT**—Dockers; **COTTON TWILL SHIRT**—Dockers

84–85 **TAN DENIM SHIRT**—Carhartt; **COTTON TIE**—J. Crew; **BLUE DENIM SHIRT**—Thornton Bay, Macy's; **SILK TIE**—Garrick Anderson; **CORDUROY SHIRT**—J. Crew; **SILK TIE**—Ermenegildo Zegna

86 **WHITE COTTON BUTTONDOWN SHIRT**—Dockers; **GREEN COTTON/POLY SWEATER VEST**—Dockers Golf; **PLEATED KHAKI**—Dockers; **BROWN LEATHER BELT**—Dockers; **BROWN SUEDE AND LEATHER SADDLE SHOES**—Dockers; **GREEN AND BROWN PLAID SOCKS**—Dockers; **GRAY ZIP-FRONT VEST**—Dockers Authentics; **T-SHIRT**—Levi Strauss & Co.; **BROWN SUEDE SHOES**—Dockers; **WATCH**—Timex; **GRAY SUIT**—Giorgio Armani

87 **NAVY SUIT VEST**—Polo/Ralph Lauren; **NUBBY LINEN VEST**—Joseph Abboud; **BROWN LEATHER VEST**—Levi Strauss & Co.; **RIBBED CASHMERE SWEATER VEST**—TSE

88 **LEATHER-TRIM BAG**—Paul Stuart; **DENIM SHIRT**—Levi Strauss & Co.; **GLASSES AND LEATHER EYEGLASS CASE**—Morganthal Frederics; **WINGTIP SHOES**—Brooks Brothers; **HEATHER BROWN WOOL VEST**—Paul Stuart; **WOOL CHALLIS TIE**—Paul Stuart; **WOOL AND NYLON TWEED PANTS**—J. Crew

89 **501 JEANS**—Levi Strauss & Co.; **WHITE BAND-COLLAR SHIRT**—Levi Strauss & Co.; **CHARCOAL PLAID CASHMERE MUFFLER**—Brooks Brothers; **BLACK RAYON COAT**—DKNY; **BLACK MERINO WOOL V-NECK SWEATER**—J. Crew; **BLACK LOAFERS**—Brooks Brothers; **GLASSES**—Christian Roth for Optical Affairs; **DENIM SHIRT**—Levi Strauss & Co.; **BROWN SUEDE SHOES**—Dockers; **KHAKIS**—Dockers; **BELT**—Dockers; **LINEN JACKET**—Barry Bricken; **STONEHENGE TIE**—Jerry Garcia

90–91 **WOOL MOCK TURTLENECK**—Searle; **MERINO WOOL TURTLENECK**—Neiman Marcus; **MERINO WOOL POLO**—Ermenegildo Zegna

93 **BLACK WOOL AND CASHMERE JACKET**—Saks Fifth Avenue; **BLACK CASHMERE TURTLENECK SWEATER**—Brooks Brothers; **CHARCOAL WOOL TROUSERS**—Brooks Brothers; **BLACK LEATHER BACKPACK**—A/X; **BLACK SHOES**—J.M. Weston; **EYE-GLASSES**—Morgenthal Optics

94 **CORDUROY PANTS**—Dockers; **WOOL TWEED PLEAT-FRONT PANTS**—J. Crew; **COTTON KHAKIS**—Dockers; **OLIVE WOOL CAVALRY TWILL PANTS**—J. Peterman Co.; **COTTON MOLESKIN PANTS**—J. Peterman Co.

96 WOOL SUIT—Paul Stuart; OXFORD
CLOTH BUTTONDOWN SHIRT, CAP-TOE
TIE SHOES, SILK TIE—Brooks Brothers;
HORN-RIM GLASSES—Polo/Ralph
Lauren; BLACK RIBBED SOCKS—Dockers;
SUIT—Paul Stuart; BLACK MERINO WOOL
POLO—Bloomingdale's; OUTERWEAR
JACKET—Patagonia; GLASSES—
Morgenthal Frederics; BOOTS—
Timberland; SOCKS—Dockers; SUEDE TIE
SHOES—J. M. Weston; SOCKS—Dockers

97 SUEDE TIE SHOES—N. Peal; GLASSES—
Christian Roth/Optical Affairs; WHITE
SHIRT—Dockers; WOOL PLAID TIE—Paul
Stuart; 501 JEANS—Levi Strauss & Co.;
SPORT COAT—Paul Stuart; POLARTEC
FLEECE VEST—Patagonia; SUIT PANTS,
SILK SCOTTIE TIE—Paul Stuart; KHAKI
COTTON SHIRT—Dockers

99 TANK WATCH—Cartier; FIELD WATCH—
Timex; VINTAGE WATCH—Rolex from
Time Will Tell, NYC

100–1 ROUND GLASSES WITH BLOND TOR-
TOISESHELL FRAMES, WIRE RIMS—
Morgenthal Frederics; BLACK GLASSES—
Ray-Ban; BLACK HORN RIMS—Optical
Affairs; BLACK WRAPAROUND
SUNGLASSES—Cutler and
Gross/Morgenthal Optics; TORTOISESHELL
GLASSES—Oliver Peoples

102 THREE-PIECE LINEN SUIT, FLAX LINEN
SHIRT, SILK TIE—Joseph Abboud;
WINGTIP BUCK SHOES—Timberland;
EYEGLASSES—Morgenthal Optics; LINEN
SUIT JACKET—Joseph Abboud; BLUE
OXFORD COTTON SHIRT—Brooks
Brothers; SILK TIE—Gene Meyer; NAVY
SEERSUCKER PINSTRIPE PANTS—
Ermenegildo Zegna; TASSEL LOAFERS—
Brooks Brothers

103 LINEN SUIT—Joseph Abboud; COTTON
POLO—Dockers; BRAIDED BELT—Dockers;
SHOES—Hush Puppies; SUNGLASSES—
Ray-Ban; THREE-BUTTON JACKET—DKNY;
BUTTON-DOWN SHIRT—J. Crew; LINEN
SUIT PANTS—Joseph Abboud; BROWN
LOAFERS—Gucci; BRAIDED LEATHER
BELT—Dockers; TANK WATCH—Cartier;
BROWN LEATHER BACKPACK—Coach

104 (left) SKIN BELT WITH SILVER BUCKLE—
Brooks Brothers; (middle) COWHIDE
LEATHER BELT—Dockers; (right) WOVEN
LEATHER BELT—Dockers

POLO/RALPH LAUREN

The original doeskin Polo blazer was
designed by the same Ralph Lauren who
made his fashion world entrance in the six-
ties proclaiming that ties were precisely
two inches too narrow. The blazer's tradi-
tional lines—also available in a flashier,
double-breasted cut—were the perfect
counterpoint to the ties that everyone now
agrees are indeed just the right width.
Lauren has made a career of merging the
classic and the modern, giving that plain
old navy blazer quite a kick in its tails, so to
speak. (*Ralph Lauren 212/606-2100*)

106 WHITE CANVAS SNEAKERS—Jack Purcell
by Converse

107 ARGYLE SOCKS—Dockers; TWEED
SOCKS—Polo/Ralph Lauren; BLACK COT-
TON SOCKS—Dockers

108–9 BROWN LOAFER—J. Crew; ANKLE
BOOT—Edward Green/Paul Stuart; MONK
STRAP SHOE—Kenneth Cole; SUEDE
WING-TIP SHOE WITH LUG SOLE—
Polo/Ralph Lauren; LEATHER TIE SHOE
WITH LUG SOLE—Dockers

110 SILVER PEN—Parker; BLACK PEN—
Uni-ball; AGENDA—Coach; NEWTON
ELECTRONIC ORGANIZER—Apple

111 LEATHER SATCHEL—Levi Strauss & Co.;
LEATHER BACKPACK—A/X

112 TRENCH COAT—Burberry's of London

113 LEATHER CAR COAT—New Republic;
COTTON BARN COAT—J. Crew

114 (front to back) BROWN LEATHER BAG—
J. Peterman Co.; BROWN LEATHER BAG—
Ghurka; BLACK LEATHER BAG—Coach

116 POCKET KNIFE—Swiss Army

122 WOOL SUIT—J. Crew; NECKLACE—Erwin
Pearl; LEATHER ATTACHÉ—T. Anthony;
BLACK PUMPS—Cole Haan

123 CASHMERE T-SHIRT, WOOL-AND-
VISCOSE PANT SUIT—Emporio Armani;
CHIFFON SCARF—Laura Ashley; BLACK
LEATHER BELT—Barneys New York; CROC-
ODILE LOAFERS—J.M. Weston; GRAY
PEARL NECKLACE—Fragments; LEATHER
BAG—Ghurka

124 JACKET—Michael Kors; STRIPED SHIRT—
DKNY; PEARL NECKLACE—Ciro; BELT—
Two Blondes; LOAFERS—J.M. Weston;
PANTS—DKNY; RED CASHMERE
SWEATER SET—TSE; GRAY FLANNEL
TROUSERS—Polo/Ralph Lauren;
PEARLS—Ciro; GRAY FLANNEL SHOES—
Chanel; BELT—Gucci

126 NAVY JACKET—Ralph Lauren; STRIPED
SHIRT—J. Crew

127 WOOL KNIT BLAZER—Private collection
of Hope Greenberg

128 SILK SHIRT—Morgane Le Faye; WHITE
TANK—Michael Kors

129 SWEATER SET—Cashmere Cashmere

130 CHARCOAL LONG-SLEEVE TWIN SET—
Paul Stuart; CHALKSTRIPE WOOL AND
CASHMERE TROUSERS—J. Crew; TANK
WATCH—Cartier; LOAFERS—Gucci; PEARL
CHOKER—Fragments

131 SKIRT—Private collection of Kim Johnson
Gross; CASHMERE TURTLENECK—TSE;
LUG-SOLE SUEDE LOAFER—J. Crew; SUN-
GLASSES—Mikli par ilkiM; OPAQUE
STOCKINGS—Hot Sox; LEATHER ZIP-
FRONT VEST—Banana Republic; EAR-
RINGS—Fragments

132 BLACK LEATHER JEANS—North Beach
Leather; DARK GREEN VELVET JEANS—
Gucci; BEIGE CORDUROY JEANS—Paul
Stuart; WHITE DENIM JEANS—Levi's
Womenswear

133 BLAZER—Gucci; SHIRT—Brooks Brothers;
SILK SCARF—Hermès; JEANS—Levi's
Womenswear; SILVER BANGLES—
Fragments; BLACK-AND-WHITE SHOES—
Bottega Veneta; BLACK-AND-WHITE-
STRIPED T-SHIRT—Levi's Womenswear;
DENIM SHIRT—Levi's Womenswear;
BLACK WOOL BLAZER WITH VELVET
COLLAR—Hermès; VELVET CAPRI
PANTS—J. Crew; PATENT LOAFERS—J.
Crew; LEATHER BELT—Paul Stuart

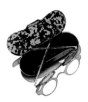

OLIVER PEOPLES

A quick perusal of your average televised Hollywood gala event lets you in on two minor revelations. 1) Movie stars wear glasses, too; and 2) They wear nice glasses, at that. They undoubtedly owe that look to Oliver Peoples, the most famous optician in Los Angeles. Based on the designs of 1,500 pairs of antique eyeglasses acquired from the estate of one Oliver Peoples, the collection reinterprets and modernizes vintage frames and sunglasses, mixing together both Old and New World materials with modern design twists. (*Oliver Peoples 310/657-5475*)

134 **BEIGE SUIT, BLOUSE**—Giorgio Armani; **DOUBLE-BREASTED SUIT**—Paul Stuart; **WATCH**—Swiss Army; **LOAFERS**—Cole Haan

135 **CASHMERE SWEATER AND DRESS**—TSE; **LOAFERS**—Nine West; **JACKET, VEST, AND SKIRT**—J. Crew; **COTTON T-SHIRT**—Dockers for Women; **SUEDE TIE SHOES**—Hush Puppies

136 **FAUX TORTOISESHELL HAIR PIN**—Colette Malouf; **FAUX TORTOISESHELL HAIR BAND, BARRETTE, AND SCRUNCHY**—Riviera; **HAIR ELASTIC**—Goody

137 (*clockwise from top left*) **SUIT JACKET AND SILK SCARVES**—Giorgio Armani; **DENIM SHIRT**—Levi's Womenswear; **SCARF**—Gucci; **WOOL JACKET**—Michael Kors; **SCARF**—Angela Cummings; **SILK BLAZER**—Private collection of Amanda Manogue Burch; **CHIFFON SCARF**—The Honey Collection

138–9 **SUEDE BELT**—Gucci

140 **BLACK STOCKING WITH LACE TOP**—DKNY; **BLACK BACK-SEAM SHINY PANTYHOSE AND BLACK HOSIERY**—Wolford

141 **BLACK CASHMERE TURTLENECK**—TSE; **WHITE BUTTON DOWN SHIRT**—J. Crew; **WOOL A-LINE SKIRT**—Laura Ashley; **BELT**—Ralph Lauren; **BLACK LEATHER TOTE, BLACK RIDING BOOT**—J. Crew; **GOLD LINK BRACELET**—Barry Kieselstein-Cord; **VELVET BLAZER**—Paul Stuart; **BAG, SHOES, LIZARD BELT**—Bottega Veneta; **TIGHTS**—Hot Sox; **SILK SHIRT**—J. Crew

142 **DRESS**—Ralph by Ralph Lauren

143 **WOOL T-SHIRT DRESS**—J. Crew

144 **NYLON WINDBREAKER, BLACK AND WHITE T-SHIRT**—Levi's Womenswear; **SKIRT SUIT**—J. Crew; **NYLON BAG**—Jill Stuart; **BLACK PATENT SHOES**—Bottega Veneta; **OPAQUE TIGHTS**—Hot Sox

145 **SILVER NECKLACE**—Fragments; **BLACK PANTS**—Dockers for Women; **BLACK COTTON T-SHIRT**—Levi's Womenswear; **BLUE WOOL CREPE JACKET**—DKNY; **PATENT LOAFERS**—Nine West; **SUNGLASSES**—DKNY; **SUEDE GLOVES**—Ralph Lauren Collection; **WOOL TWILL SUIT AND CASHMERE TURTLENECK**—Ralph Lauren Collection; **BELT**—Bottega Veneta; **SOCKS**—Hot Sox; **SUEDE SHOES**—Laura Ashley; **GLASSES**—Morgenthal Frederics

146 **SHOES**—Hush Puppies

147 **BALLET SLIPPER**—Bottega Veneta; **PATENT LOAFER**—J. Crew; **LEATHER TIE SHOE**—J. M. Weston; **SUEDE CROPPED RIDING BOOT**—J.M. Weston

148 **ALL PIECES**—Polo/Ralph Lauren

149 **QUILTED JACKET**—Wathne; **SCARF**—Hermès; **BROWN HOUNDSTOOTH JACKET**—Jil Sander; **CORDUROY PANTS**—Dockers for Women; **CROCODILE PURSE**—Giorgio Armani; **WATCH**—Timex; **BROWN SUEDE ANKLE BOOT**—J. M. Weston; **ARGYLE SOCKS**—Hot Sox; **PEA COAT**—Schott; **TURTLENECK AND LEGGINGS**—The Limited; **GLOVES**—Coach; **BOOTS**—Bruno Magli; **BACKPACK**—Takashimaya

150 **POCKET KNIFE**—Swiss Army

DOCKERS

For further proof of the ongoing American romance with the elegance of function, we present to your kind attention a pair of khaki pants. Khakis' apparent indestructability may give away their military roots, but their fit and soft comfort are tailored just for your peacetimes. Since its founding in 1986, Dockers has been the American Khaki Company, offering designs that are simple, durable, and practical. There's a pair of Dockers to cover most any situation life throws at you. Pleated, with cuffs, for a meeting with Mr. and Ms. Big of Big Enterprises; flat-front, stone-washed, and shorts for a hike in the woods; baggy to bring you right back to the heart of the city. Or any combination of the above. And it's not just pants (they never were just pants): there's also a full line of Dockers jackets, shirts, socks, and belts. Plus the new line, Dockers Authentics: looser-fitting, urban-style, in casual shirts, jackets, and the Authentic pants that can only be Dockers. (*Dockers 800/DOCKERS*)

QUOTES

2 NICK NOLTE, *North Dallas Forty*, as quoted in *Great Movie Lines*, by Dale Thompson (Ballantine/Random House, 1993).

6 AUSTRALIAN ABORIGINAL SAYING.

11 CHARLES DARWIN, as quoted in *The Moral Animal*, by Robert Wright (Vintage, 1994).

12 SLOAN WILSON, *The Man in the Gray Flannel Suit* (Simon & Schuster, 1955).

14 JOHN T. MOLLOY, *Dress for Success* (Warner Books, 1975).

15 MASURU IBUKA, as quoted in *The Tom Peters Seminar* (Vintage, 1994).

16 JOHN POWERS, "Dressing Down," *The Boston Globe Magazine*, October 8, 1995.

17 JOYCE DAVENPORT, as quoted in *Uncle John's Second Bathroom Reader* (St. Martin's Press, 1989).

21 CHARLES DARWIN, as quoted in *The Moral Animal*, by Robert Wright (Vintage, 1994).

22 BUDD SCHULBERG, *What Makes Sammy Run?* (Modern Library, 1941).

25 ANDY WARHOL, as quoted in *Uncle John's Second Bathroom Reader* (St. Martin's Press, 1989).

32 MARTHA DAVIS, as quoted in *Rock Talk: The Great Rock and Roll Quote Book*, edited by Joe and John Kohut (Faber & Faber, 1994).

34 PETER DRUCKER, as quoted in *The Tom Peters Seminar* (Vintage, 1994).

35 JOHN CHEEVER, *Bullet Park* (Alfred A. Knopf, 1969).

37 T. H. HUXLEY, "The Struggle for Existence in Human Society," as quoted in *The Moral Animal*, by Robert Wright (Vintage, 1994).

38 KURT VONNEGUT, *Breakfast of Champions* (Dell, 1973).

40 SONNY CROCKETT, as quoted in *Primetime Proverbs: The Book of TV Quotes*, edited by Jack Mingo & John Javna (Harmony Books, 1989).

43 TOMMY NUTTER, as quoted in *Just Joking*, by Donald Smith and Jon Winokur (Word Star International, 1992).

45 MIES VAN DER ROHE, as quoted in *Good Advice*, by William Safire and Leonard Safir (Wings Press, 1982).

51 SHIRLEY MACLAINE, in *The Apartment* (Mirisch Company, 1960; MGM/UA Video, 1988).

59 P. J. O'ROURKE, as quoted in *Just Joking*, by Donald Smith and Jon Winokur (Word Star International, 1992).

61 FRANK ZAPPA, as quoted in *Just Joking*, by Donald Smith and Jon Winokur (Word Star International, 1992).

63 DAVID GIVENS, as quoted in *The Moral Animal*, by Robert Wright (Vintage, 1994).

64 TOM WOLFE, *The Bonfire of the Vanities* (Farrar, Straus & Giroux, 1987).

69 ANDRÉ MAUROIS, as quoted in *Correct Quotes* (Word Star International, 1992).

70 KEN AULETTA, as told to *Chic Simple*.

71 FAITH POPCORN, from *Clicking* (Harper-Collins, 1996); ALVIN TOFFLER, from *PowerShift* (Bantam, 1990).

79 F. SCOTT FITZGERALD, as quoted in *A Moveable Feast*, by Ernest Hemingway (Scribner, 1964).

88 TIMOTHY F. PRICE, from "Managing By Values," *Business Week*, August 1, 1994.

92 MICHAEL CRICHTON, *Jurassic Park* (Alfred A. Knopf, 1990).

95 JEFF ALTMAN, as quoted in *The Comedy Quote Dictionary* (Doubleday, 1992).

98 JAY McINERNEY, *Bright Lights, Big City* (Vintage Contemporaries, 1984).

104 JAMES CAGNEY, as quoted in *This Is Really a Great City (I Don't Care What Anybody Says)*, by J. P. Fennell (Citadel Press, 1991).

106 HAL RUBENSTEIN, *Paisley Goes with Nothing* (Doubleday, 1995).

108 PHIL KNIGHT, as quoted in *The Tom Peters Seminar* (Vintage, 1994).

119 T. H. HUXLEY, "The Struggle for Existence in Human Society," as quoted in *The Moral Animal*, by Robert Wright (Vintage, 1994).

120 EDITH WHARTON, *The House of Mirth* (1905; Bedford Books, 1994).

125 JEAN HARLOW, in *This Is Really a Great City (I Don't Care What Anybody Says)*, by J. P. Fennell (Citadel Press, 1991).

130 ELSA KLENSCH, *Style* (Perigree, 1995).

143 THIERRY MUGLER, as quoted in *French Chic*, by Susan Sommers (Villard Books, 1990).

151 PETER ROBINSON, "Five Ways to Make Business Schools into Useful Institutions," *The Red Herring*, April/May 1994.

152 JUDY MCGRATH, "Will the Suit Always Work?" by Cathy Horyn, *Vogue*, February 1995.

153 MAX DEPREE, *Leadership Is an Art* (Doubleday, 1989).

154 THE ALLMAN BROTHERS, from "Ramblin' Man" (1973).

157 ROGER AILES, *You Are the Message* (Dow Jones Irwin, 1988).

168 CHARLES DUDLEY WARNER, from *Correct Quotes* (Word Star International, 1992).

176 ANITA RODDICK, *Body & Soul* (Crown, 1994).

PHOTOGRAPHY BY JAMES WOJCIK

page 18 BLUE AND WHITE-COLLAR CHAMBRAY SHIRTS page 29 SUIT PANTS, WHITE SHIRT, SUIT JACKET page 30 BLUE GARBAGE PAIL page 31 WARDROBE page 32 PIGGY BANK page 41 BROWN BRIEFCASES page 44 BLAZER page 51 LIGHT-BLUE CASHMERE SWEATER OUTFIT page 61 BLACK CASHMERE CARDIGAN page 84–85 RUGGED SHIRTS page 87 SUIT VEST AND NAVY VEST page 106 WHITE CANVAS SNEAKERS page 110 AGENDA AND ELECTRONIC NOTEPAD page 112 TRENCH COAT page 113 LEATHER CAR COAT, BARN COAT page 116 SWISS ARMY KNIFE page 124 STRIPED SHIRT OUTFIT, RED SWEATER OUTFIT page 126 NAVY BLAZER, STRIPED SHIRT page 127 WOOL KNIT BLAZER page 128 SILK SHIRT, WHITE TANK page 129 SWEATER SET page 134 BEIGE ARMANI PANT SUIT page 136 HAIR ACCESSORIES page 137 SCARF SHOTS page 149 RED PEA-COAT OUTFIT page 150 SWISS ARMY KNIFE

PHOTOGRAPHY BY DANA GALLAGHER

page 32 PIGGY BANK

CHIC SIMPLE STAFF

PARTNERS Kim & Jeff
ART DIRECTOR Wayne Wolf
ASSOCIATE ART DIRECTOR Alicia Yin Cheng
EDITORIAL ASSISTANT Will Georgantas
OFFICE MANAGER Joanne Harrison
COPY EDITOR Borden Elniff
EDITORIAL INTERN Vered Frank

ACKNOWLEDGMENTS

MANY MANY THANKS TO: Amanda Manogue Burch, Hope Greenberg, and Lisa Wertheimer Wells. SPECIAL THANKS TO: Mallory Andrews, Barneys New York, Ken Berger, Paul Bogaards, Claire Bradley, Gabrielle Brooks, Amy Capen, Dan Chew, Cassie Ederer, Richela Fabian, Michelle Faro, Alan Firestone, Jane Friedman, Patrick Gates, Gordon Gray, John Groton, Kate Doyle Hooper, Andy Hughes, Carol Janeway, George Kalossa at Polo/Ralph Lauren, Gia Kim, Nicholas Latimer, Coleen McKay, Dwyer McIntosh, Monique Makhlouf, Shalini Matani, Sonny Mehta, Sandi Mendelson, Anne Messitte, Thomas Oatman at New Republic Clothier, Mona Reilly at Paul Stuart, Lisa Scheik at Gucci, Rebecca Shafer at TSE, Mel Siminsky, Cathy E. Shaw-Sirotin, Suzanne Smith, Takuyo Takahashi, Shelley Wanger, Brad Williams, and Amy Zenn.

INVALUABLE RESOURCES

Roger Ailes, *You Are the Message* (Dow Jones-Irwin, 1988); Donald Charles Richardson, *Men of Style: The Zoli Guide for the Total Man* (Villard Books, 1992); Riccardo Villarosa and Giuliano Angeli, *The Elegant Man* (Random House, 1990); *Statistical Forecasts of the United States*, 2nd ed.; Alan Flusser, *Clothes and the Man* (Villard Books, 1985).

COMMUNICATIONS

Chic Simple is about using a deep pool of information to simply your lifestyle and make hard decisions easier. We try to provide as much of that information as we can, but we also depend on receiving important additional tips from our readers. Casual dressing in the workplace is an evolution, not a trend. Please share with us any new aspects of casual dress in your everyday life or workplace. If you could like to receive our free Chic Simple catalog, please send us one hundred shares of your company's stock/controlling interest, or your address, whichever is easier, to:

CHIC SIMPLE
84 WOOSTER STREET, NEW YORK, NY 10012
Fax: (212) 343-9678

American Online address: **ChicSimple**
Compuserve address: **72704,2346**
E-mail address: **info@chicsimple.com**
Website address: **http://www.chicsimple.com**

Stay in touch because . . .
"The more you know, the less you need."

Please let us know if you are interested in Chic Simple on-site seminars on casual businesswear.

A NOTE ON THE TYPE

The text of this book was set in New Baskerville, Futura, and Impact. The ITC version of **NEW BASKERVILLE** is called Baskerville, which itself is a facsimile reproduction of types cast from molds made by John Baskerville (1706–75) from his designs. Baskerville's original face was one of the forerunners of the type style known to printers as the "modern face"—a "modern" of the period 1800. **FUTURA** was produced in 1928 by Paul Renner (1878–1956), former director of the Munich School of Design, for the Bauer Type Foundry. Futura is simple in design and wonderfully restful to read. It has been widely used in advertising because of its even, modern appearance in mass and its harmony with a great variety of other modern types.

SEPARATION AND FILM PREPARATION BY
PROFESSIONAL GRAPHICS INC.
Rockford, Illinois

PRINTED AND BOUND BY
BUTLER & TANNER, LTD.
Frome, England

HARDWARE

Power PC 9500, 8100, Apple Macintosh Power PC 8100, Quadra 800 personal computers; APS Technologies Syquest Drives; Iomega Zip Drive; MicroNet DAT drive; SuperMac 21-inch color monitor; Radius PrecisionColor Display/20; Radius 24X series video board; QMS 1660 Printer; Hewlett-Packard LaserJet 4, Supra fax modem; Braun FlavorSelect KF145B.

SOFTWARE

QuarkXPress 3.31, Adobe Photoshop 2.5.1, Microsoft Word 6.0, FileMaker Pro 2.0, Adobe Illustrator 5.0.1.

MUSICWARE

James Brown (*Star Time, disc 1*), The Harder They Come (*Motion Picture Soundtrack*), John Coltrane (*Coltrane Plays the Blues*), Luna (*Penthouse*), John Coltrane with the Red Garland Trio (*Traneing In*), Dead Presidents (*Motion Picture Soundtrack, volume 2*), Neil Diamond (*Hot August Night*), Easy Rhythms for Your Cocktail Hour (*Music for a Bachelor's Den, volume 4*), Bill Evans (*Waltzes for Debbie*), Red Garland Trio (*All Kinds of Weather*), The Jesus & Mary Chain (*Stoned & Dethroned*), Los Lobos (*Colossal Head*), Bill Morrissey (*North*), Nusrat Fateh Ali Khan with Michael Brook (*Night Song*), Charlie Parker (*Swedish Schnapps + The Great Quintet Sessions 1949–51*), Smithsonian Collection of Recordings (*American Popular Song Disc 5*).

CHIC
SIMPLE
library

CLOTHES

BODY

HOME

COOKING

WOMEN'S WARDROBE

PACKING

BED LINENS

EYEGLASSES

SCARVES

ACCESSORIES

SCENTS

TOOLS

DESK

SHIRT AND TIE

COOKING TOOLS

BATH

PAINT

NURSERY

STORAGE

"One of the great challenges for entrepreneurs is to identify a simple need."

ANITA RODDICK, *founder of the Body Shop*

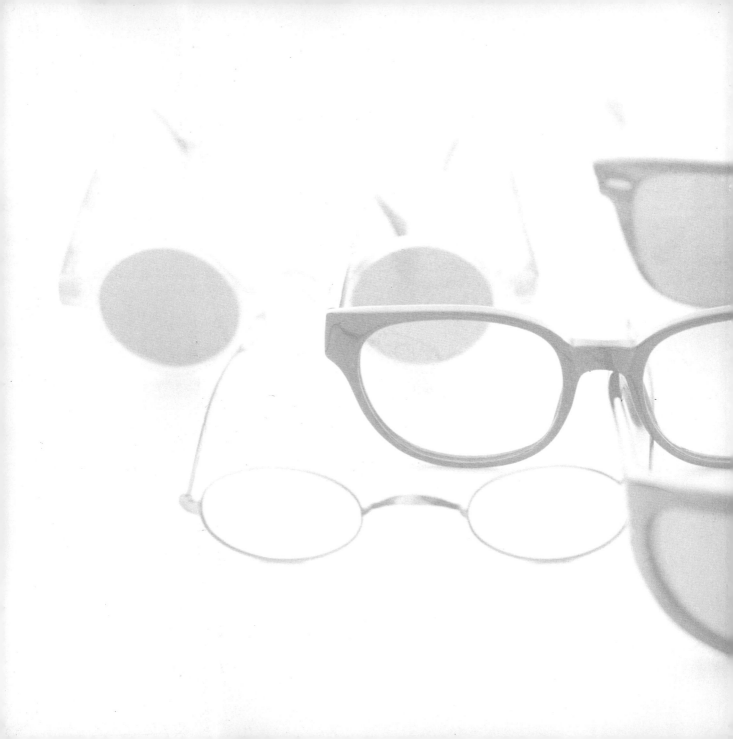